Published by Hero Collector Books, a division of Eaglemoss Ltd. 2019
1st Floor, Kensington Village, Avonmore Road, W14 8TS, London, UK.

General Editor: **Ben Robinson**
Project Manager: **Jo Bourne**

Most of the contents of this book were originally published as part of
STAR TREK – The Official Starships Collection and STAR TREK DISCOVERY –
The Official Starships Collection by Eaglemoss Ltd. 2013-2018

To order back issues: Order online at
www.shop.eaglemoss.com

ISBN 978-1-85875-539-7

Printed in China

STAR TREK™
SHIPYARDS
KLINGON FLEET

THE ENCYCLOPEDIA OF STAR TREK SHIPS

CONTENTS

ACKNOWLEDGMENTS

This book would not have been possible without all of the writers, producers, production designers, concept artists and modelers (both traditional and CG) who have worked on *STAR TREK* over the years.

In particular we'd like to acknowledge the work of Foundation Imaging, Digital Muse, Eden FX and Pixomondo who created many of the CG models that fill the pages of this book. Before that Greg Jein, Bill George, and Tony Meininger's Brazil Fabrications were responsible for many of the physical models, which were recreated by our own talented CG modellers Fabio Passaro and Ed Giddings.

We'd especially like to acknowledge the work of the modellers at the CG companies. Sadly we don't always know the names of everyone involved, but we know that particular thanks are due to Pierre Drolet, Brandon MacDougall and Koji Kuramura. We'd also like to thank Rob Bonchune and Adam 'Mojo' Lebowitz, who not only introduced us to Ed and Fabio, but also created many of the renders you will find inside this book.

We'd like to thank all the VFX supervisors and producers whose role in creating the final ships is often overlooked. William Budge provided invaluable assistance when it came to establishing the lengths of the Klingon ships from *STAR TREK: DISCOVERY*. When it came to tracking down the appearances of different classes of ship, the website *Ex Astris Scientia* was an invaluable resource.

We'd like to thank our friends at CBS Consumer Products: Risa Kessler, Marian Cordry and John Van Citters.

More than anyone, we'd like to thank Gene Roddenberry and Matt Jefferies for laying the foundations for everything that followed. More recently Michael Piller, Ron D. Moore and Ira Steven Behr have played important roles in guiding the Klingons into the 24th century, and Alex Kurtzman and Bryan Fuller gave them new life in the 23rd.

FOREWORD

Having produced two volumes that deal with Stafleet ships, we've turned our attention to the most significant `alien' race in *STAR TREK:* the Klingons. Our mission is to produce a detailed and comprehensive guide to *STAR TREK*'s ships. This volume covers the ships used by the Klingon Empire, from their debut in the original *STAR TREK* to their latest appearances in *STAR TREK: DISCOVERY.*

As before there are rules. The ships in these books are all canon ships that have appeared in one of the *STAR TREK* TV series or movies, and in the pages that follow you will find detailed plan views of every ship, with profiles that provide the most important information we have about them. These ships are all from the Prime timeline and don't take account of the vessels that can be found in the movies that have been made since 2009. Nor do we include ships that have only appeared in books, games, calendars or the animated *STAR TREK* series from the 1970s.

The history of Klingon ships is a complex and fascinating subject that poses the *STAR TREK* historian with some continuity problems. In particular the Klingon bird-of-prey is a thorny topic. In the original script for *STAR TREK III,* it was a Romulan ship, which explains how the Klingons acquired the name and cloaking technology. Over the years it has changed size wildly, from as little as 50m long to as much as 600m. This is clearly the result of *STAR TREK* being a TV show rather a parallel reality, but we have done what we can to rationalise it.

More recently, people have been surprised by the variety of Klingon ships that have appeared in *STAR TREK: DISCOVERY.* It makes sense to us that a vast empire made up of warring houses would operate dozens of different types of ship. In fact, we look forward to seeing many more Klingon ships and hope to have the opportunity to return to update this volume in the future.

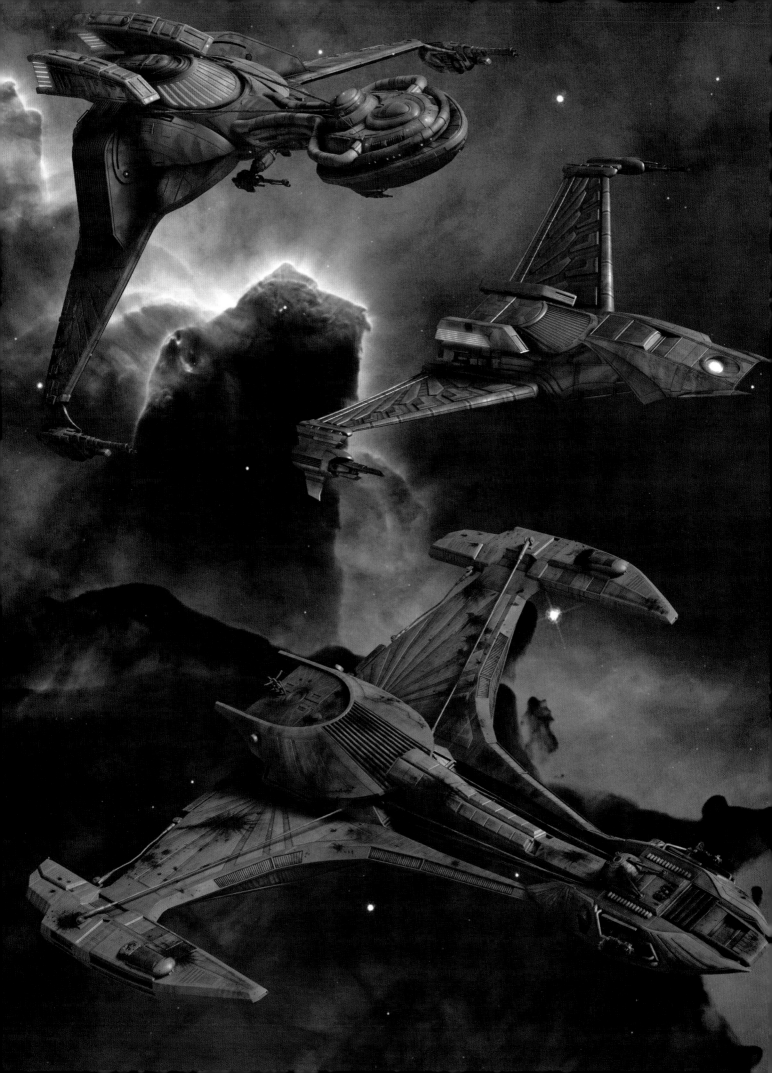

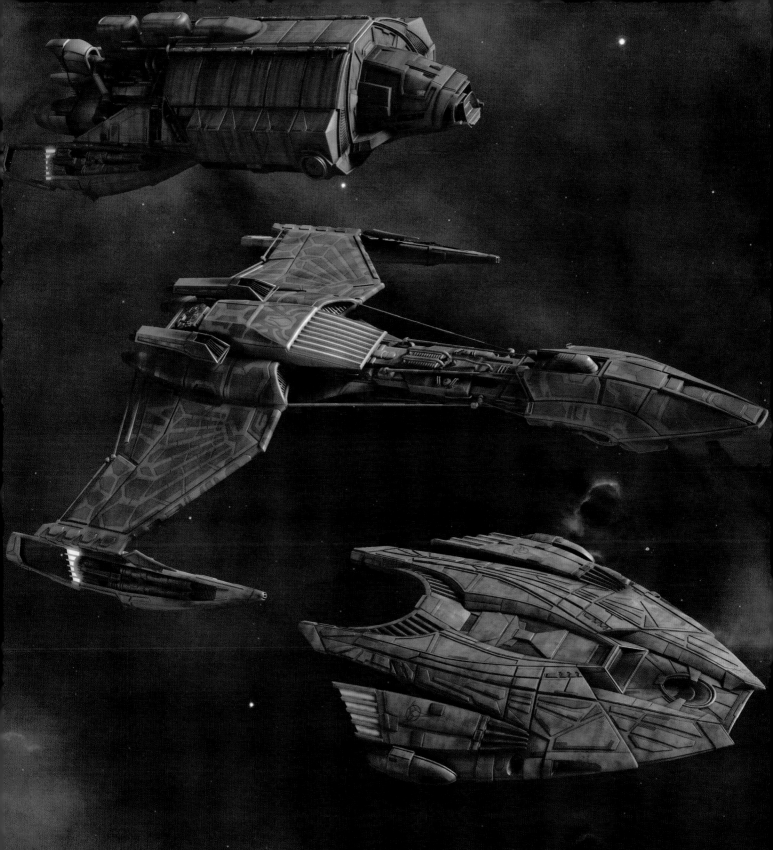

CHAPTER 1
22nd CENTURY

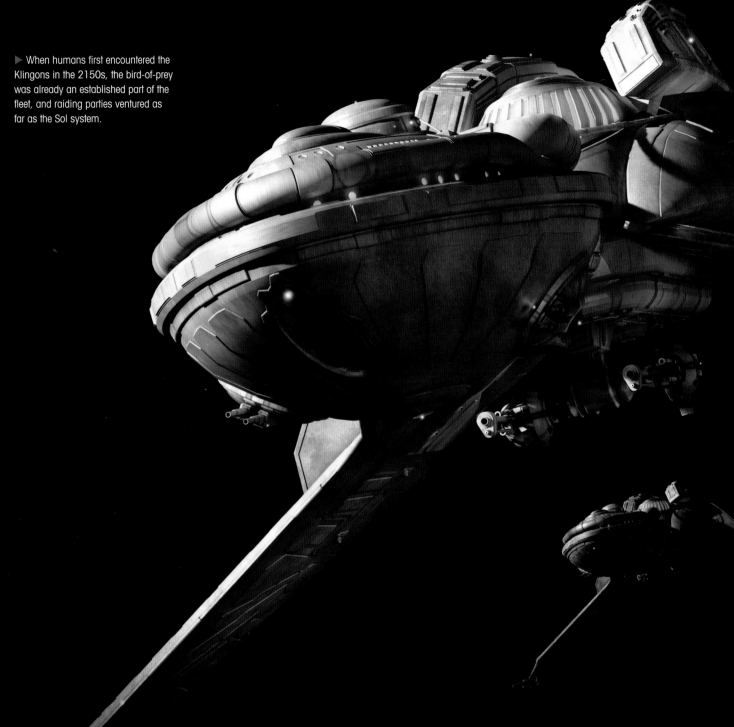

When humans first encountered the Klingons in the 2150s, the bird-of-prey was already an established part of the fleet, and raiding parties ventured as far as the Sol system.

KLINGON DEFENSE FORCE
BIRD-OF-PREY (2150s)

In the 22nd century, birds-of-prey were on the front line of the Klingon Empire.

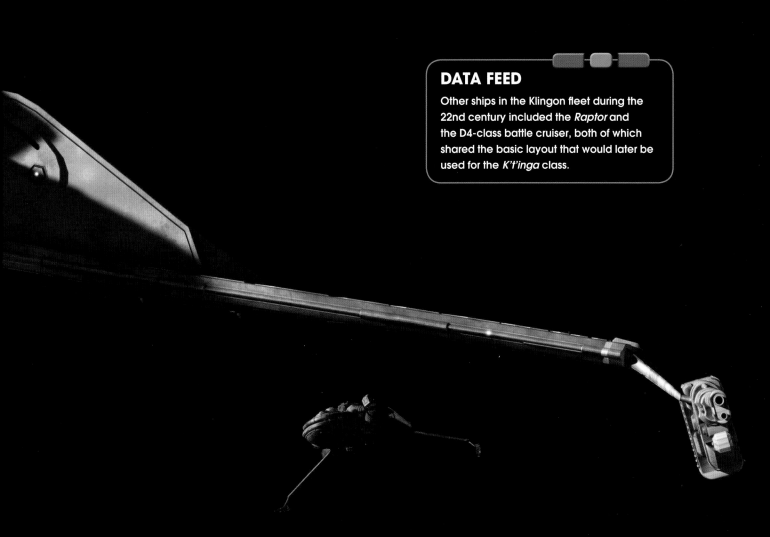

Small, winged craft known as birds-of-prey that act as scouts and raiders have been an essential part of the Klingon fleet since the Empire first achieved spaceflight. The same basic layout has been adapted over the years to become more and more powerful, but the essentials have remained the same – an engineering hull with two wings that is connected to a bridge module by a long neck.

Humans first encountered a Klingon bird-of-prey in 2153 when the High Council sent Duras to apprehend Captain Archer, who had fallen foul of them by helping a group of Klingon rebels. Duras was so confident that he attacked Archer's ship, the *Enterprise* NX-01, on the outer perimeter of the Sol system. He was only forced to retreat when three other ships came to *Enterprise*'s aid.

LONE RAIDERS

In the mid-22nd century, it wasn't uncommon for a bird-of-prey to operate independently, often straying far from Klingon space. If it encountered a serious threat, its commander could call on the support of other birds-of-prey. For example, when Duras discovered that Archer's ship had been upgraded with more powerful weapons, he

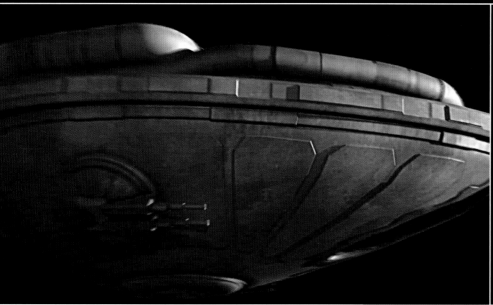

◀ The bird-of-prey was an extremely heavily armed ship and the exterior bristled with disruptor cannons. Twin cannons were mounted on either side of the bridge module.

▶ The bird-of-prey's most powerful weapons were its torpedoes. The ship had fore and aft launchers. The forward launcher could be clearly seen at the front of the bridge module.

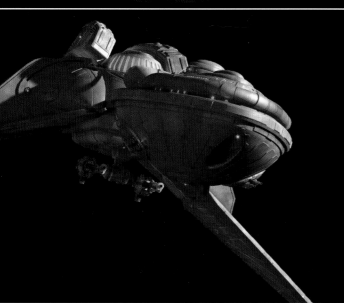

◀ Like other Klingon ships of the period, the bird-of-prey carried a disruptor turret that was mounted on the underside of the ship. The turret was fitted with twin disruptor cannons and could rotate through 360 degrees and in the Z axis, providing a wide field of fire.

▶ The first weapons most Klingon commanders fired were the bird-of-prey's wingtip disruptors.

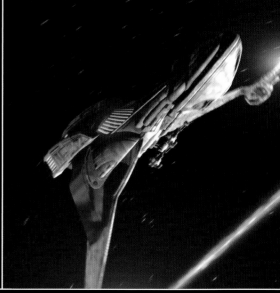

summoned two more birds-of-prey to assist him. The bird-of-prey also formed patrols with larger ships, and in 2155, Fleet Admiral Krell's warship had an escort of two birds-of-prey.

ARMED TO THE TEETH
The kind of bird-of-prey that Duras commanded was capable of speeds up to warp 5 and was much better armed than most ships of the period. Before *Enterprise*'s 2153 refit, Duras' ship was more than a match for the NX class and easily capable of outgunning two Orion interceptors. This was due to an impressive arsenal of weaponry consisting of eight forward disruptor banks, including a pair of neck mounted disruptors, a pair of wing tip mounted disruptor cannons, and a 360 degree

rotating turret containing twin belly-mounted disruptor cannons. The ship was also equipped with two torpedo launchers, one located forward and the other towards the rear. In keeping with the Klingons' belief in mounting head-on attacks, the rear of the ship was much less heavily armed than the front.

The Klingons placed a little less emphasis on the bird-of-prey's defensive capabilities. The bridge module was heavily protected with dispersive armor that was designed to withstand direct cannon fire, making the entire area the most protected section of the ship. Power could be routed to defensive shields that surrounded the vessel, but priority was given to the forward shielding and the rear presented an enemy with

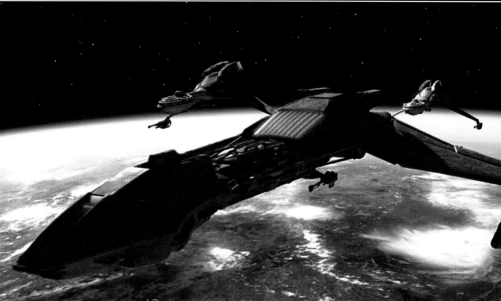

▲ Birds-of-prey often
formed part of larger
patrol groups. In 215-
Admiral Krell's warshi
had an escort of two
birds-of-prey when he
visited the Qu'vat
colony with the intenti
of wiping it out to
protect the Empire fro
an infectious disease.

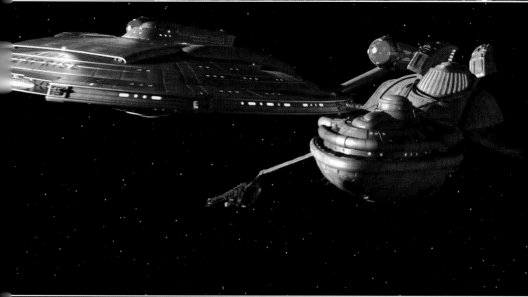

◄ In the mid-22nd
century ships routinely
docked with one anoth
The bird-of-prey's mair
docking ports were on
either side of the
engineering hull.

ole target. The bird-of-prey also had a
sign flaw in that a direct hit on the main
nction, located above the sensor array
rd of the warp reactor, could disable the
wer grid.

EMITTERS

of-prey also boasted tractor beam
gy at a time when Earth ships had to
nysical grappling lines, and had emitters
on the underside of each wing. These
t to hold and pull enemy ships into its
y, which was located on the underside
o. Unlike the larger *Raptor* class, the bird-
as equipped with escape pods with the
ated on the belly of the ship.

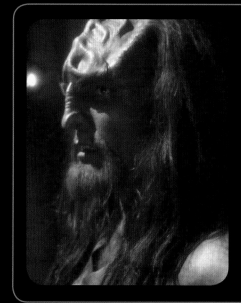

DATA FEED

The first Klingon bird-of-prey Starfleet encountered was commanded by Duras, son of Toral. This Klingon captain had been humiliated by Captain Archer, who cost Duras his command when he prevented him from capturing some Klingon 'rebels'. The Klingon High Command restored Duras's rank and sent him to apprehend Archer, but he underestimated his foe, who destroyed Duras' ship in a battle in the Expanse.

◀ The design of the bird-of-prey's bridge barely changed between the 22nd and 24th centuries. The commander was always on a throne-like seat in the center, the roof was made up of grating, and there was a combination of wall mounted and free-standing consoles.

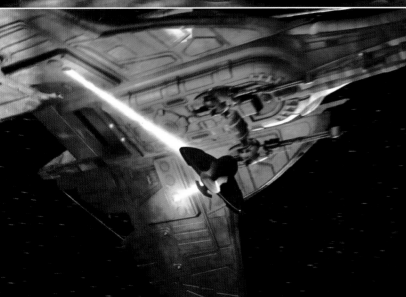

◀ The bird-of-prey was fitted with tractor emitters on the underside of the wings that were powerful enough to pull a small ship into its shuttlebay, even if the target vessel resisted.

▶ The bird-of-prey was a small, highly maneuverable ship that often operated independently. It was designed for battle and was heavily armed.

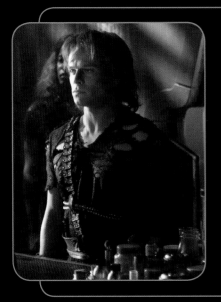

DATA FEED

In 2153, a group of genetically engineered humans, known as augments, captured a Klingon bird-of-prey and nearly started a war between Earth and the Klingons. The augments easily overpowered the Klingon crew and rapidly mastered the ship's systems. They retro-fitted one of the bird-of-prey's torpedoes with a bio-genetic weapon, and planned to wipe out the colony on Qu'Vat. They were only stopped by the *Enterprise* NX-01.

The bulk of the ship's overall mass was incorporated in the aft section of the ship, which contained the mess hall and kitchen, crew quarters, engineering, the shuttlebay and labs. Despite the ship's small size, the shuttlebay was large enough to store a Denobulan medical ship. Like the *Raptor*-class scouts of the same period, the bird-of-prey carried live food in its targ pits which were located near to the galley.

PROPULSION SYSTEMS

The warp engines were powered by a matter-antimatter reactor that used dilithium crystals to focus the reaction. The bright red plasma generated by the warp engines could clearly be seen from the outside of the ship through large

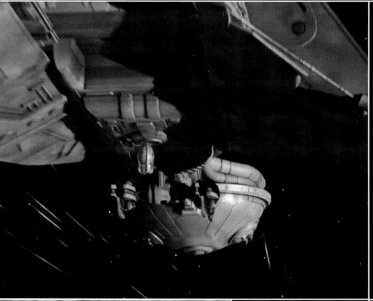

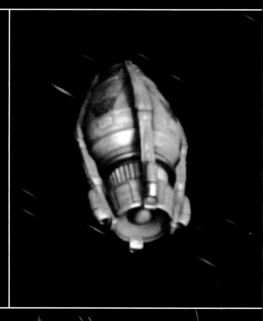

◀▶ It comes as a surprise to many people, but most Klingon ships carry escape pods. Klingons believe that it is wiser to survive so you can continue the battle than to lose as a result of seeking glory. In the 22nd century, the bird-of-prey used single-pilot escape pods with basic steering capabilities that could be ejected from the underside of the ship. Internal sensors informed the bridge crew if an escape pod was launched.

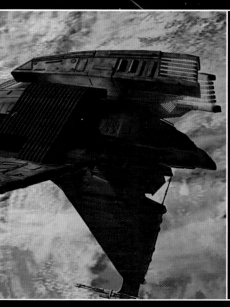

▶ The bird-of-prey used deflector shields to protect it from enemy fire. The amount of energy could be reallocated to offer greater protection to different areas. If the maximum amount of power was diverted to the forward shields, the ship could withstand the impact of the newly-introduced photon torpedoes. However, this meant underpowering the aft shields and left the rear of the ship vulnerable to attack.

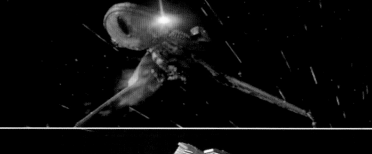

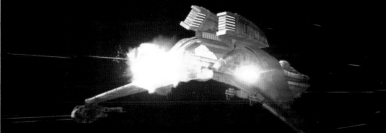

grilles on the upper side of the engineering hull. The impulse engines were mounted above this with twin modules angled towards one another at the top. The plasma in the impulse engines glowed with a cooler orange color. The bird-of-prey's self destruct system worked by overloading the dilithium matrix to create an uncontrolled reaction that literally tore the ship apart.

The layout of the bridge of a 22nd-century bird-of-prey would have been instantly recognizable to a 24th-century Klingon. The ship's viewscreen was located against the forward bulkhead while the captain's chair was in the center of the bridge. The entranceway to the bridge was positioned directly behind this with two free-standing consoles located on either side of the doorway, one of

which was assigned to the weapons officer. Additional stations were located around the perimeter of the bridge.

The 22nd-century bird-of-prey was often used to mount raids outside the borders of the Empire and was ideally suited to making swift, running attacks. In this era, the bird-of-prey did not have transporter technology, so once the crew had overpowered another vessel, they often boarded them to take prisoners. The primary docking ports were in the sides of the engineering hull.

The design was so fundamental to Klingon thinking that it formed the basis for generations of similar ships with the Klingons making as few changes as they could while making the bird-of-prey tougher and stronger.

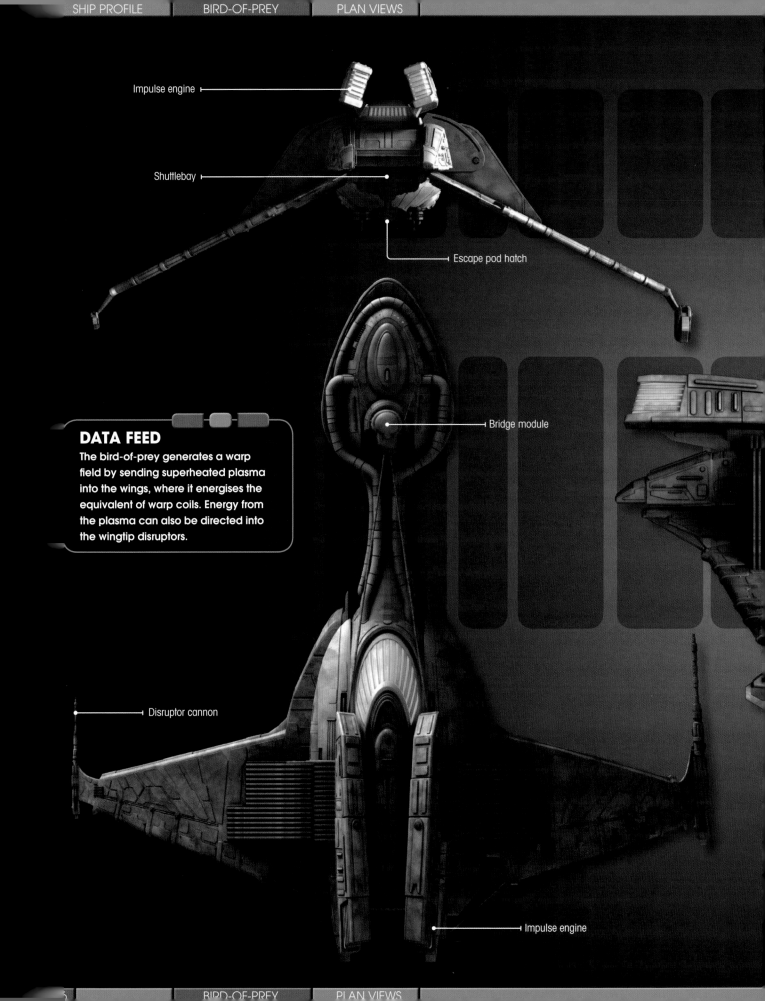

Impulse engine

Shuttlebay

Escape pod hatch

Bridge module

DATA FEED

The bird-of-prey generates a warp field by sending superheated plasma into the wings, where it energises the equivalent of warp coils. Energy from the plasma can also be directed into the wingtip disruptors.

Disruptor cannon

Impulse engine

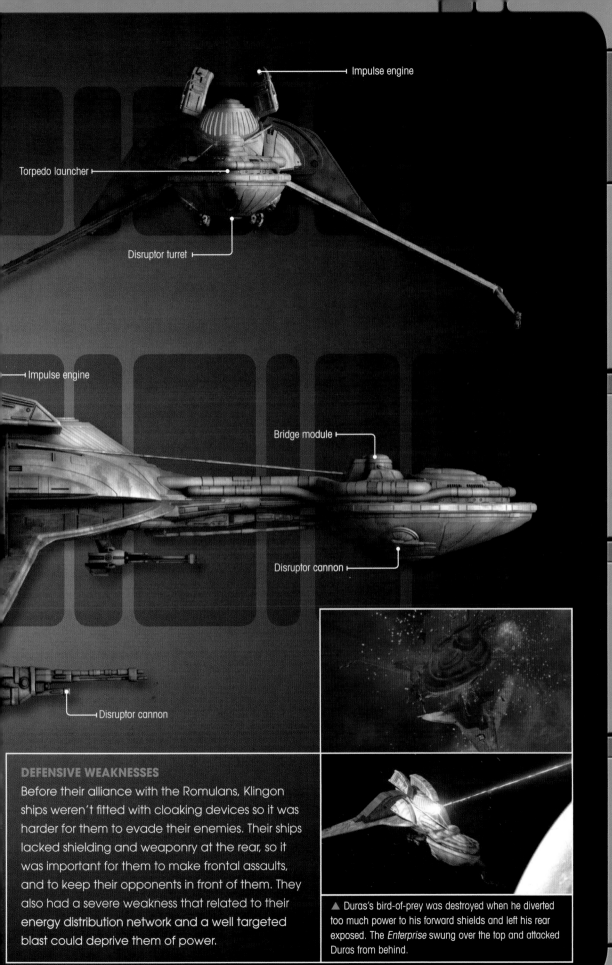

Impulse engine

Torpedo launcher

Disruptor turret

Impulse engine

Bridge module

Disruptor cannon

Disruptor cannon

HOUSE OF DURAS

It seems likely that the Duras who attacked Captain Archer was an ancestor of the Duras who tried to take control of the Klingon Empire during the civil war in 2368.

OFTEN WRONG

There is little doubt that Arik Soong, who 'birthed' the augments was an ancestor of Dr. Noonien Soong who created the android Data. After his problems with his genetically engineered children, Arik Soong switched his focus to cybernetics.

DEFENSIVE WEAKNESSES

Before their alliance with the Romulans, Klingon ships weren't fitted with cloaking devices so it was harder for them to evade their enemies. Their ships lacked shielding and weaponry at the rear, so it was important for them to make frontal assaults, and to keep their opponents in front of them. They also had a severe weakness that related to their energy distribution network and a well targeted blast could deprive them of power.

▲ Duras's bird-of-prey was destroyed when he diverted too much power to his forward shields and left his rear exposed. The *Enterprise* swung over the top and attacked Duras from behind.

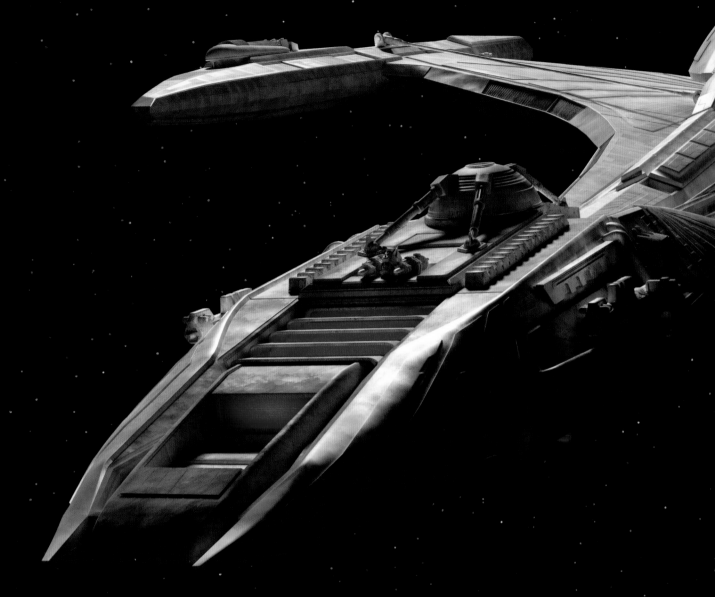

▼ The *Raptor* was a small Klingon scout ship that was operated by a crew of 12.

KLINGON
RAPTOR

In the 22nd century *Raptor*-class vessels mounted raids along the borders of the Klingon Empire.

The Klingon *Raptor* was a small raiding vessel that first entered service in the 2130s. Typically *Raptors* patrolled the edges of Klingon space mounting raids on alien outposts. They were designed to enter a planet's atmosphere and land on the surface, where the crew could carry off technology, supplies and information. It was one of the first classes of Klingon ship encountered by the *Enterprise* NX-01. The Vulcan database identified it as a scout ship but it wasn't until crewmembers from the *Enterprise* found themselves trapped on the *I.K.S. Somraw*, while it was in the process of being slowly crushed by the atmosphere of a gas giant, that Starfleet was able to get its first good look at the inside of the ship and its systems.

Outwardly, the design of the *Raptor* had the same basic layout as the D5 battle cruiser, though at 145 meters long it was noticeably shorter. It featured a head and long, thin neck leading to a set of wings on either side of the body housing the warp nacelles, which in turn housed the warp coils of the vessel's warp system. The *Raptor's* hull was not only twice the thickness of Starfleet's *NX*-class ships but was reinforced with a coherent molecular alloy that enabled it to withstand pressures of up to fifteen thousand GSC.

The *Raptor* was designed to operate independently for extended periods of time and could survive for up to six months without returning to Klingon space. The crew would routinely

◀ The crew of the *I.K.S. Somraw* was incapacitated after they mounted a raid on a Xarantine outpost. They celebrated their victory by drinking captured Xarantine ale, which was laced with a neurotoxin.

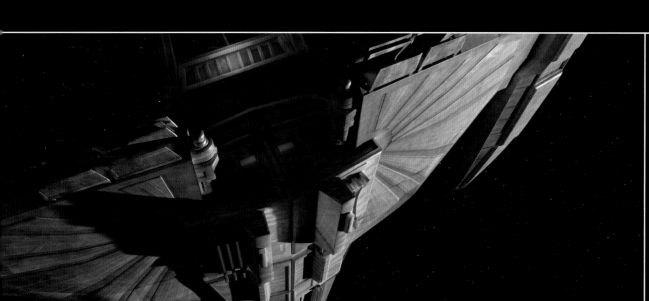

◀ At just under 150 meters long, the *Raptor* was a relatively small ship but it had the same basic layout as the larg battle cruisers.

▶ After the *Somraw* wa damaged in a battle wit a Xarantine ship, the captain decided to take refuge in the atmospher of a gas giant, where h could make repairs. Unfortunately, the crew succumbed to the effect of a Xarantine neurotoxi leaving the ship in dang

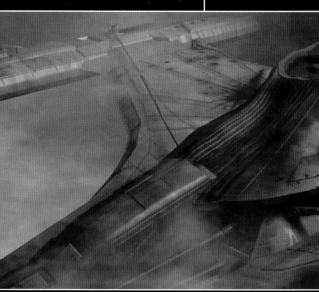

▲ The interior design of Klingon ships has barely changed in centuries, and the bridge of a Klingon *Raptor* closely resembled that of a bird-of-prey from the late 24th century.

supplement their supplies of food and water by mounting raids. Despite this it rarely operated far from other Klingon ships and could easily call on the support of other small Klingon ships such as the bird-of-prey.

The *Raptor* had a crew complement of 12 and was laid out over four decks, with various parts of the interior being color-coded. As you would expect of a Klingon ship, it was not built with comfort in mind. Low-level lighting and exposed pipes gave rooms and corridors a cramped appearance. The Main Bridge, which could be operated by three crew members, was located in the 'head' area of the ship. A command chair was positioned in the middle of the room and faced a large viewscreen located on the opposite wall. An access console was placed between

the command chair and the viewscreen, while a number of manned consoles controlling and monitoring the helm, weapons system, structural integrity and engineering were dotted around the perimeter. Main Engineering or, as the Klingons referred to it, 'the reactor pit,' was located one deck below the bridge. The warp engines were powered by a matter-antimatter reactor and could maintain speeds of warp 5. The ship's impulse engines relied on a nuclear-fusion engine.

STATE OF THE ART WEAPONS
The *Raptor* was also extremely well armed, which may have led to Captain Archer later referring to it as a battle cruiser rather than a scout vessel. It was fitted with six torpedo ports containing a number of warp-capable photon torpedoes, technology that

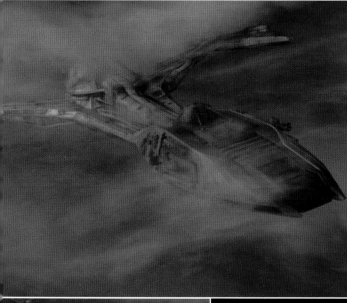

▶ The only member of the *Somraw*'s crew who was able to resist the effects of the Xarantine toxin, was the ship's engineer, Bu'kah. Like the rest of the crew she drank the ale, but when she started to feel the effects, she took refuge in one of the ship's food lockers. The cold inhibited the toxin's effects leaving her conscious. When a landing party from the *Enterprise* NX-01 boarded the ship, she stole their shuttle and escaped.

▶ Klingons prefer their food live or freshly slaughtered and the *Somraw*'s galley carried several live *targs*, the Klingon equivalent of boars. They were used to prepare dishes such as heart of *targ*.

◀ *Raptor*'s are tough ships, but the *Somraw* was still being crushed by the enormous pressure of the atmosphere.

used matter-antimatter to generate an explosion. Before 2151 this technology was unknown to Starfleet and was vastly superior to the weapons system of the *Enterprise*. The torpedoes could be fired from both fore and aft. The *Raptor* was also kitted out with multi-spectral tactical sensors, multiple disruptor arrays and deflector shields.

The galley was located on deck four and, to satisfy the dietary demands of its Klingon crew, carried live food in the form of bloodworms which were stored in a chilled area, as well as a well stocked *targ* pit. Freshly slaughtered *targs* were hung from a number of ceiling hooks.

The *Raptor* had a similar mission profile to the era's bird-of-prey, which ultimately supplanted it. By the 23rd century the *Raptor*'s architecture was reserved for larger vessels.

DATA FEED

Captain Archer's attempts to help the *Somraw* were not entirely successful. Archer rescued the ship, but the Klingon captain was far from happy that he had been saved by an alien, or that anyone had learned of his foolishness in allowing his crew to be knocked out by Xarantine ale. The Klingons' first response was to attack their rescuers, but they chose to retreat rather than enter into a battle with *Enterprise* that they were bound to lose.

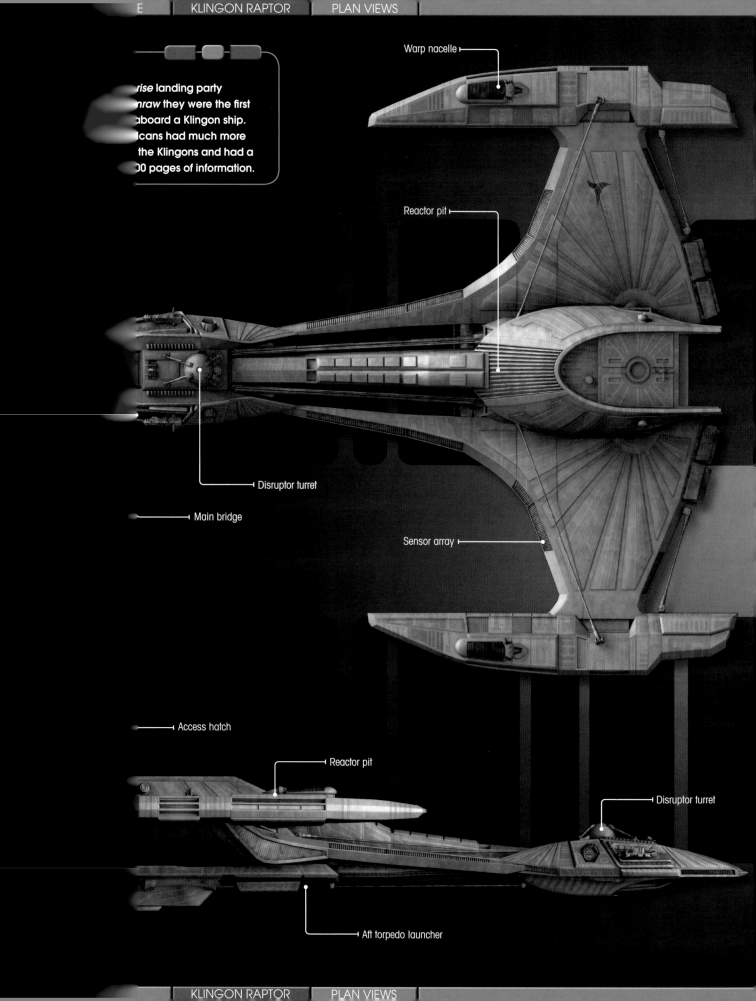

rise landing party
nraw they were the first
aboard a Klingon ship.
cans had much more
the Klingons and had a
00 pages of information.

Warp nacelle

Reactor pit

Disruptor turret

Main bridge

Sensor array

Access hatch

Reactor pit

Disruptor turret

Aft torpedo launcher

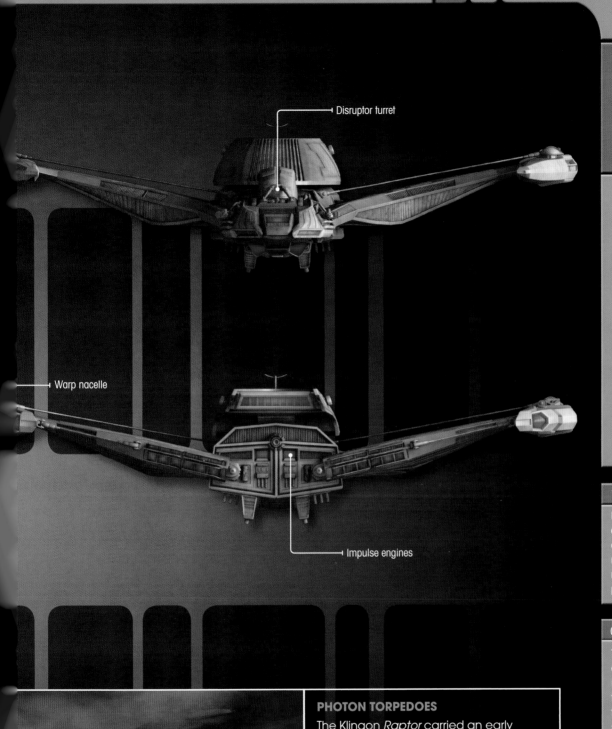

Disruptor turret

Warp nacelle

Impulse engines

WARP SPEED

Klingon ships of the era were capable of achieving speeds in the region of warp 5, which made interstellar travel a practical reality.

COLOR CODED

The Klingons used a color coding system to identify different areas of the *Raptor*, for example, the galley was in blue sector on deck 4.

PHOTON TORPEDOES

The Klingon *Raptor* carried an early form of photon torpedo – a technology that was unfamiliar to Malcolm Reed. These torpedoes worked by creating an explosive matter-antimatter reaction and contained a small sustainer engine that allowed them to be fired at warp. The *Enterprise* party used them to generate shockwaves that pushed the ship higher into the gas giant's atmosphere.

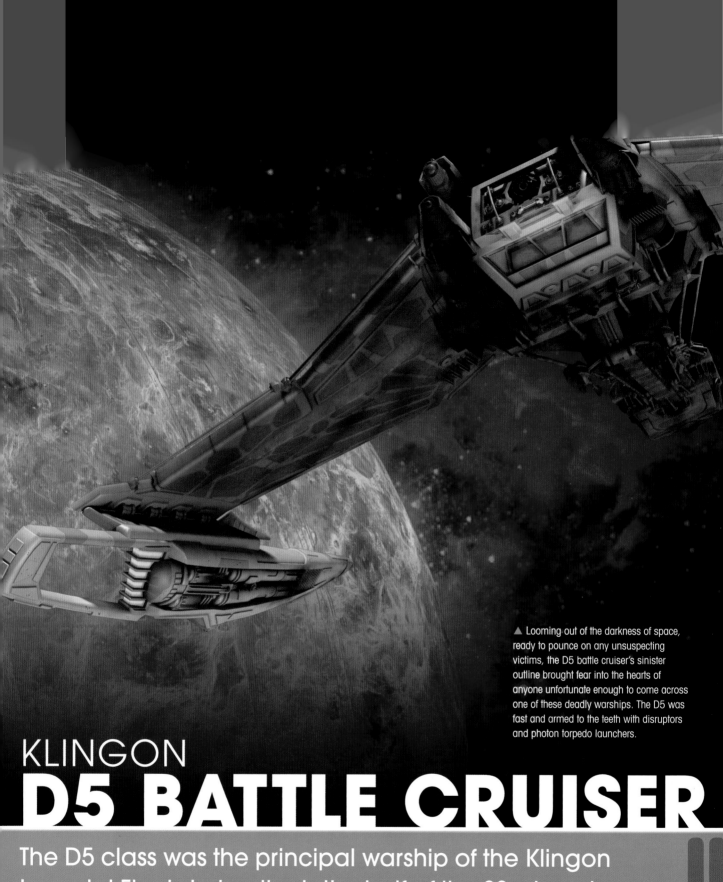

▲ Looming out of the darkness of space, ready to pounce on any unsuspecting victims, the D5 battle cruiser's sinister outline brought fear into the hearts of anyone unfortunate enough to come across one of these deadly warships. The D5 was fast and armed to the teeth with disruptors and photon torpedo launchers.

KLINGON
D5 BATTLE CRUISER

The D5 class was the principal warship of the Klingon Imperial Fleet during the latter half of the 22nd century.

weaponry. It featured several disruptor cannons, including two on the wingtips, plus one on the nose beneath the main photon torpedo launcher. These were supplemented by two large disruptor cannons mounted on a turret platform on the belly of the main hull. This could rotate through 360 degrees, allowing it to fire at targets anywhere around the ship, while also adding more firepower to both the fore and aft weapons.

DURABLE DEFENSES

The D5 battle cruiser was also well protected, with dispersive armor over its diffusion bonded monocrystal hull. *Enterprise* NX-01's tactical officer Malcolm Reed speculated that sustained phase cannon fire could pierce the D5's armor, but that it would take some time, and he doubted it would "sit still long enough to give us the chance."

The D5 class was also faster than *Enterprise*, and its warp engine in conjunction with its nacelles could power it to a top speed of warp 6. The aft-mounted impulse engines on the D5 also gave it superb maneuverability at sub-light speeds.

While the D5 used multi-spectral sensors not too different in principle to those on board *Enterprise*, they were, according to Dr. Arik Soong, more sophisticated. They were able to detect phenomena that the Starfleet ship could not.

The main bridge of the D5 class was located in the forward head of the ship, as it was on other Klingon vessels. The ship could be operated by just three crew members, and featured a centrally located chair from where the commanding

The D5-class battle cruiser was the largest, most powerful warship used by the Klingons in the second half of the 22nd century. At approximately 155 meters in length, it was slightly smaller than Starfleet's *NX* class, but its tactical abilities were far superior.

In appearance, the D5 shared many similar design traits with other Klingon vessels of the era, and utilized a roughly predatory bird-like form. The angular head of the D5 contained the main bridge, and behind this was a long, thin neck that connected to the main body, which spread out into downward swooping wings.

The aggressive styling was not just for show, and it was backed up by a formidable array of

DATA FEED

Enterprise NX-01 could fake the warp signature of a D5-class cruiser by reconfiguring its coil assembly, but a Klingon ship's sensors would detect the deception if it got within 80,000 kilometers.

◀ The ambience of the bridge on a D5-class battle cruiser could best be described as industrial, as it was constructed from bare metal with bulky stanchions providing structural support. It was dark and dingy, while the walls seemed to ooze with a filmy substance, as if they were sweating dirt.

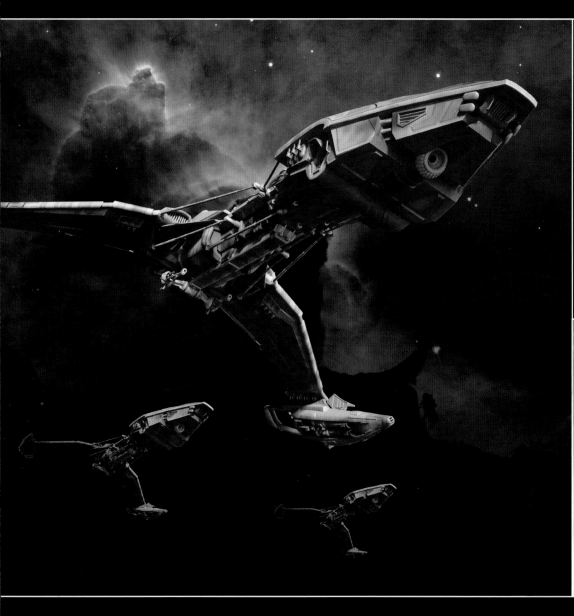

▶ Unable to outrun Captain Magh's battle cruiser, *Enterprise* fired its grappler into the Klingon ship's nacelle. The shearing stress tore apart the nacelle, leaving Magh's ship stranded.

▼ *Enterprise* fired a modified torpedo into the rings of a gas giant, which ignited a pocket of plasma and blinded the sensors of the *I.K.S. Bortas*. *Enterprise* was then able to escape from the Klingon ship.

▲ The D5 had a lean, muscular appearance, with support cabling at various points around the exterior, particularly along the neck, which made it look like it was straining every sinew. A huge photon torpedo launcher in the nose added to the overall ominous look of the ship.

officer issued orders, with two consoles to the left and right of this position. At the front of the bridge was a viewscreen, while another console which was often unmanned, was located between the screen and the command chair.

In 2152, a D5-class battle cruiser named the *I.K.S. Bortas* was tasked with finding and capturing refugees who had fled *Raatooras*, a colony that had been annexed by the Klingon Empire. The D5, under the command of Duras, found that the ship the refugees were on had been rescued by *Enterprise* and Captain Archer refused to hand them over. The *Bortas* subsequently engaged in battle with *Enterprise*, but its sensors were disabled when the Starfleet ship fired into the rings of a gas giant, igniting the plasma. The *Bortas* was temporarily blinded, and *Enterprise* escaped.

In 2154, *Enterprise* was intercepted by a D5-classs cruiser while crossing Klingon space. *Enterprise* was attempting to stop a group of human augments, who planned to destroy a Klingon colony named Qu'Vat, in the hope of igniting a war between Earth and the Klingon Empire.

GRAPPLING WITH THE KLINGONS

The commander of the D5, Captain Magh, did not believe *Enterprise*'s excuse for entering their territory and launched an attack. With aft plating failing, *Enterprise* dropped out of warp and fired its grappler at the D5's port nacelle. Once it was hooked on, *Enterprise* accelerated to full impulse and the nacelle was ripped apart. This prevented the D5 from continuing their pursuit, leaving *Enterprise* free to stop the augments.

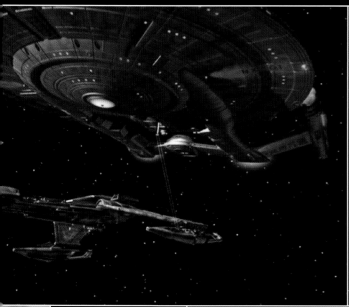

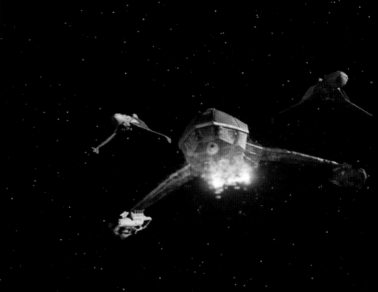

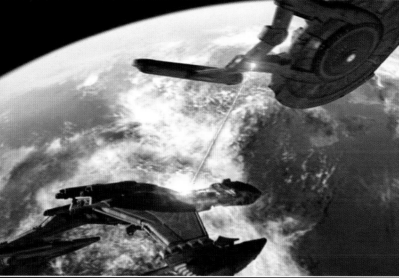

▶ *Enterprise* took on Admiral Krell's battle cruiser in an effort to stop it destroying the Qu'Vat colony. Despite being heavily outgunned, *Enterprise* managed to delay the Klingon assault just long enough for Dr. Phlox to engineer a cure to the Klingon augment virus. Krell stopped the attack when a sample of the virus was beamed aboard his ship.

▲ In addition to the photon torpedo launcher in the nose of the ship and disruptors located at the front of the nacelles, D5 battle cruisers also had a rotating turret on the underside of the main body. This featured a double-barreled disruptor weapon that could be aimed and fired in any direction around the ship.

Later in 2154, *Enterprise* and its sister ship *Columbia* NX-02 came under attack from two birds-of-Prey and a D5 battle cruiser under the command of Admiral Krell. The Klingon ships had been dispatched to destroy the Qu'Vat colony, where the Klingon augment virus had been created. *Enterprise* and *Columbia* engaged the Klingon ships, while Dr. Phlox, who was on Qu'Vat, sought an antidote for the augment virus.

Before long, the Klingon ships' tactical superiority was all too evident, as *Columbia* lost weapons and *Enterprise*'s hull plating was almost gone. The battle came to an abrupt halt when a sample of the virus was transported to Krell's cruiser. Dr. Phlox offered to give them the antivirus he had created, but only if Krell stopped the attack and spared the colony and the Starfleet ships.

DATA FEED

Duras, son of Toral, was the commander of the *I.K.S. Bortas* in 2152. After *Enterprise* thwarted his efforts to retrieve the rebel colonists of *Raatooras*, Duras was reduced in rank from captain to second officer and assigned to the Ty'Gokor defense perimeter. He was, of course, an ancestor of the infamous Duras family of the 24th century that tried to seize control of the Klingon Empire by colluding with the Romulans.

Warp nacelle ⊢

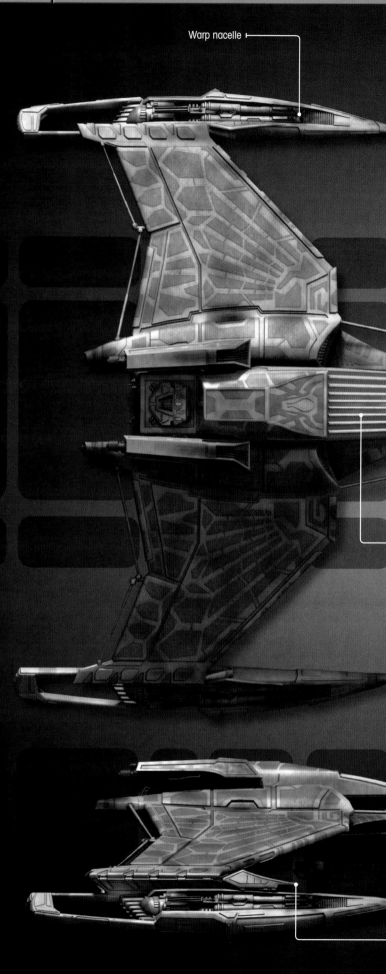

CARGO VARIATION

The Klingon D5 battle cruiser could also be converted into a tanker or freighter, where it was fitted with eight underslung cylindrical containers. This allowed the ship to transport around 80,000 liters of cargo, such as deuterium. It did mean, however, that it was not as well armed as other D5s because the fitting of the containers necessitated the removal of the ventral twin-disruptor turret.

In 2152, a D5 vessel with this tanker configuration under the command of Korok raided a deuterium mining colony. The Klingon ship had only 12 crew members, but for the past few seasons it was enough for them to forcibly take most of the deuterium that the colonists had mined. When the colonists refused to hand over their hard-earned deuterium, a fight ensued in which eight members of their community lost their lives to the Klingons. This exploitative relationship came to end when the crew of *Enterprise* helped the colonists fight back, successfully driving off Korok and his men.

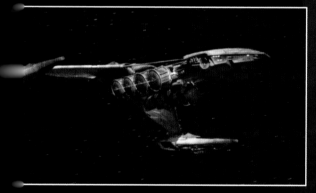

▲ Korok's D5 battle cruiser had been modified to carry eight barrel-shaped containers in two rows of four. It appeared that Korok and his crew raided isolated communities, taking their valuable supplies.

DATA FEED

Duras' ship the *I.K.S. Bortas* would, like Duras himself, have a 24th century equivalent. A *Vor'cha*-class attack cruiser named the *Bortas* would serve as Chancellor Gowron's flagship at the time of the Klingon Civil War in 2367-68. Ironically, it fought against ships loyal to the House of Duras.

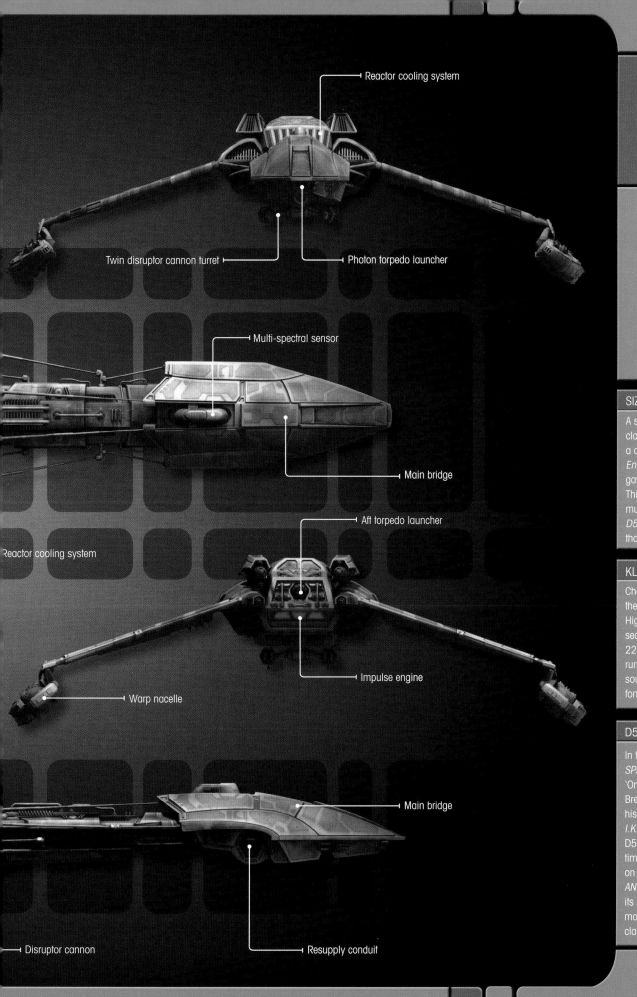

Reactor cooling system

Twin disruptor cannon turret ├───────┤ Photon torpedo launcher

├ Multi-spectral sensor

Main bridge

Reactor cooling system

├ Aft torpedo launcher

├ Impulse engine

├ Warp nacelle

Main bridge

├ Disruptor cannon Resupply conduit

SIZE DISPARITY

A schematic of a D5-class vessel was seen on a display monitor aboard *Enterprise* NX-01 which gave its length as 75m. This figure appears to be much too short, as the *D5* was at least double that length at 150m.

KLINGON GOSSIP

Chancellor M'Rek was the leader of the Klingon High Council in the second of half of the 22nd century. It was rumored by Klingon sources that he was very fond of Orion slave girls.

D5 OR NOT D5?

In the *STAR TREK: DEEP SPACE NINE* episode 'Once More Unto the Breach,´ Kor said that his former ship, the *I.K.S. Klothos*, was a D5-class vessel. The only time this ship was seen on screen was in *THE ANIMATED SERIES*, when its appearance was much more similar to the D7-class battle cruiser.

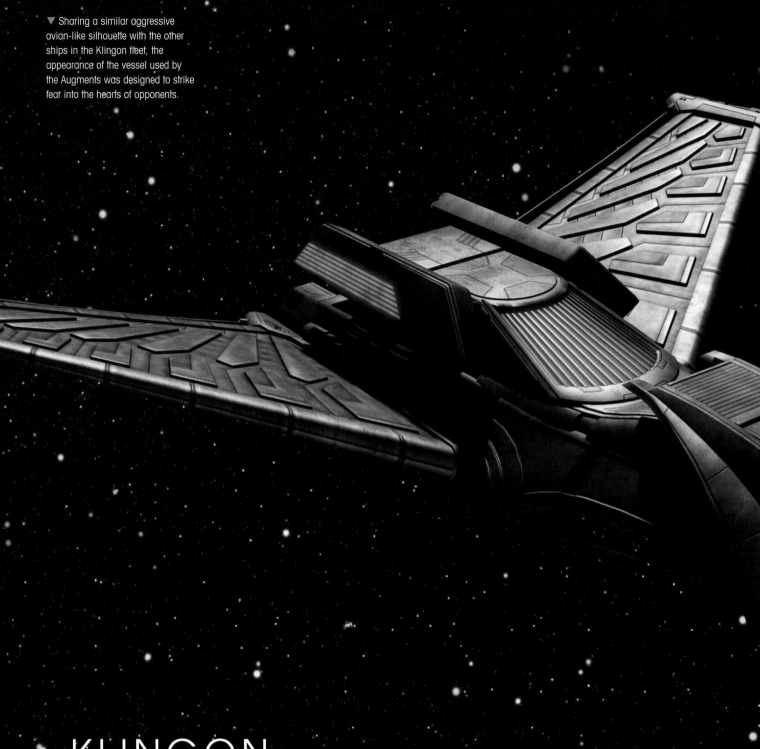

▼ Sharing a similar aggressive avian-like silhouette with the other ships in the Klingon fleet, the appearance of the vessel used by the Augments was designed to strike fear into the hearts of opponents.

KLINGON
AUGMENTS' SHIP

In 2154, the Klingon Augments used a small type of attack ship to mount a daring raid on *Enterprise* NX-01.

The vessel used by the genetically modified Klingon Augments in the mid-22nd century was the smallest Klingon starship known to be in operation at that time. At roughly 70 meters long, it was smaller than a bird-of-prey or *Raptor*-class vessel, but still well armed, and could accommodate about six crew members.

The design architecture of the Augments' vessel was unmistakably Klingon in appearance. Essentially, it resembled a scaled-down version of the D5-class battle cruiser, but it included features of both the bird-of-prey and the *Raptor* class, while also incorporating its own unique elements.

Like the bird-of-prey, the Augments' ship featured disruptor cannons mounted on either side at the tips of the wings and a torpedo launcher inset in the nose of the forward command module. These weapons were a match for the offensive capabilities of Starfleet's *NX* class.

The warp engines on the Augments' ship were mounted on the underside of the main body,

whereas on the bird-of-prey they were attached to the dorsal side. These engines were capable of propelling it to a top speed that was comparable to *Enterprise* NX-01's maximum speed of warp 5. A superstructure was located on the top of the main rear body, and this contained the cargo loading door, aft sensor platform and the maneuvering thrusters.

Like other Klingon ships of this era, the rusty-green-colored hull surface of the Augments' vessel featured a feather-like plating pattern, which added to its bird-like appearance. The plating was composed of a coherent molecular alloy that was twice as thick as the polarized hull of Starfleet's *NX* class. This meant that together with its dispersive armor, which was standard on all Klingon ships, it could withstand multiple direct hits from phase cannon fire without being compromised.

The crew of *Enterprise* NX-01 encountered the Klingon Augments' ship in 2154 when they were attempting to track down Dr. Phlox, who had been kidnapped and taken off in what was suspected to be a Rigelian freighter.

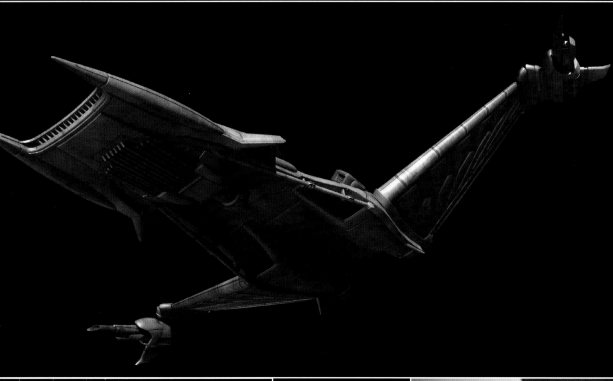

◀ Like most other Klingon ships, the vessel used by the Augments had the bridge module at the front, separated from the main body by a thin neck section. This ship had upward swept wings with powerful disruptor cannons attached to the ends.

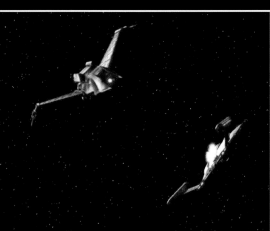

▶ Laneth was a member of the unit infected with the Klingon augment virus. She was part of the crew that took part in the attack on *Enterprise*. Upon returning to the *Qu'Vat* colony she mistakenly reported that their mission to destroy the Starfleet ship had been a success.

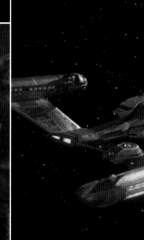

▲ Heavily armed for its size, the Klingon Augments' ship was a match for *Enterprise* NX-01 in battle. It swooped in on fast strafing runs with its disruptor cannons blazing, maneuvering out of range before *Enterprise* could disable it.

SURPRISE ATTACK

When *Enterprise* caught up with the freighter, the crew found that it had been badly damaged and there were no survivors. As they examined the wreckage, the Klingon Augments' ship emerged out of nowhere, unleashing a vicious attack. As disruptor cannon fire hammered *Enterprise*'s hull, a four-person Klingon boarding party beamed over in order to sabotage the Starfleet vessel.

A team of MACOs were dispatched to deal with the Klingon intruders, but one of the boarders, Marab, contacted his ship and gave it precise coordinates of where to target its disruptors. As the two vessels exchanged fire, a disruptor blast slammed into the section where the MACOs were ensconced, forcing them to retreat.

The Klingon intruders then had time to access one of *Enterprise*'s terminals and download a program into its computer systems. Once their work was complete, the Klingons made their way back to where they had beamed aboard. On their way there, however, Marab was shot and wounded, and the other Klingons were forced to leave him behind as they beamed back to their ship.

Once they were on board, the Augments' ship headed off at warp speed, but *Enterprise* was unable to follow as the Klingons had disabled its antimatter flow regulators. The computer subroutine they had downloaded was designed to cause *Enterprise*'s warp reactor to breach, leading the ship to explode. The idea behind the

◀▶ A four-person boarding party beamed over to *Enterprise* from the Augments' ship and uploaded a computer virus. It was designed to overload the engines and make the ship explode.

▼ The Augments' ship was used to snatch Dr. Phlox from a Rigelian freighter, before taking him to the Qu'Vat colony where it was hoped he could find a cure to the augment virus.

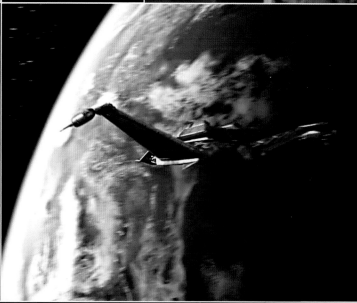

◀ The crew of *Enterprise* were examining the battered remains of a Rigelian freighter when the Klingon Augments' ship launched a surprise attack. It was extremely maneuverable, making it difficult for *Enterprise* to lock on with its weapons. Even if *Enterprise* scored a direct hit, it would have done little damage as the Klingon ship was well shielded with thick alloy plating and dispersive armor.

subroutine was to make it look as if a malfunction with *Enterprise*'s engines had occurred. This way its destruction would be blamed on an engineering defect and the Klingons' involvement would remain hidden.

RETURN TO BASE

Believing that they had accomplished their mission, the Klingon Augments returned to their base at the Qu'Vat colony aboard their ship. Later, the Klingon Augments reported, prematurely as it turned out, that *Enterprise* had been destroyed. They believed that this would leave their captive, Dr. Phlox, available to continue his research into finding a cure for the augment virus that was spreading rapidly through the Klingon population.

DATA FEED

Marab and other Klingon warriors from his unit were chosen to undergo the augmentation process. He was later part of the raid on *Enterprise*, which was designed to destroy the Starfleet ship, but in such a way that it would look like an accident. Marab was apprehended during the mission, and was subsequently convinced to help the Starfleet crew gain access to the Qu'Vat colony where the research into the augmentation virus was taking place.

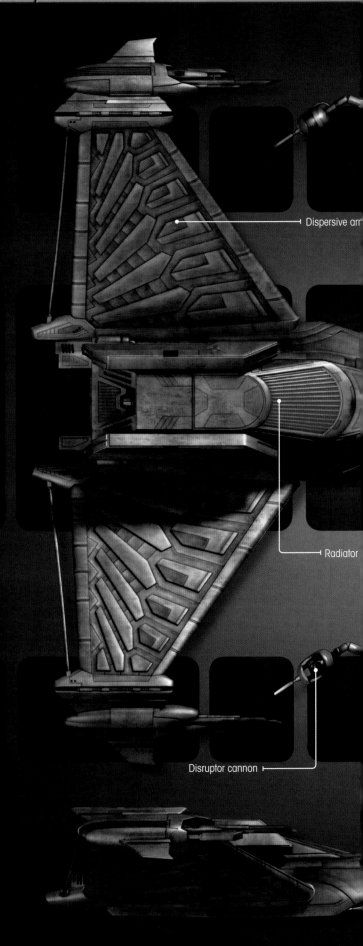

KLINGON AUGMENT VIRUS

The Klingon Augments were created under a secret program led by a Klingon scientist named Antaak. Using several human augment embryos that had survived Earth's Eugenics Wars, Antaak attempted to bio-engineer enhanced Klingon warriors. While the Klingon Augments that were created did develop superior strength and intelligence like their human equivalents, they also began to exhibit human characteristics, including losing their cranial ridges. More seriously, all of them eventually succumbed to an agonizing death when their neural pathways began to degrade. While working to make the augmentation process safe, Antaak inadvertently crossed the Augment DNA with the Levodian flu, creating an epidemic. This plague threatened the Klingons with extinction until Dr. Phlox was able to find a cure.

▲ Antaak was a Klingon doctor who tried to use DNA from human Augments to create Klingon Augments, but his experiments met with disastrous results as he unwittingly unleashed a deadly virus.

Dispersive arr

Radiator

Disruptor cannon

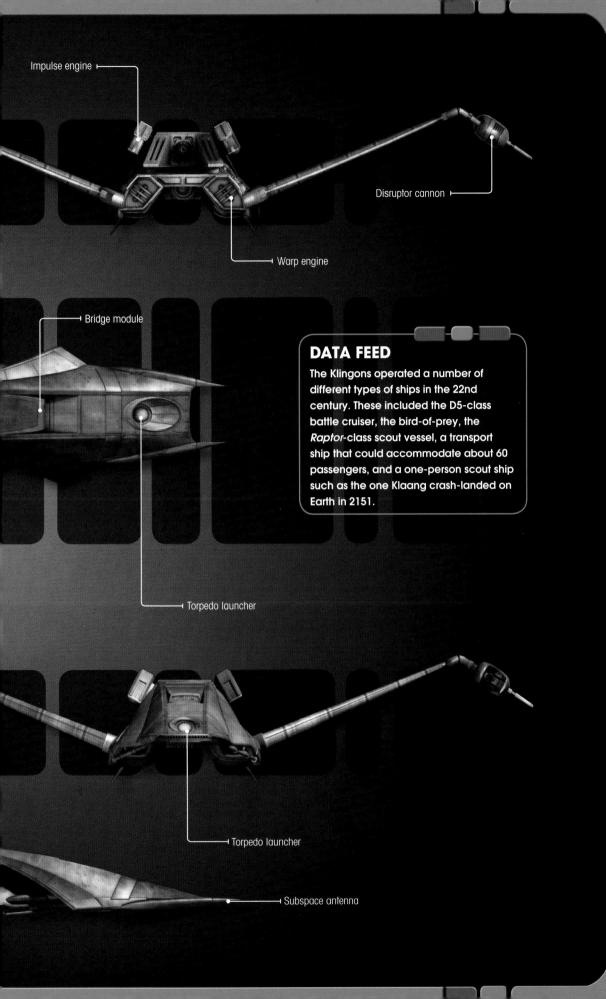

Impulse engine

Disruptor cannon

Warp engine

Bridge module

DATA FEED

The Klingons operated a number of
different types of ships in the 22nd
century. These included the D5-class
battle cruiser, the bird-of-prey, the
Raptor-class scout vessel, a transport
ship that could accommodate about 60
passengers, and a one-person scout ship
such as the one Klaang crash-landed on
Earth in 2151.

Torpedo launcher

Torpedo launcher

Subspace antenna

POPULAR OUTPOST

The Klingon Augments'
ship operated out of
the Qu'Vat colony, a
settlement that had a
population of several
million Klingons.

DEATH PENALTY

When one of the Klingon
Augments, Marab,
learned that Lt. Reed lied
to his captain, he said
that Reed was lucky
to still be alive. Marab
revealed that if a Klingon
betrayed their captain,
he would be executed
immediately.

FRESH MEAT

As with other Klingon
ships of this era, it was
likely that the Augments
kept live food on board
their ship in the form
of boar-like livestock
known as targs. These
animals were kept
in targ pits that were
presumably adjacent
to the galley.

oroth's Klingon transport vessel was in operation in the mid-22nd century, and was an unusual starship design for the warrior race. It was approximately 88 meters in length, and was horseshoe-shaped. It was still typically aggressive, and featured the familiar Klingon dark-green hull with raised blocks, which may have acted as a defensive plating.

The transport ship possessed warp nacelles in slightly raised sections on either side of the main body, and the ends of the nacelles at the rear emitted a neon green light. At the front of the vessel was an aperture, which gave off a red glow from inside. It was very similar in appearance to the photon torpedo launcher seen on other Klingon vessels, although it was never seen in use on the transport vessel. It did, however, feature at least four forward-facing disruptor-type weapons that were heavily shielded. While most Klingon vessels of this era, such as the D5-class battle cruiser, were offensively superior to Starfleet's finest ships, the transport vessel struggled to match the firepower of *Enterprise* NX-01.

The transport ship did, however, feature a tractor beam, a technology Starfleet had yet to master as *Enterprise* had to make do with a much simpler

GOROTH'S
STARSHIP

Goroth's ship was in service with the Klingon fleet in the 22nd century and was used to apprehend fugitives.

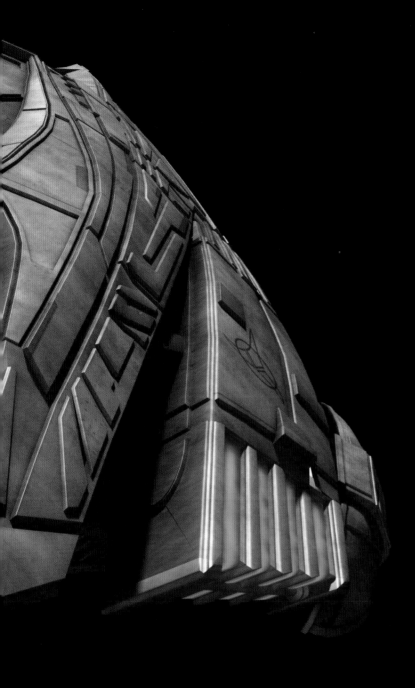

grappler system that used a metal chain with claws at the end.

In an emergency, the crew of the transport ship could use escape pods to flee. The one-person rafts were shaped similarly to barrels, and there were at least seven pods located on the underside of the main hull.

RUDIMENTARY FACILITIES

The interior of the transport vessel was typical of Klingon vessels in that it was dark, dingy and equipped with no creature comforts. The interior corridors were bathed in red light and featured bare metal walls and no carpeting. The interior also contained a brig for transporting fugitives, which consisted merely of a basic bed covered with a sheepskin-like rug.

In 2153, a Klingon transport vessel was under the command of Captain Goroth. His ship was used mainly to apprehend fugitives who were wanted under Klingon law, so they could be returned to the Klingon homeworld of Qo'noS for trial. It also appeared to be used for policing their borders and detaining anyone who dared make unauthorized entry into Klingon space.

The crew of *Enterprise* crossed paths with Goroth's ship in March 2153 after Captain Jonathan Archer had been kidnapped and taken to the Klingon ship. A few months earlier, the Klingons had placed a bounty on Archer's head after he had helped a group of Arin'Sen refugees, who fled from the planet *Raatooras* after it was annexed by the Klingon Empire. For this

▲ Unlike most Klingon vessels, Goroth's starship did not resemble a predatory bird with outstretched wings, but was rather a compact horseshoe shape. It was still an aggressive design, and featured warp engines for faster-than-light travel and multiple disruptors, which were heavily shielded.

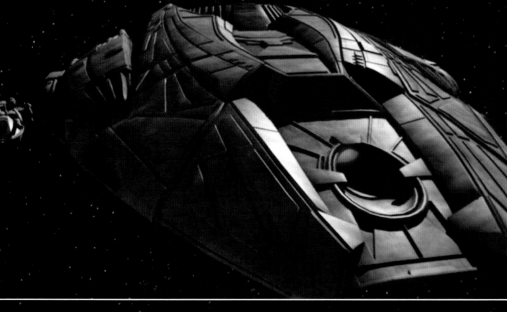

◀ In addition to its powerful disruptors, Goroth's transport ship had a large circular opening on the front of the ship that was typical of a Klingon photon torpedo launcher.

▼ Goroth was captain of the transport ship. He was forced to defend himself with a handheld disruptor after Captain Archer escaped from the ship's brig and tried to fight his way off the ship.

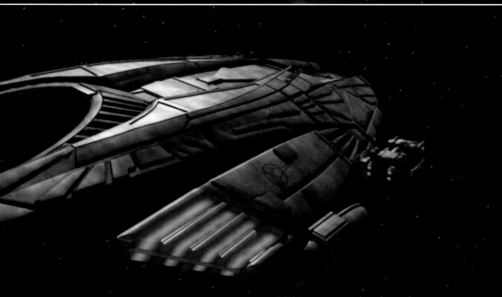

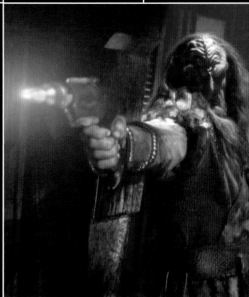

▲ The horseshoe shape of Goroth's starship could really be seen from the rear. Its shape was not typical of Klingon vessels, but the dark green color of the hull, plus the stylized plating, were very much Klingon ship motifs.

'crime,' a Klingon court sentenced Archer to life imprisonment in the dilithium mines of the prison colony *Rura Penthe*. Archer promptly escaped after his crew bribed a few Klingon officials, but it now meant he was a wanted man.

SNATCHED AND DELIVERED
Goroth offered 9,000 darseks to a Tellarite bounty hunter named Skalaar to apprehend Archer and bring him to his ship. After months of searching, Skalaar finally found Archer and kidnapped him from *Enterprise* before making contact with Goroth. Rather than deliver him to Qo'noS, Goroth wanted the Starfleet captain brought to his ship.

After Skalaar's shuttle had docked with Goroth's vessel, the Klingons took Archer and paid Skalaar

just 6,000 darseks, instead of the 9,000 they had previously agreed, before roughly throwing Skalaar off their ship despite his protestations.

Fortunately, Skalaar already had reason not to trust the Klingons. He had only become a bounty hunter in order to raise the funds he needed to pay the fine to get his freighter ship, the *Tezra*, back after it had been impounded by the Klingons for crossing into their territory. He had recently contacted his brother to tell him that he would soon have the money to get his ship back, but his brother told him that the Klingons had already ripped apart the *Tezra* and used its systems for spare parts on their own ships.

Even more annoyed after being ripped off again by the Klingons, Skalaar told the crew of *Enterprise*

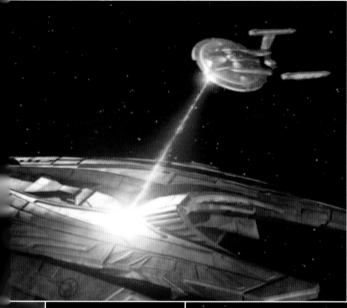

▶ Archer was thrown in a spartan brig aboard the transport ship, but Skalaar had provided him with a device that helped him escape. He then knocked out a guard, stole his disruptor and fought his way to the escape pods on the lower deck of the ship.

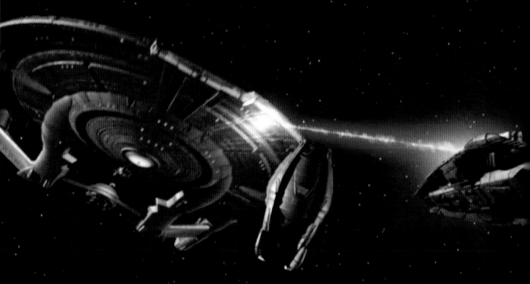

▲ After Skalaar told the crew of Enterprise where their captain could be found, they attacked the Klingon transport ship with phase cannons, eventually knocking out its weapons and damaging one of its warp nacelles.

▶ As Archer fled the Klingon ship in one of its escape pods, *Enterprise* disabled Goroth's ship before using a grappler to retrieve the captain.

here their captain could be found. He also rovided Archer with a device to help him scape from the brig aboard Goroth's ship.
 As *Enterprise* closed in on the Klingon vessel, rcher freed himself and took out several Klingon uards as he made his way to an escape pod and eft the vessel. The Klingon ship dropped out of arp and used its tractor beam to lock on to the od, but *Enterprise* arrived with its phase cannons lasting. The two ships exchanged fire, but nterprise emerged victorious after it took out the eapons on the Klingon ship, leaving the crew free o retrieve the pod the captain was in. *Enterprise* uickly left before more Klingon vessels arrived, hile Goroth's ship was left to limp back to Qo'noS ith no weapons and a damaged port nacelle.

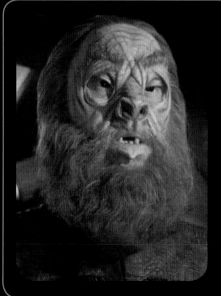

DATA FEED

Skalaar was a Tellarite who used to run a freighter called the Tezra. He was enormously proud of his ship as it could haul a million metric tons at a speed of warp 4.5 thanks to engine upgrades he fitted himself. It was impounded by the Klingons after he cut across their space without permission. Subsequently, he became a bounty hunter in order to raise the money to buy back his ship, but unbeknown to him, the Klingons had already cannibalized it for spare parts.

UNEVEN MATCH

Goroth's starship was not a frontline vessel in the Klingon Imperial Fleet. It appeared to be used mainly for tracking individuals who had run foul of Klingon law and transporting them back to the homeworld for trial. Certainly other Klingon ships, such as the D5 battle cruiser, were considered superior to Starfleet NX-class vessels in terms of tactical ability and speed. While Goroth's ship was well armed for a transport ship, it was no battle cruiser. This was fortunate for the crew of *Enterprise* NX-01, as they were able to fairly easily overpower Goroth's ship, something that would not have been possible with a D5 battle cruiser.

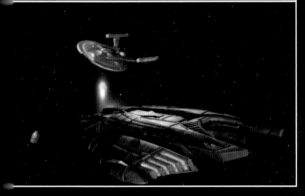

▲ Goroth's ship was well armed considering it was used mainly for transport duties, but it did not have the firepower to beat *Enterprise*.

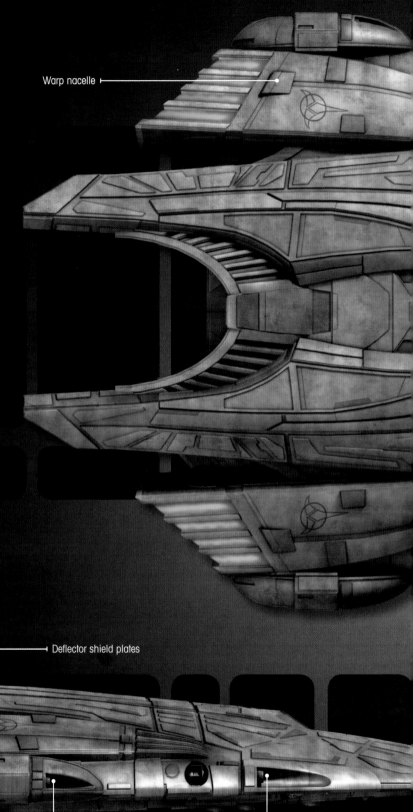

Warp nacelle ⊢

Deflector shield plates ⊢

Disruptor cannon ⊢ Disruptor cannon ⊢

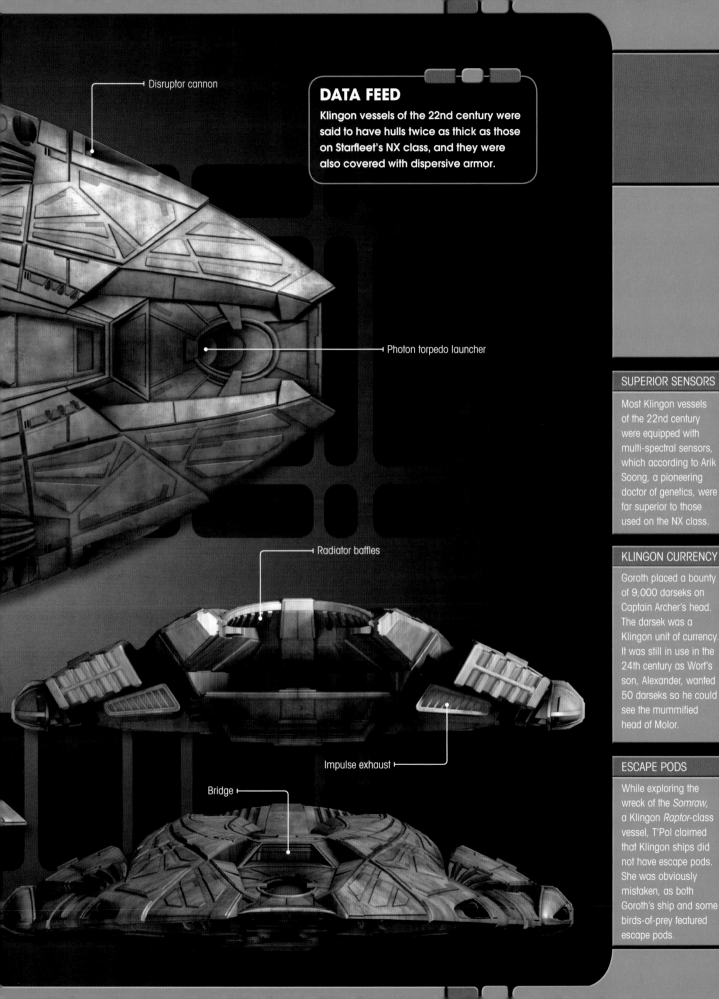

Disruptor cannon

DATA FEED

Klingon vessels of the 22nd century were said to have hulls twice as thick as those on Starfleet's NX class, and they were also covered with dispersive armor.

Photon torpedo launcher

Radiator baffles

Impulse exhaust

Bridge

SUPERIOR SENSORS

Most Klingon vessels of the 22nd century were equipped with multi-spectral sensors, which according to Arik Soong, a pioneering doctor of genetics, were far superior to those used on the NX class.

KLINGON CURRENCY

Goroth placed a bounty of 9,000 darseks on Captain Archer's head. The darsek was a Klingon unit of currency. It was still in use in the 24th century as Worf's son, Alexander, wanted 50 darseks so he could see the mummified head of Molor.

ESCAPE PODS

While exploring the wreck of the *Somraw,* a Klingon *Raptor*-class vessel, T'Pol claimed that Klingon ships did not have escape pods. She was obviously mistaken, as both Goroth's ship and some birds-of-prey featured escape pods.

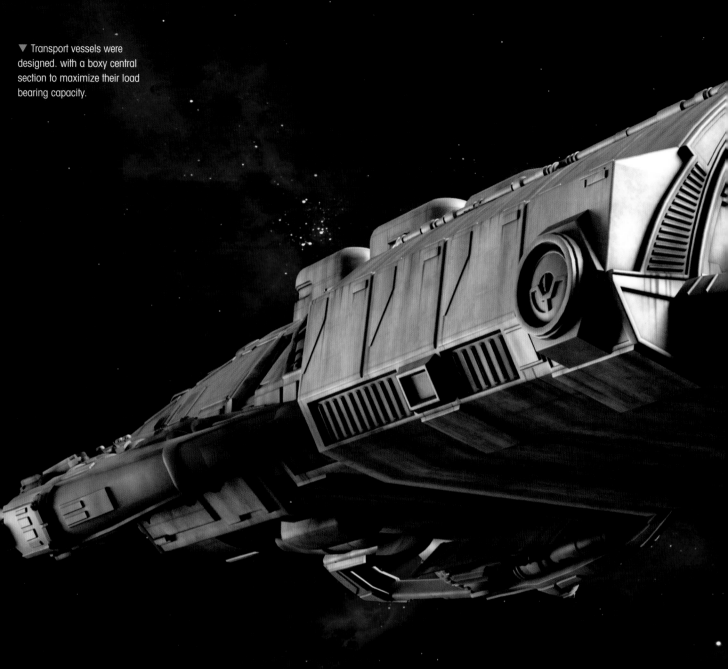

▼ Transport vessels were designed. with a boxy central section to maximize their load bearing capacity.

KLINGON 22ND CENTURY
TRANSPORT SHIP

In the 2150s, the Klingons used small ships with a brick-shaped fuselage to transport people to and from their outposts.

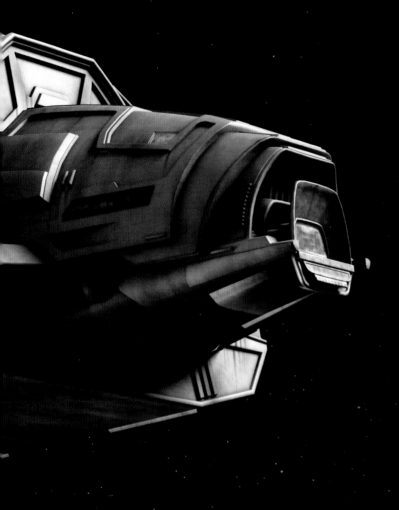

docking hatch located on the starboard side of the container section, towards the front, which allowed the passengers to transfer to another ship or a space station.

The rear of the ship was taken up by the propulsion systems, including the warp and impulse engines. The warp nacelles were attached to either side of the ship adjacent to the engineering section, and were of a similar shape and style to those found on a Klingon D5-class battle cruiser, only much shorter. While the D5 class had a maximum speed of warp 6, it was unlikely the transport could travel as fast, but it could probably reach velocities around warp 4 or 5.

TOUGH CONSTRUCTION

Most Klingon vessels of this era were composed of diffusion bonded monocrystal, which made them extremely robust, and it was likely the transport was constructed from the same materials. The outer hull of the transport was colored green, while it also featured various exposed pipes and conduits, particularly around the engine area.

As a Klingon ship, even a transport, it was highly likely that it was armed. Another Klingon transport vessel of the same time period, which was commanded by Goroth and had a different configuration, was equipped with disruptors. It is therefore reasonable to assume that the transport featured disruptors, even if they were not as powerful as those found on Klingon warships.

In 2152, *Enterprise* NX-01 encountered a Klingon transport when it received a distress call from one

The Klingon transport was a warp-powered starship from the 22nd century used to carry people between planets or outposts. It was roughly 55 meters in length and had a passenger capacity of about 60 individuals.

It had a small, sloping cone-shaped cockpit section, with a prominent deflector dish attached to the front of it. The command capsule poked out of a large square passenger compartment in the center of the ship, much like a tortoise's head emerges from its shell. The main part of the vessel was basically a rectangular container, which comprised of five equally sized segments. This was where the personnel or passengers stayed while they were being transported. There was also a

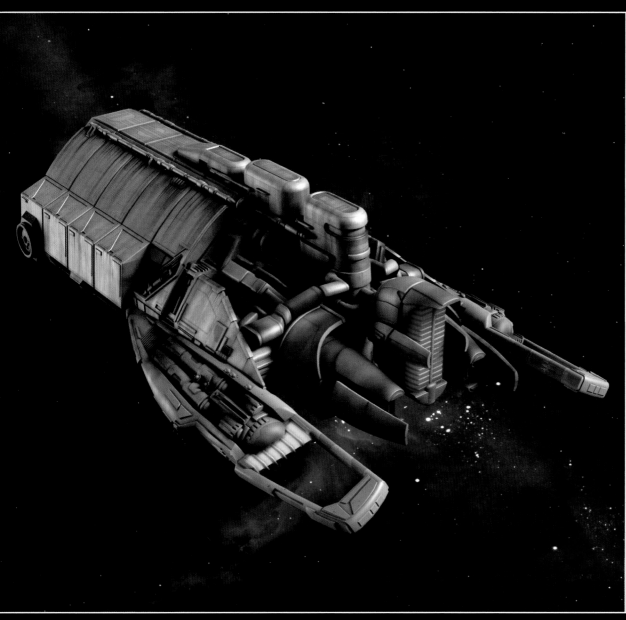

▶ When *Enterprise* first came across the Klingon transport ship that was carrying the refugees, it was in a bad way. The port engine was venting reactor coolant, and most of the main systems were failing.

▼ *Enterprise* maneuvered to the starboard side of the smaller Klingon transport ship to avoid its damaged engine. It then docked with the transport before rescuing the remaining aliens, who were starving.

▲ The engineering section and nacelles were located at the rear of the transport ship. It looked as if the engineering section had been joined to the passenger compartment as an afterthought, as the two segments combined together rather awkwardly.

system just outside Klingon territory. The transport's port engine was venting reactor coolant, which caused its main propulsion to go offline, and life support was failing.

When *Enterprise* had docked with the transport, the crew found that it was populated not by Klingons, but refugees. They explained that the Klingons had arrived on their colony a few years earlier and annexed it. In exchange for their allegiance, the Klingons claimed they would become part of their Empire and benefit from their protection. In fact, the Klingons stripped the planet of its natural resources and never provided them with anything, including food and fuel.

Once the colony's resources had been depleted, the Klingons failed to return and

appeared to have abandoned it. They left behind an old dilapidated transport ship, in which the colonists were forced to flee.

PERILOUS JOURNEY

Three weeks later, the warp drive on the transport failed, and for the next six weeks they tried to make it to the nearest inhabited system at impulse. During their journey, half of the starving passengers had died, leaving just 27, and Captain Archer believed most of them would not have lasted another week.

Chief Engineer Trip Tucker determined that the transport was beyond repair, and Archer made the decision to take the refugees aboard his ship. Just as they had finished transferring them, a Klingon D5

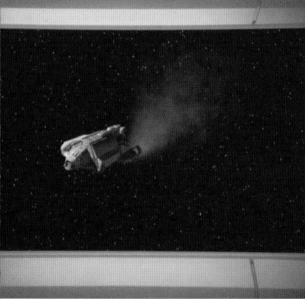

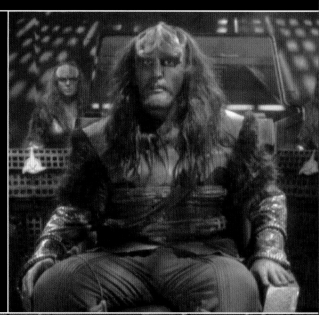

▶ Duras, who commanded the *Bortas,* arrived just as *Enterprise* had finished transferring the people from the transport ship. Duras claimed that these people were fugitives and enemies of the Empire.

▼ When Archer refused to hand over the refugees, Duras opened fire on *Enterprise.* The Starfleet ship then lured the *Bortas* into the rings of a gas giant and ignited the plasma.

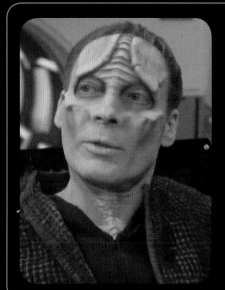

battle cruiser commanded by Duras, son of Toral, intercepted them and demanded the surrender of the 'fugitives' for inciting a rebellion. Captain Archer refused to hand them over, and Duras' ship, the *I.K.S. Bortas,* launched an attack.

During the battle, *Enterprise* lured the *Bortas* into the rings of a gas giant and ignited the plasma with a modified torpedo. This disrupted the sensors of both ships, but allowed *Enterprise* to escape, and the colonists were subsequently relocated to a planet unknown to the Klingons.

As a result of this incident, the Klingons accused Archer of conspiring against the Empire for which the penalty was death. Duras, meanwhile, was reduced in rank from captain to becoming second officer serving on the Ty'Gokor defense perimeter.

DATA FEED

The aliens that were found aboard the Klingon transport were pale-skinned humanoids, with distinctive ridged foreheads. They had been living under Klingon rule for several years, during which time their colony had been completely stripped of all its natural resources, leaving them with nothing. Believing that they had been abandoned to die, the aliens managed to leave in an old Klingon transport, but its engines failed before they reached an inhabited world.

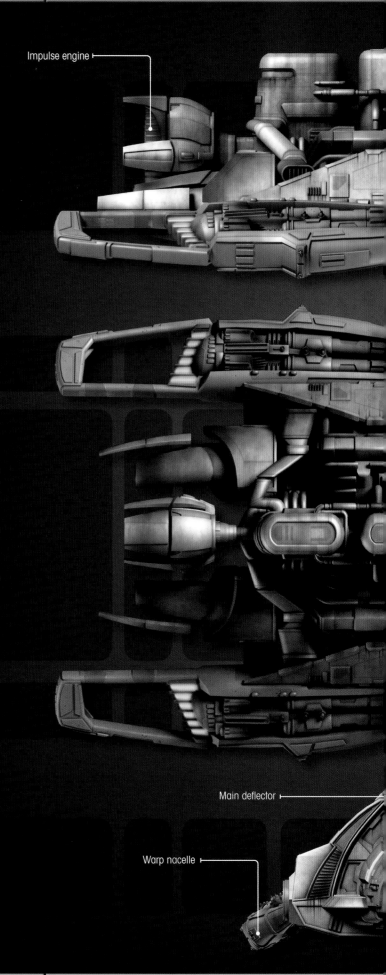

Impulse engine ⊢

Main deflector ⊢

Warp nacelle ⊢

KLINGON JUSTICE

A short period after helping the refugees from the Klingon transport, Captain Archer was arrested by the Klingons. He was put on trial at Narendra III for helping "rebels" try to escape the Empire with the sentence being death.

Initially, Archer's lawyer, Kolos, provided a weak defense. Kolos had become cynical and tired after years of watching Klingon justice favor the warrior class. When Archer challenged him that he was not acting like an honorable Klingon, it inspired Kolos to provide a much more vigorous defense. Through his efforts, the sentence was reduced from the death penalty to a lifetime of labor in the dilithium mines on *Rura Penthe*.

Archer had not been in the labor camp for long when Lt. Malcolm Reed managed to bribe a corrections officer and free him. For the next year, Archer continued to be hunted by the Klingons for his crimes against the Empire.

▲ After rescuing the refugees from the transport ship, Captain Archer was placed on trial in a Klingon court on Narendra III for conspiring against the Empire. He was found guilty and sent to *Rura Penthe*.

DATA FEED

The Klingons also operated a transport vessel in the 24th century, which was for civilians. In 2372, a ship of this type decloaked directly in front of the *U.S.S. Defiant* NX-74205 and was blown up, while the Starfleet ship was fighting two Klingon ships. Lt. Commander Worf, who was commanding the *Defiant*, faced extradition to the Empire for the crime of destroying a civilian ship, but it was later found out that the Klingons had staged the whole incident.

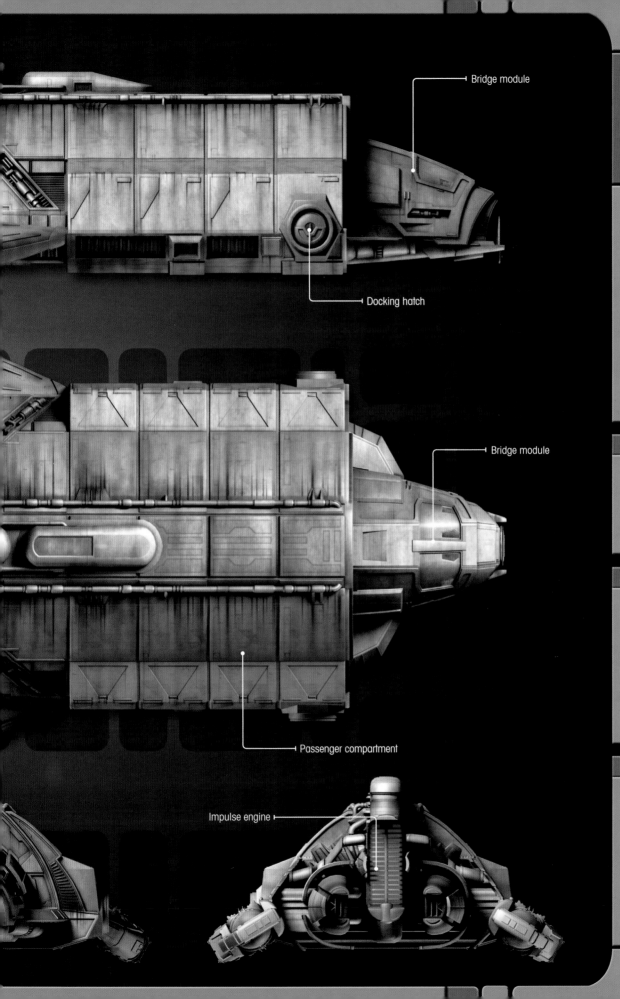

Bridge module

Docking hatch

Bridge module

Passenger compartment

Impulse engine

ESSENTIAL SYSTEMS

The Klingon transport was equipped with food processors and water recyclers, but these vital systems failed during the refugee's journey.

DWINDLING CREW

Originally, there had been 54 refugees aboard the Klingon transport when they left their colony, but after six weeks only half of them remained alive. By the end, they had been forced to divert auxiliary power to life support.

SPECIES NAME

The species of the refugees who were rescued from the Klingon transport was never stated. The co-writer of the episode 'Judgment,' David Goodman named them the Arin'Sen after his friend Michael Aronson in a production report.

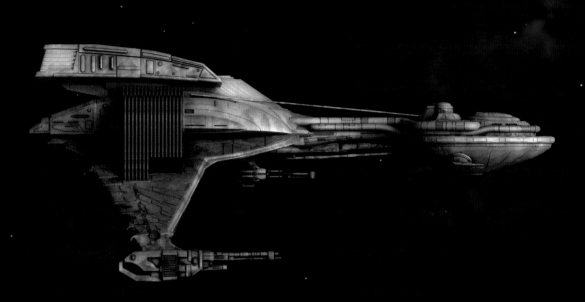

KLINGON DEFENSE FORCE: BIRD-OF-PREY

145m

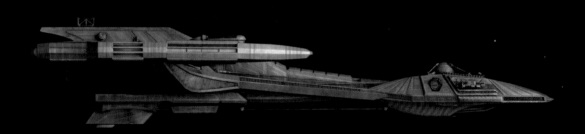

KLINGON *RAPTOR*

145m

AUGMENTS' SHIP

0m

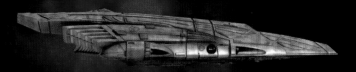

GOROTH'S STARSHIP

88m

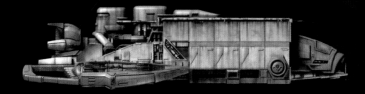

KLINGON 22ND CENTURY TRANSPORT SHIP

90m

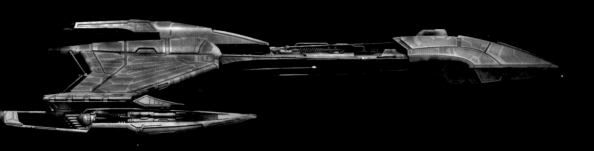

D5 BATTLE CRUISER

55m

CHAPTER 2
23rd & 24th CENTURY

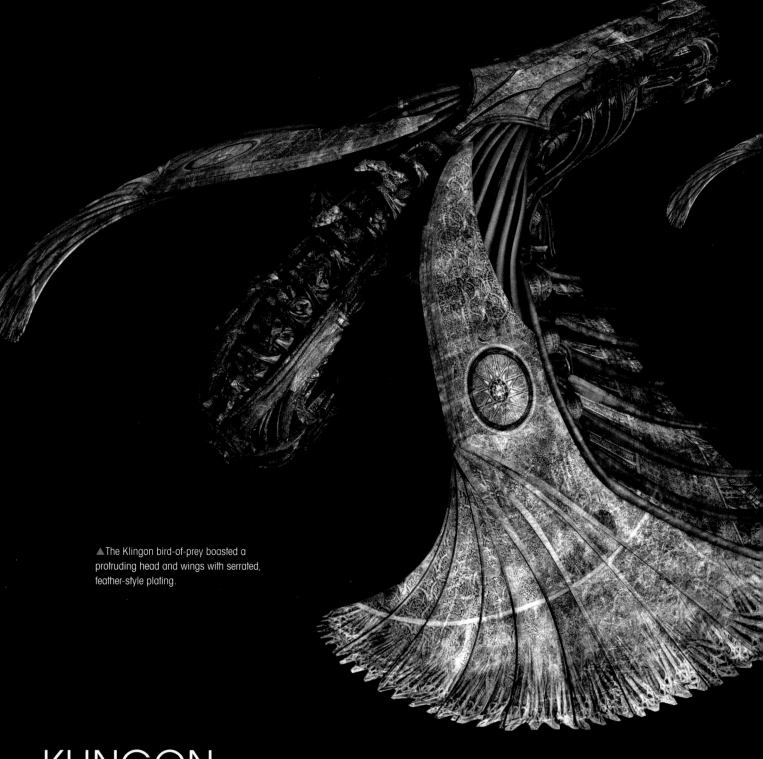

▲ The Klingon bird-of-prey boasted a protruding head and wings with serrated, feather-style plating.

KLINGON
BIRD-OF-PREY

The mid-23rd century iteration was a small but well-armed warship that could often outmaneuver larger enemies.

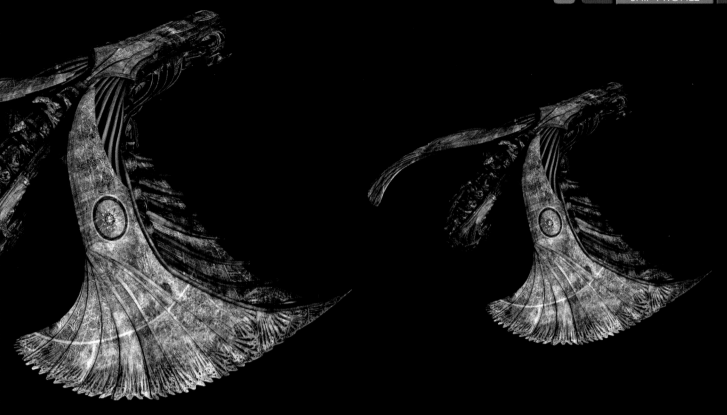

The bird-of-prey was one of the best known vessels used by the Klingon Empire across the 22nd and 23rd centuries. The mid-23rd century iteration was a relatively small warship (though larger classes may have existed) that had a similar avian design to other Klingon birds-of-prey, complete with a protruding head, folded wings and serrated feather-style plating. The vessel boasted an impressive array of weapons for its size, including photon torpedoes and phasers, while the rear-mounted engine allowed for maximum maneuverability.

After General Kol seized control of the Klingon sarcophagus ship, he ordered that all birds-of-prey under his command be fitted with the sarcophagus's cloaking technology. As with all cloaked ships, this made it almost impossible for enemies to detect and fire upon them until they decloaked. In terms of defensive capabilities, the bird-of-prey was fitted with deflector shields, but these were not especially powerful and could not hold out for long against heavy fire.

The bird-of-prey played a significant role in the Battle at the Binary Stars of 2256, the first battle of the Federation-Klingon War. Though many of the ships were destroyed, they managed to inflict significant damage against enemy vessels. The bird-of-prey was most effective when several worked together to overwhelm an enemy, as when a number of them took part in an ambush on the *U.S.S. Gagarin* alongside larger Klingon vessels.

◄ Birds-of-prey joined the Klingon attack on Federation targets.

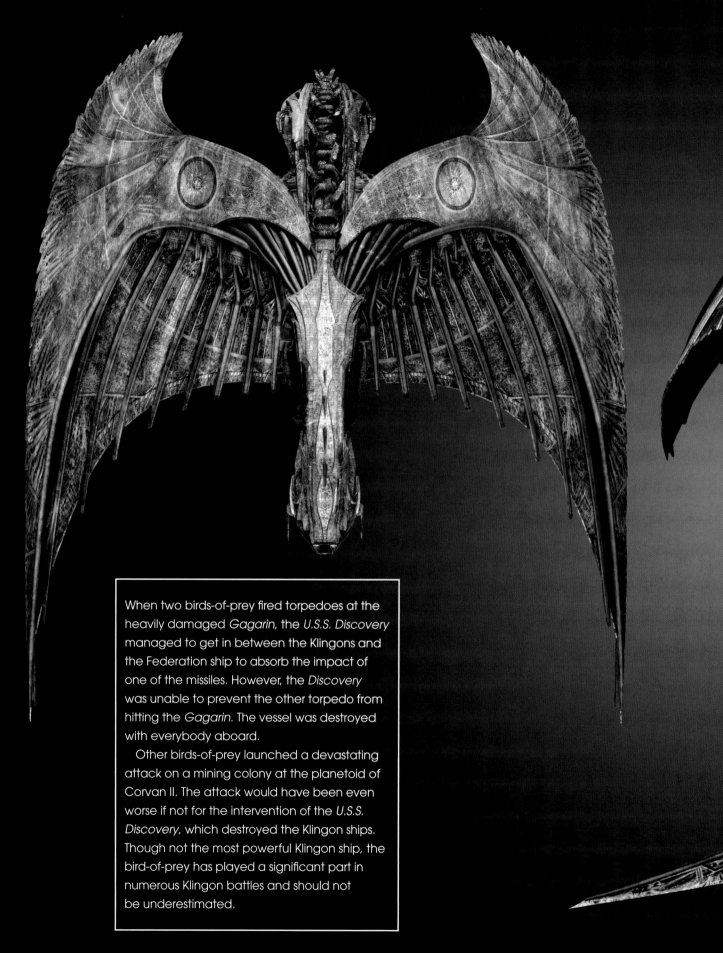

When two birds-of-prey fired torpedoes at the heavily damaged *Gagarin*, the *U.S.S. Discovery* managed to get in between the Klingons and the Federation ship to absorb the impact of one of the missiles. However, the *Discovery* was unable to prevent the other torpedo from hitting the *Gagarin*. The vessel was destroyed with everybody aboard.

Other birds-of-prey launched a devastating attack on a mining colony at the planetoid of Corvan II. The attack would have been even worse if not for the intervention of the *U.S.S. Discovery*, which destroyed the Klingon ships. Though not the most powerful Klingon ship, the bird-of-prey has played a significant part in numerous Klingon battles and should not be underestimated.

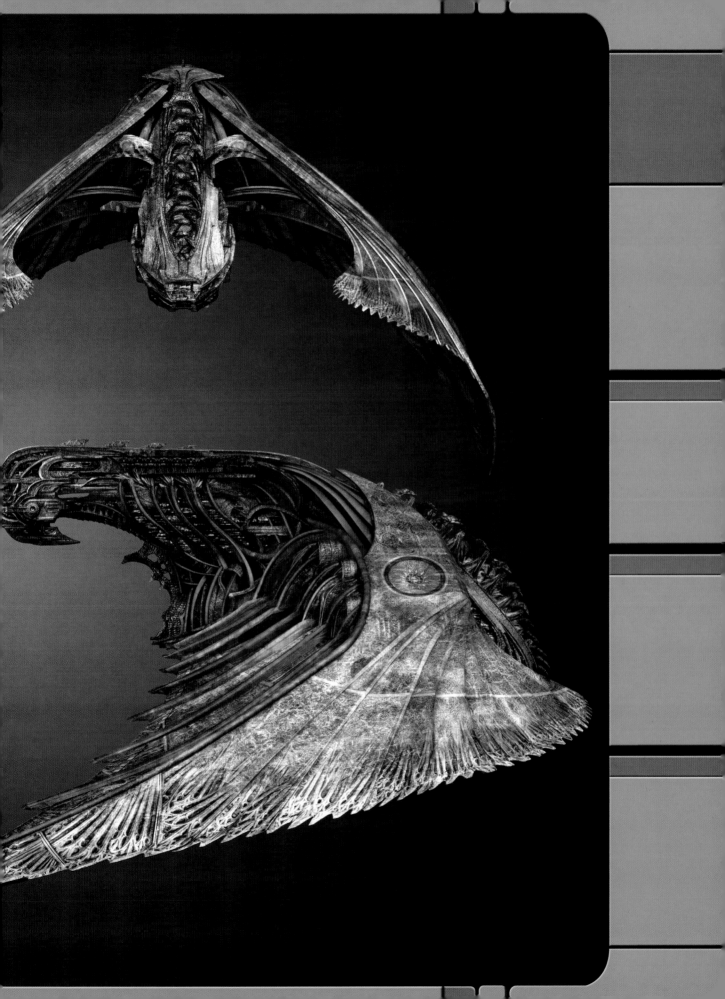

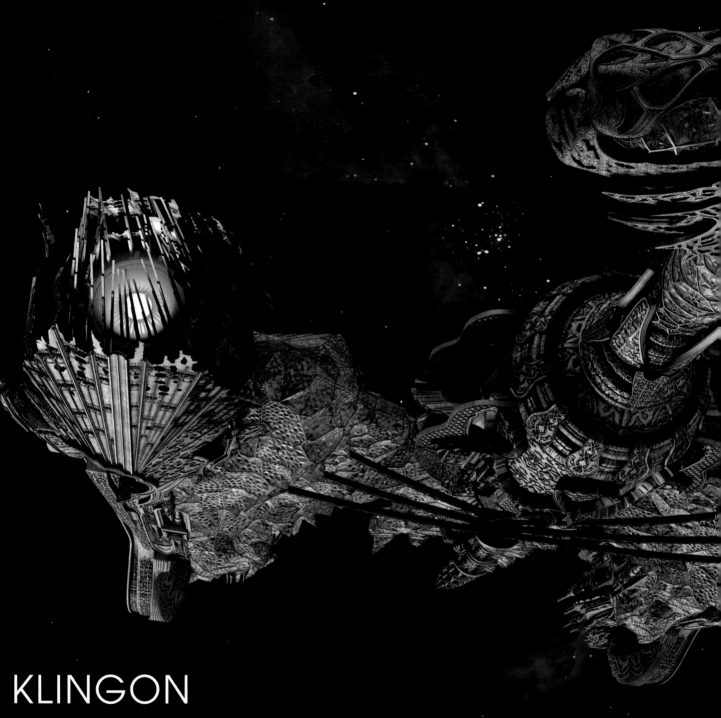

KLINGON
SARCOPHAGUS

The sacred sarcophagus ship was a harbinger of war that united the Klingon Empire against the Federation.

SHIP

Thought to be centuries old, the Klingon sarcophagus ship – or ship of the dead – was the flagship of the once mighty House of T'Kuvma. In the 23rd century, this unique vessel was left as nothing more than a derelict wreck following the house's fall from honor. But in 2256, the restored sarcophagus ship played a key role in the Battle at the Binary Stars, marking the beginning of fresh hostilities between the Klingon Empire and the Federation.

The sarcophagus ship was named for the manner in which it honored Klingon dead – its hull was adorned with sacred caskets containing the remains of fallen warriors. These caskets were placed on the hull to form an ornate armored surface, the dead forming an extra layer of protection from attack.

Abandoned for years following the death of his father, the young T'Kuvma rediscovered the derelict ship, encountering other Klingon children playing among its abandoned decks. Following a brutal beating at their hands, T'Kuvma vowed he would restore the vessel and return honor to his house.

MIGHTY VESSEL
In the intervening years, T'Kuvma developed the technology that would give his house supremacy in battle – the ability to render a ship invisible and cloaked from sensors. The sarcophagus ship was several times bigger than the largest Federation starships; its internal architecture was typically ornate, reflecting the sacred and holy nature of its hull decoration. The bridge was a multi-levelled, high-vaulted chamber, with staircases connecting each level. Any obvious control consoles for

navigation, weapons and tactical were absent, while the exterior view of space was via the large observation window that dominated the chamber.

T'Kuvma embarked on a plan to unite the Klingon Empire against the Federation, using the sarcophagus ship as a beacon in summoning the houses of the Klingon Council. It encountered the *U.S.S. Shenzou* at the edge of Federation space, decloaking and firing on the starship. This was the first action in the Battle at the Binary Stars, with thousands of lives lost and open war declared.

The *Shenzou* disabled the sarcophagus ship with a torpedo beamed onto the body of a dead Klingon that was being pulled toward the neck section of the Klingon ship by tractor beam. T'Kuvma was subsequently killed in an incursion by Starfleet officers Captain Philippa Georgiou and Commander Michael Burnham. The sarcophagus ship was left drifting, its remaining crew under the command of T'Kuvma's torchbearer, Voq.

FATED FLAGSHIP

The sarcophagus ship drifted for six months, its resources dwindling, until the arrival of Kol of the House of Kor. Kol sought the sarcophagus' cloaking technology to give the Klingons an edge against the Federation and secured the crew's loyalty with food. With motive power restored thanks to a dilithium processor unit salvaged from the nearby wreck of the *U.S.S. Shenzou*, Kol claimed the sarcophagus ship as his new flagship, marooning Voq aboard the derelict *Shenzou*.

The sarcophagus ship traveled to the planet Pahvo after the Pahvans transmitted an invitation in the hope they could bring harmony to the Federation and Klingons. Kol was intent on using his powerful flagship to destroy this peaceful world and its unique planetary transmitter, but the *U.S.S. Discovery* engaged the sarcophagus ship in battle above Pahvo. With *Discovery* officers transporting aboard the Klingon vessel, the Federation ship was able to use its spore drive technology to penetrate the sarcophagus' cloak. The sarcophagus ship was destroyed in a barrage of photon torpedoes launched by the *Discovery*, its commander and crew perishing.

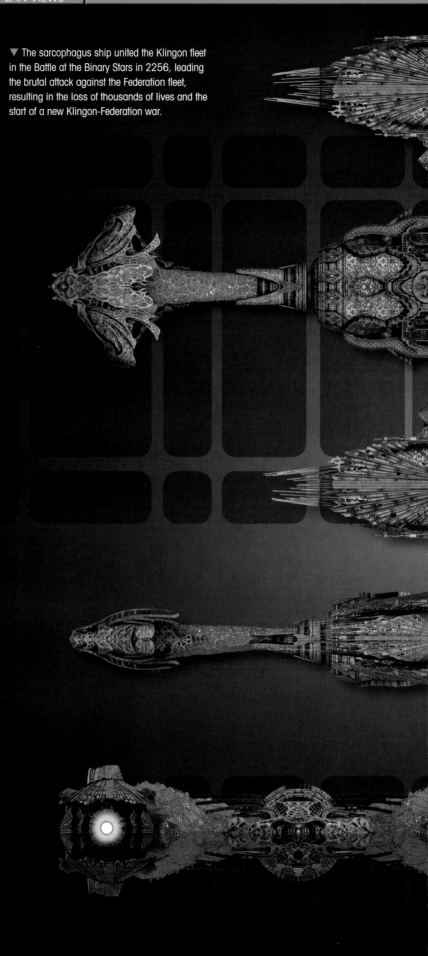

▼ The sarcophagus ship united the Klingon fleet in the Battle at the Binary Stars in 2256, leading the brutal attack against the Federation fleet, resulting in the loss of thousands of lives and the start of a new Klingon-Federation war.

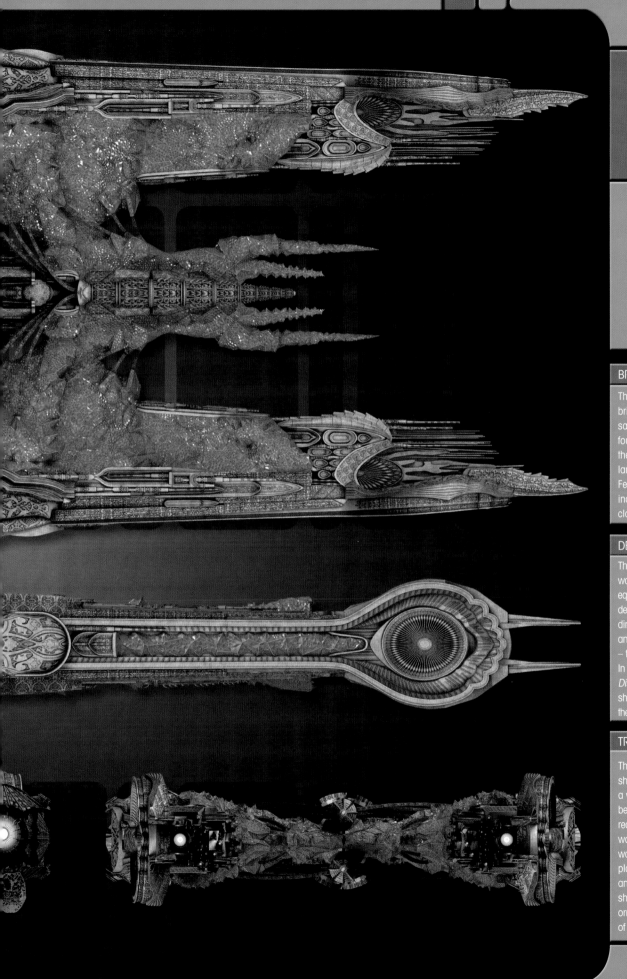

BRIDGE

The multi-leveled bridge of the sarcophagus ship was four times bigger than the bridge area of the largest contemporary Federation starships, including the *Walker*-class *U.S.S. Shenzou*.

DESTRUCTIVE POWER

The sarcophagus ship was thought to be equipped with enough destructive weaponry – directed energy weapons and torpedo banks – to destroy a planet. In 2256, the *U.S.S. Discovery* prevented the ship from destroying the planet Pahvo.

TRACTOR BEAM

The neck section of the ship was equipped with a wide-dispersal tractor beam, primarily used to recover bodies of fallen warriors from space. The warriors' remains were placed in sacred caskets and attached to the ship's hull, adding to the ornate armoured network of dead Klingons.

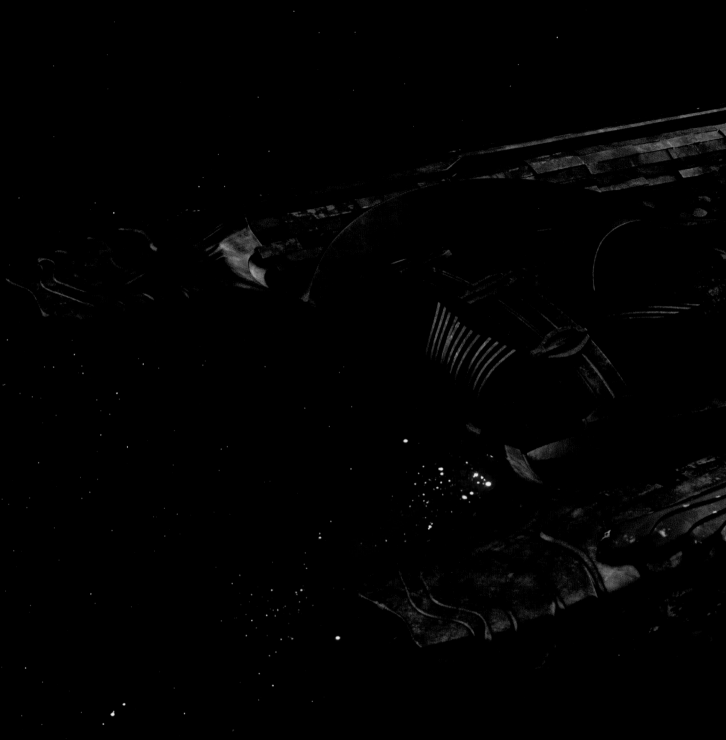

VEQLARGH CLASS

This mysterious ship is named for a mythological figure that Klingons fear and respect.

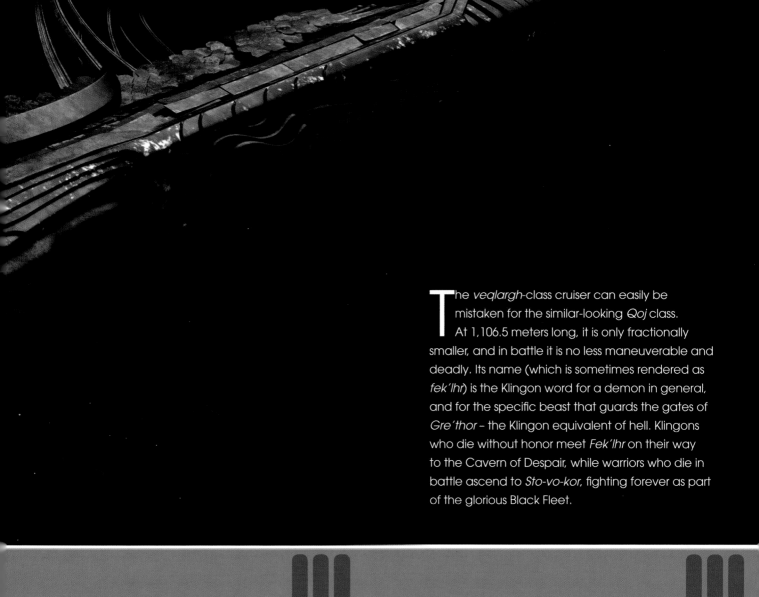

The *veqlargh*-class cruiser can easily be mistaken for the similar-looking *Qoj* class. At 1,106.5 meters long, it is only fractionally smaller, and in battle it is no less maneuverable and deadly. Its name (which is sometimes rendered as *fek'lhr*) is the Klingon word for a demon in general, and for the specific beast that guards the gates of *Gre'thor* – the Klingon equivalent of hell. Klingons who die without honor meet *Fek'lhr* on their way to the Cavern of Despair, while warriors who die in battle ascend to *Sto-vo-kor*, fighting forever as part of the glorious Black Fleet.

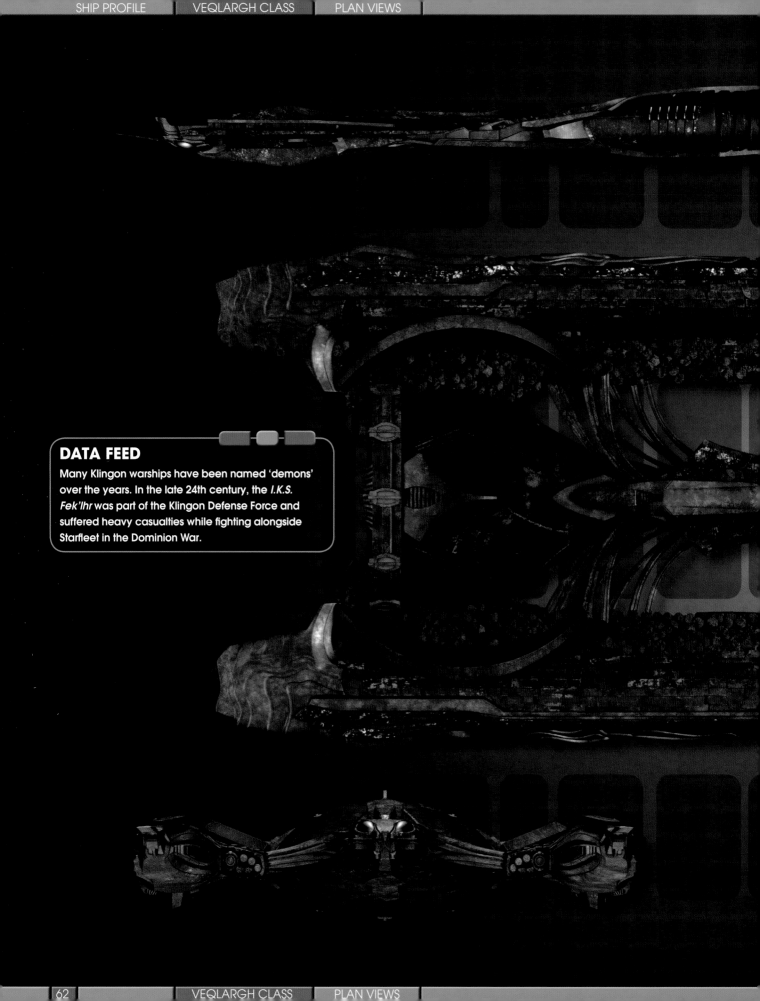

DATA FEED

Many Klingon warships have been named 'demons' over the years. In the late 24th century, the *I.K.S. Fek'lhr* was part of the Klingon Defense Force and suffered heavy casualties while fighting alongside Starfleet in the Dominion War.

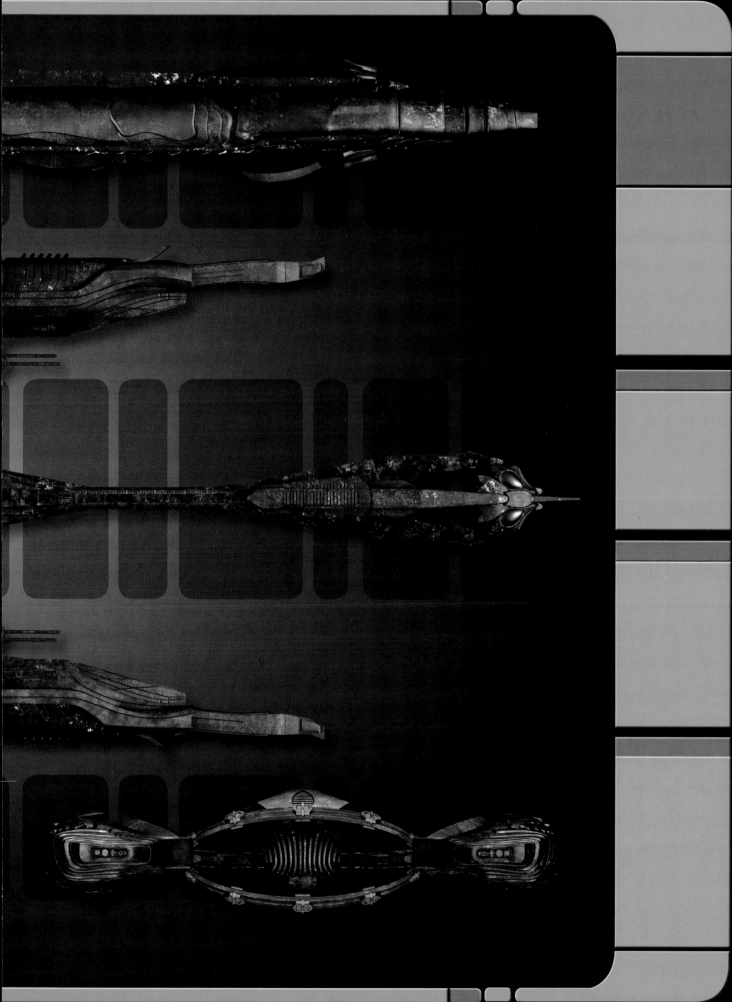

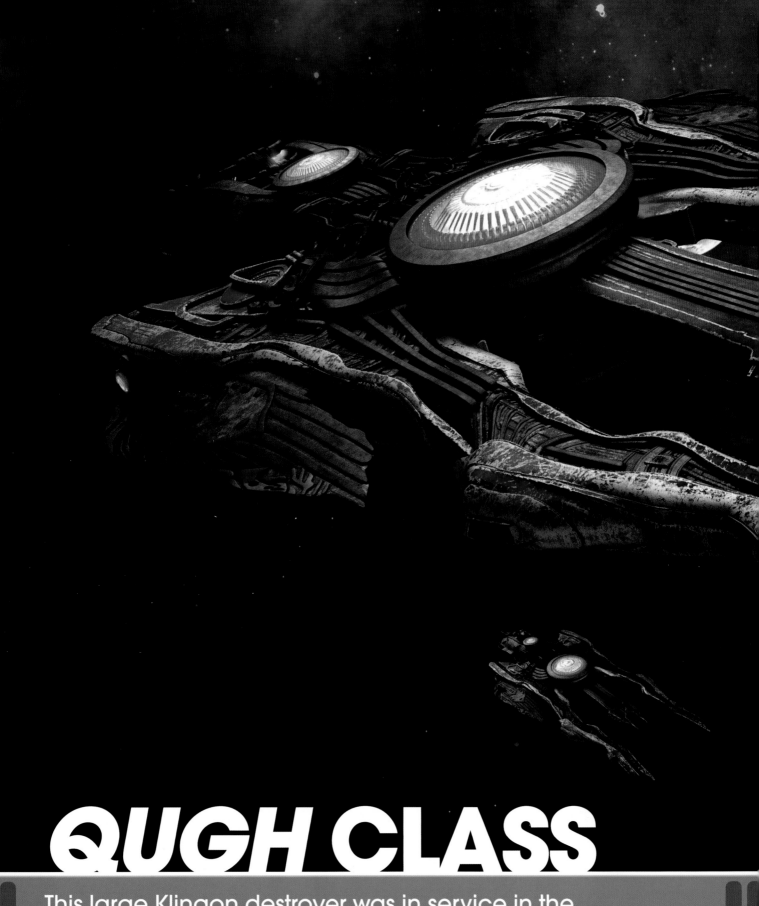

QUGH CLASS

This large Klingon destroyer was in service in the mid-23rd century during the Federation-Klingon war.

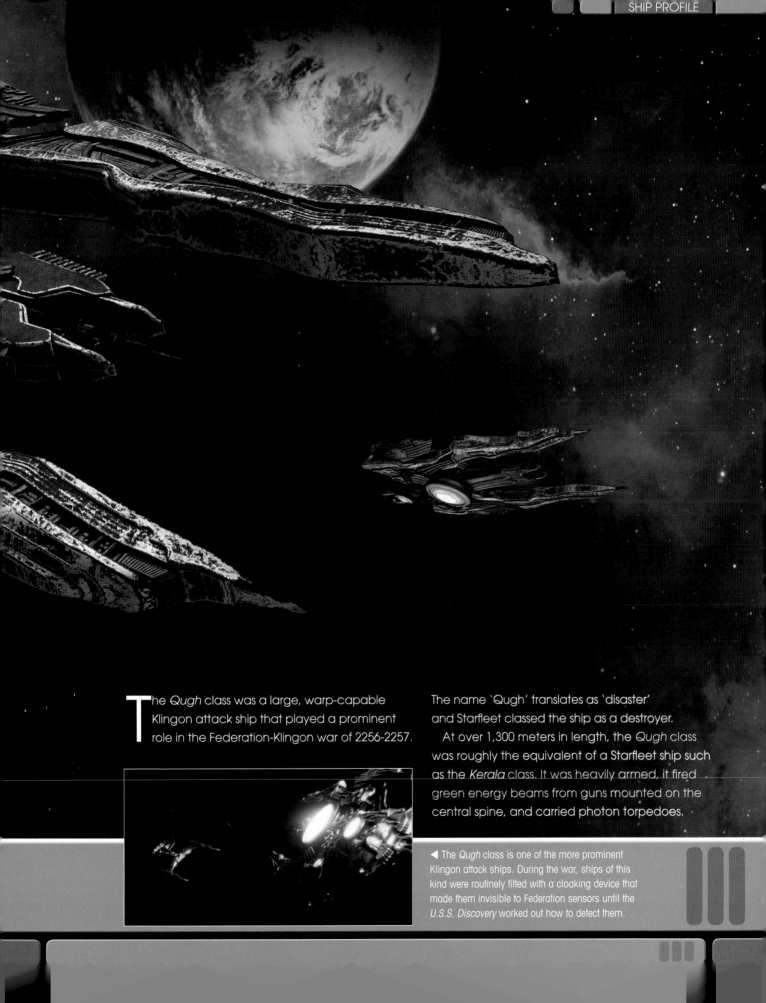

The *Qugh* class was a large, warp-capable Klingon attack ship that played a prominent role in the Federation-Klingon war of 2256-2257.

The name 'Qugh' translates as 'disaster' and Starfleet classed the ship as a destroyer.

At over 1,300 meters in length, the *Qugh* class was roughly the equivalent of a Starfleet ship such as the *Kerala* class. It was heavily armed, it fired green energy beams from guns mounted on the central spine, and carried photon torpedoes.

◀ The *Qugh* class is one of the more prominent Klingon attack ships. During the war, ships of this kind were routinely fitted with a cloaking device that made them invisible to Federation sensors until the *U.S.S. Discovery* worked out how to detect them.

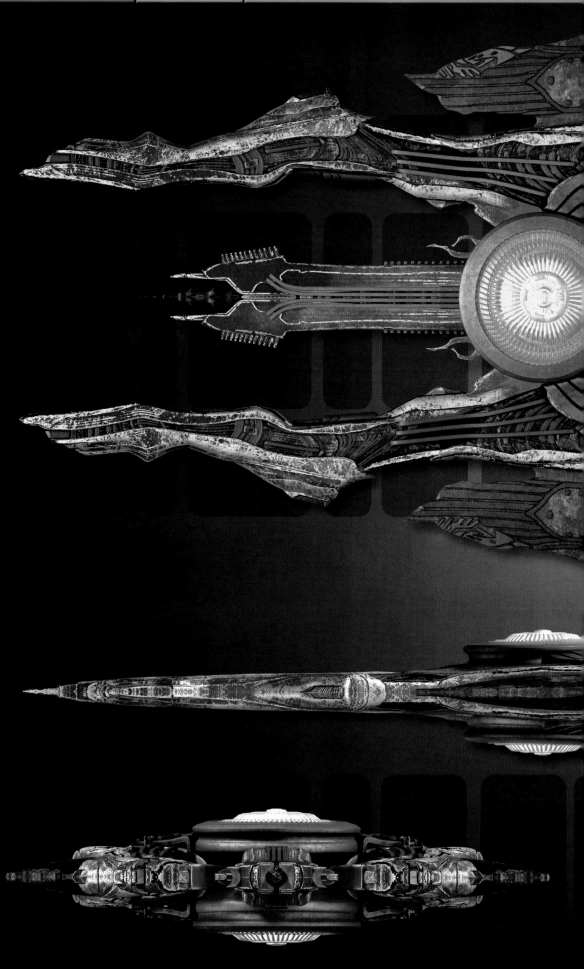

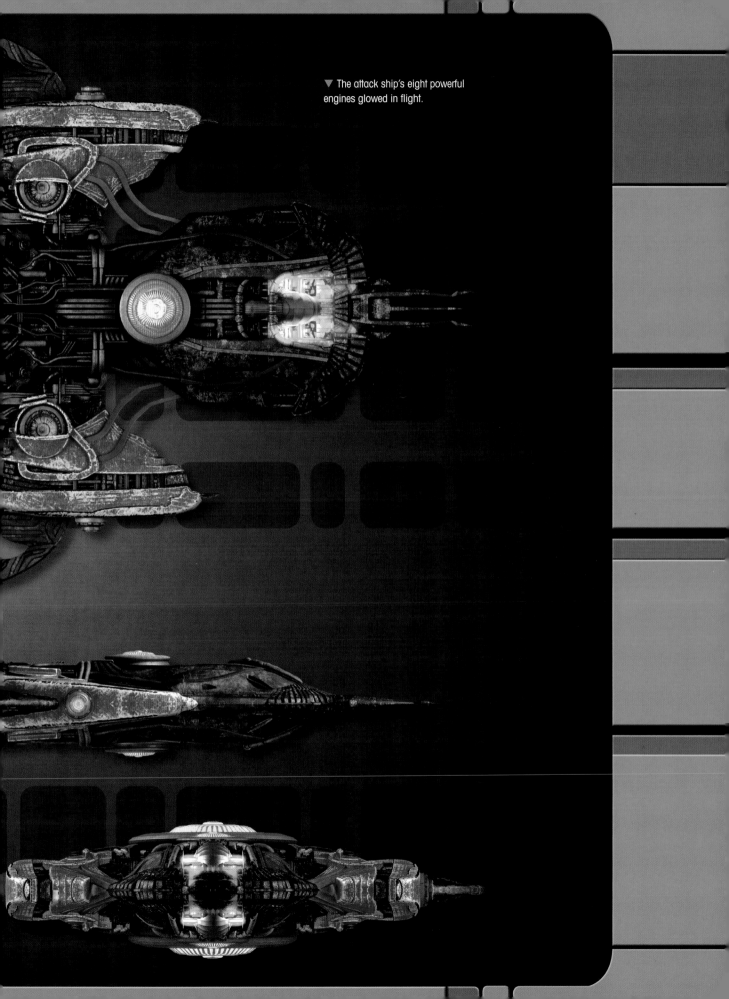

▼ The attack ship's eight powerful engines glowed in flight.

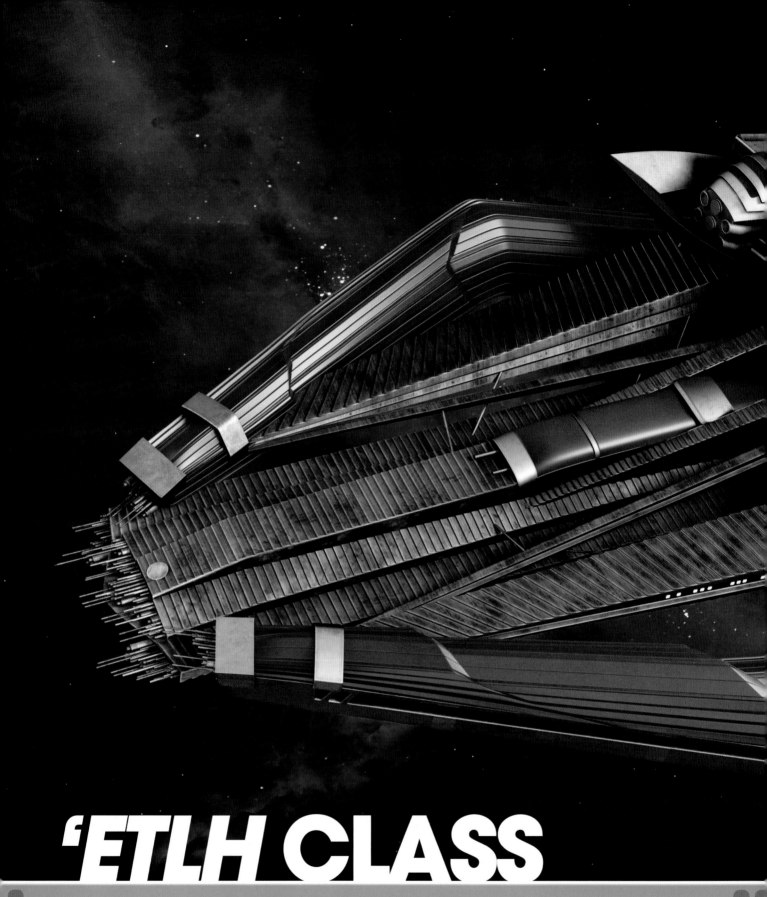

'ETLH CLASS

The 'etlh class is unusual vessel with a design midway between an armored animal and a spear blade.

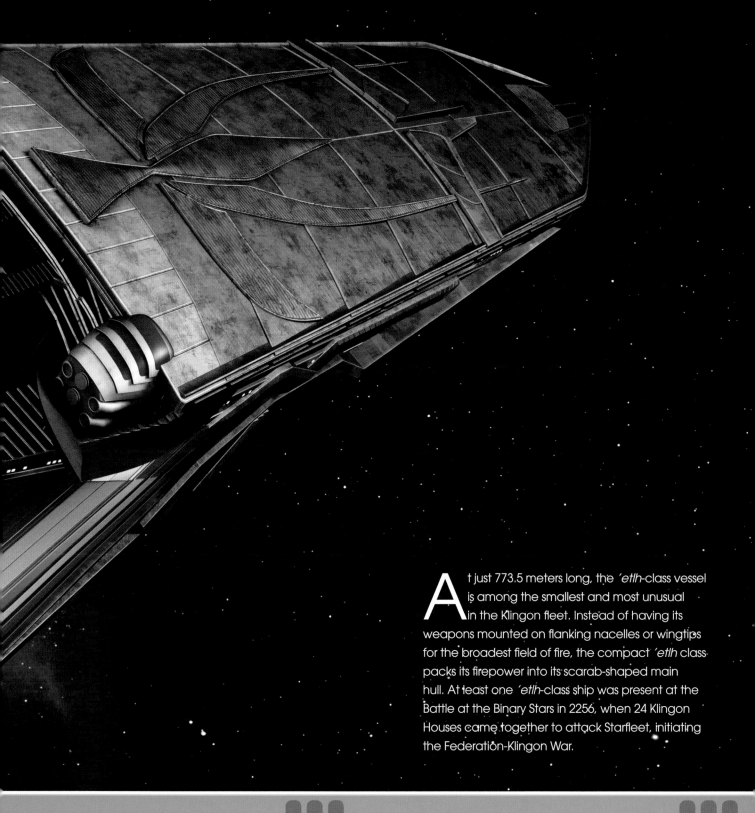

At just 773.5 meters long, the *'etlh*-class vessel is among the smallest and most unusual in the Klingon fleet. Instead of having its weapons mounted on flanking nacelles or wingtips for the broadest field of fire, the compact *'etlh* class packs its firepower into its scarab-shaped main hull. At least one *'etlh*-class ship was present at the Battle at the Binary Stars in 2256, when 24 Klingon Houses came together to attack Starfleet, initiating the Federation-Klingon War.

DATA FEED

'etlh is an old Klingon word for a blade. Used in phrases such as *'batlh 'etlh'* – meaning 'glory blade' or 'honor blade' – its spelling changed over time to describe weapons such as the *bat'leth* and the smaller *mek'leth*.

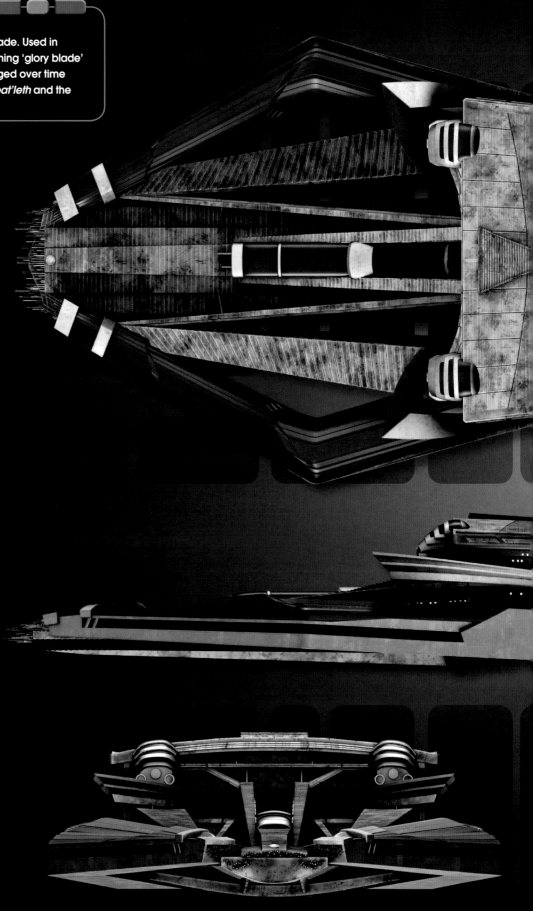

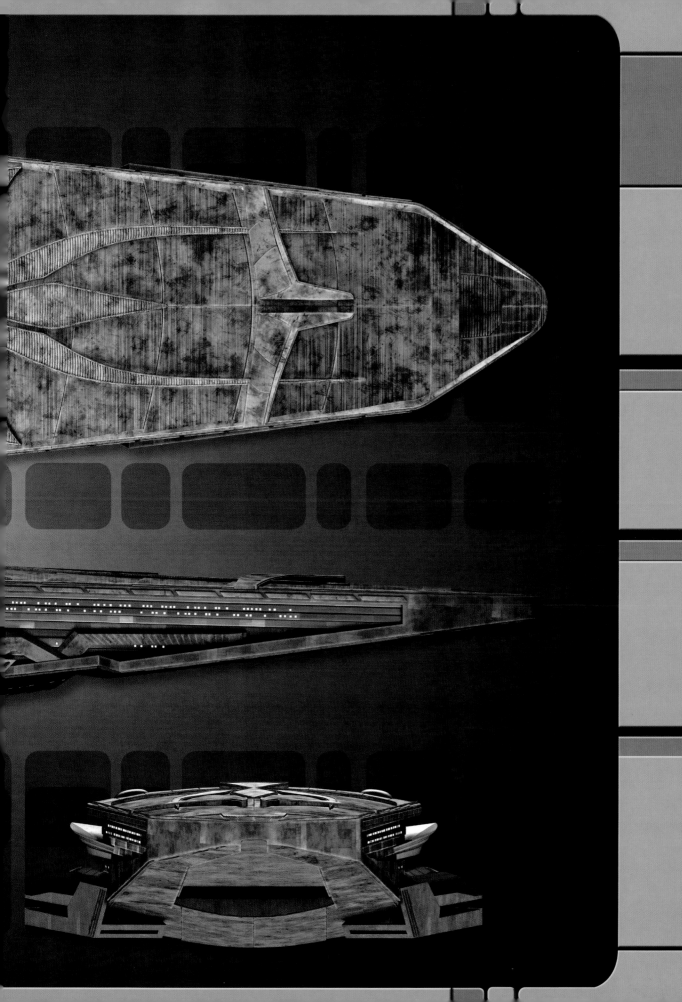

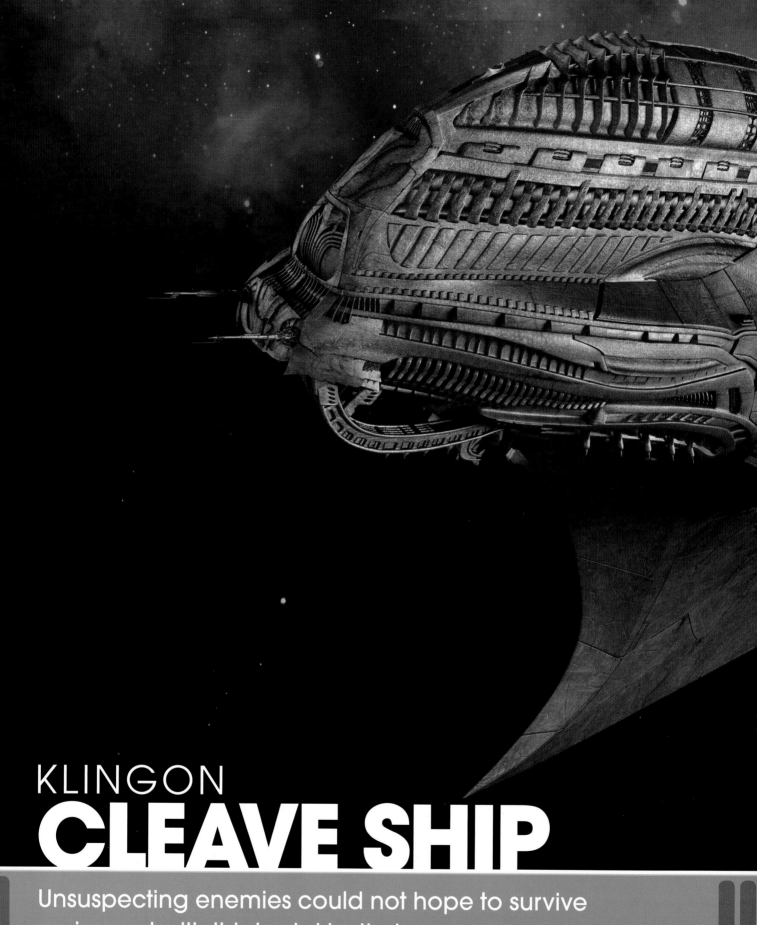

KLINGON
CLEAVE SHIP

Unsuspecting enemies could not hope to survive
an impact with this brutal battering ram.

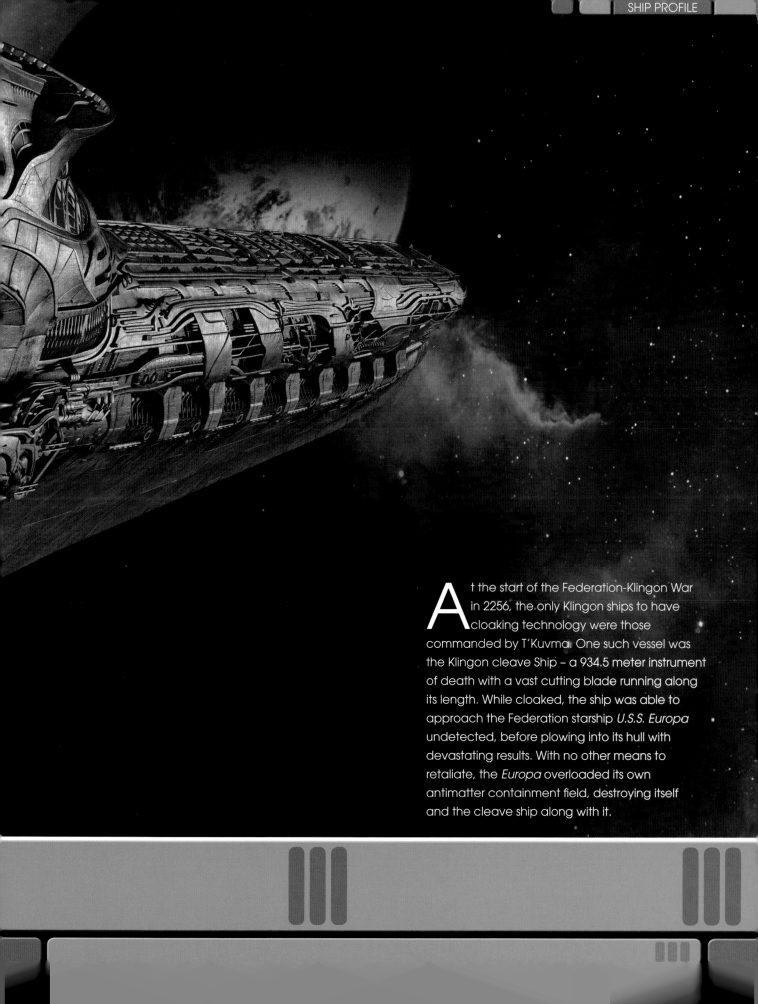

At the start of the Federation-Klingon War in 2256, the only Klingon ships to have cloaking technology were those commanded by T'Kuvma. One such vessel was the Klingon cleave Ship – a 934.5 meter instrument of death with a vast cutting blade running along its length. While cloaked, the ship was able to approach the Federation starship *U.S.S. Europa* undetected, before plowing into its hull with devastating results. With no other means to retaliate, the *Europa* overloaded its own antimatter containment field, destroying itself and the cleave ship along with it.

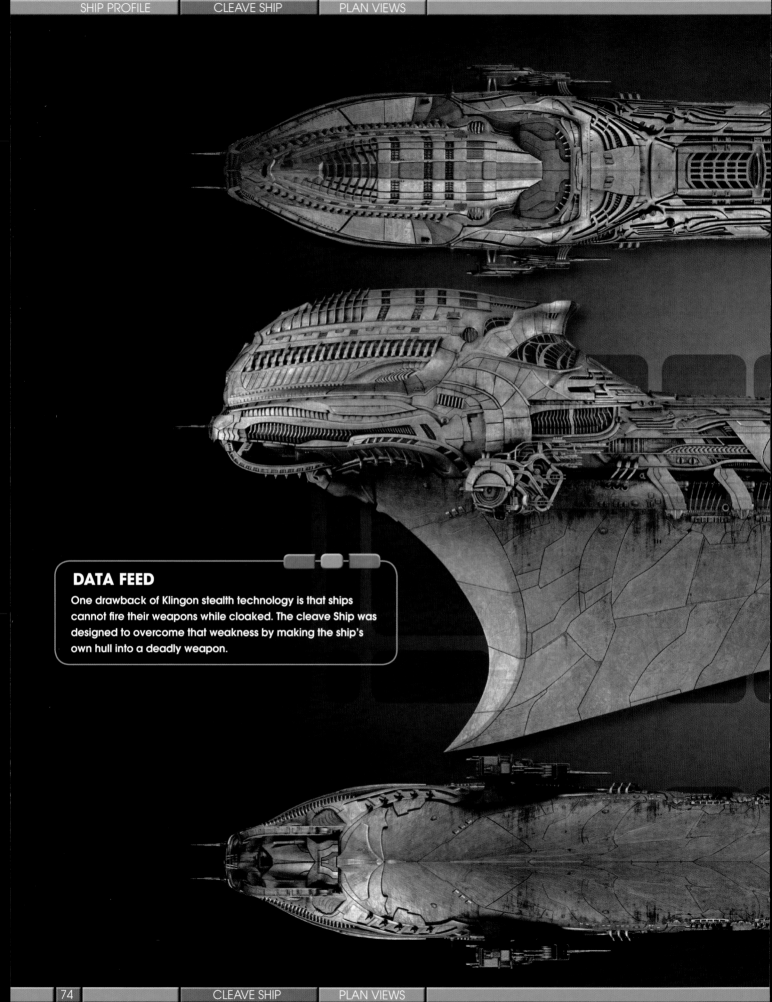

DATA FEED

One drawback of Klingon stealth technology is that ships cannot fire their weapons while cloaked. The cleave Ship was designed to overcome that weakness by making the ship's own hull into a deadly weapon.

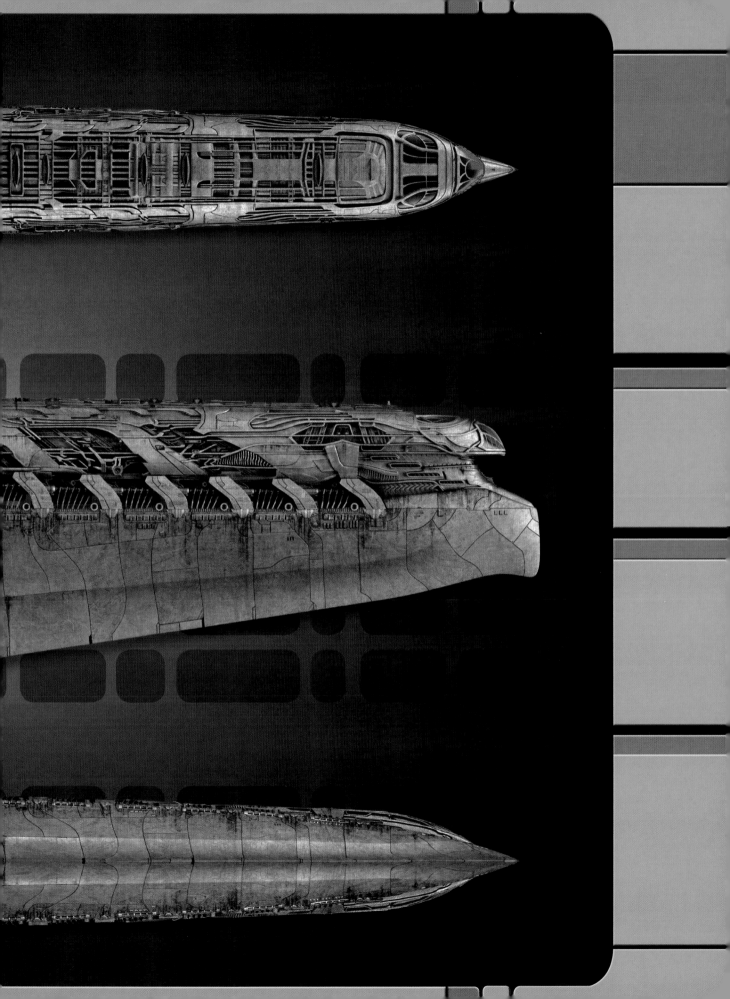

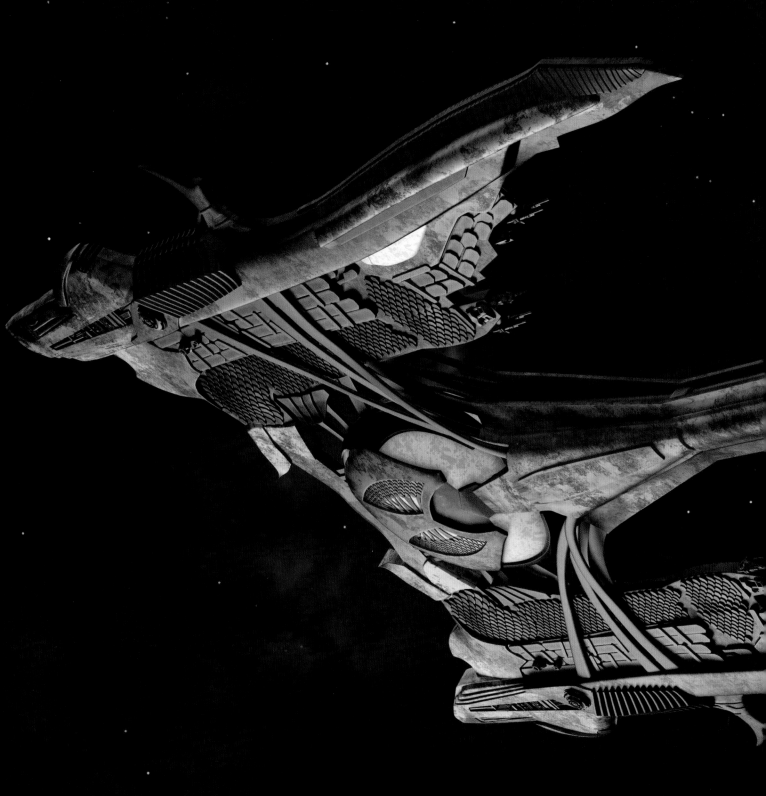

BORTAS BIR CLASS

Kol of House Kor had this powerful class as his flagship until he could get his hands on the sarcophagus ship.

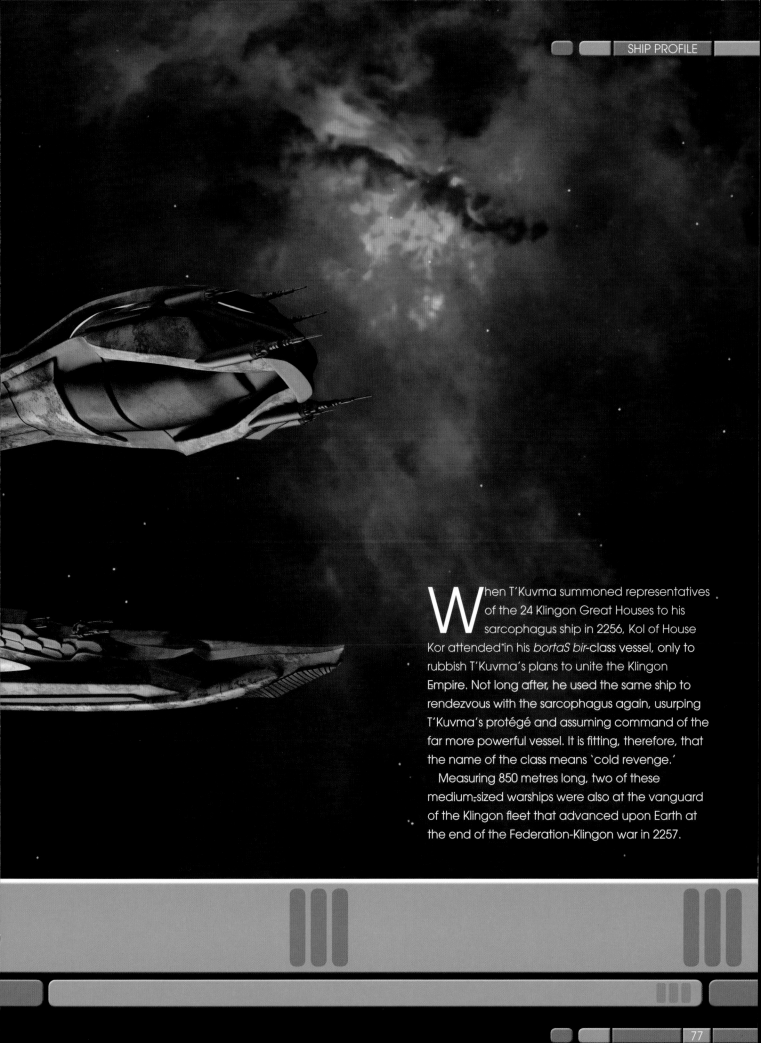

When T'Kuvma summoned representatives of the 24 Klingon Great Houses to his sarcophagus ship in 2256, Kol of House Kor attended in his *bortaS bir*-class vessel, only to rubbish T'Kuvma's plans to unite the Klingon Empire. Not long after, he used the same ship to rendezvous with the sarcophagus again, usurping T'Kuvma's protégé and assuming command of the far more powerful vessel. It is fitting, therefore, that the name of the class means 'cold revenge.'

Measuring 850 metres long, two of these medium-sized warships were also at the vanguard of the Klingon fleet that advanced upon Earth at the end of the Federation-Klingon war in 2257.

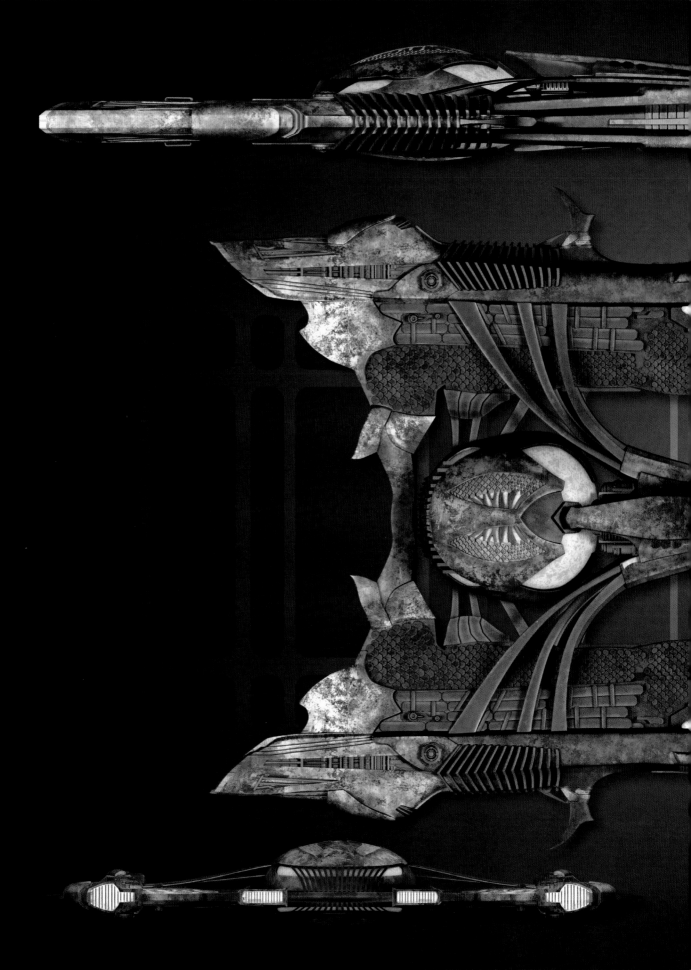

DATA FEED

In the 2150s, the Klingon Imperial Fleet included a D5-class battle cruiser called the *I.K.S. Bortas*, commanded by Duras, son of Toral. More than 200 years later, a *Vor'cha*-class attack cruiser in the Klingon Defense Force was also named the *I.K.S. Bortas*, serving as Chancellor Gowron's flagship.

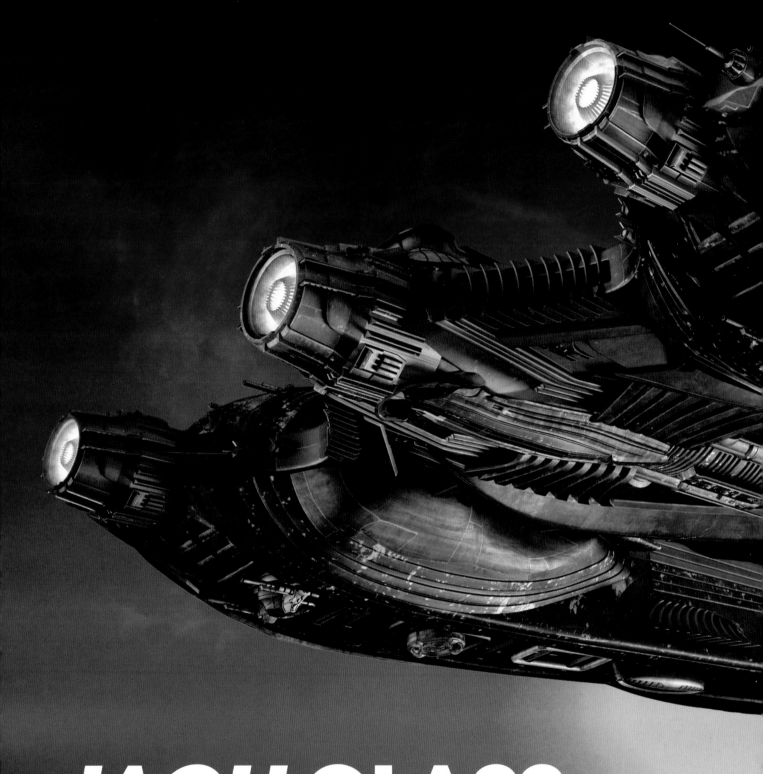

JACH CLASS

The *jach* class was a versatile cruiser that supported the house of T'Kuvma in the Battle at the Binary stars of 2256.

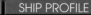

With its elongated, triple-pronged configuration, the *jach* cruiser was a formidable addition to any battle with enemy starships. Sharing some design commonality with the *chargh*-class cruiser, the jach's distinctive tapered primary hull marked it out from other, similarly configured cruisers. Powered by three engine exhausts, *jach*-class cruisers provided support to the house of T'Kuvma when summoned to engage with the Federation starship *U.S.S. Shenzou* in the Battle at the Binary stars.

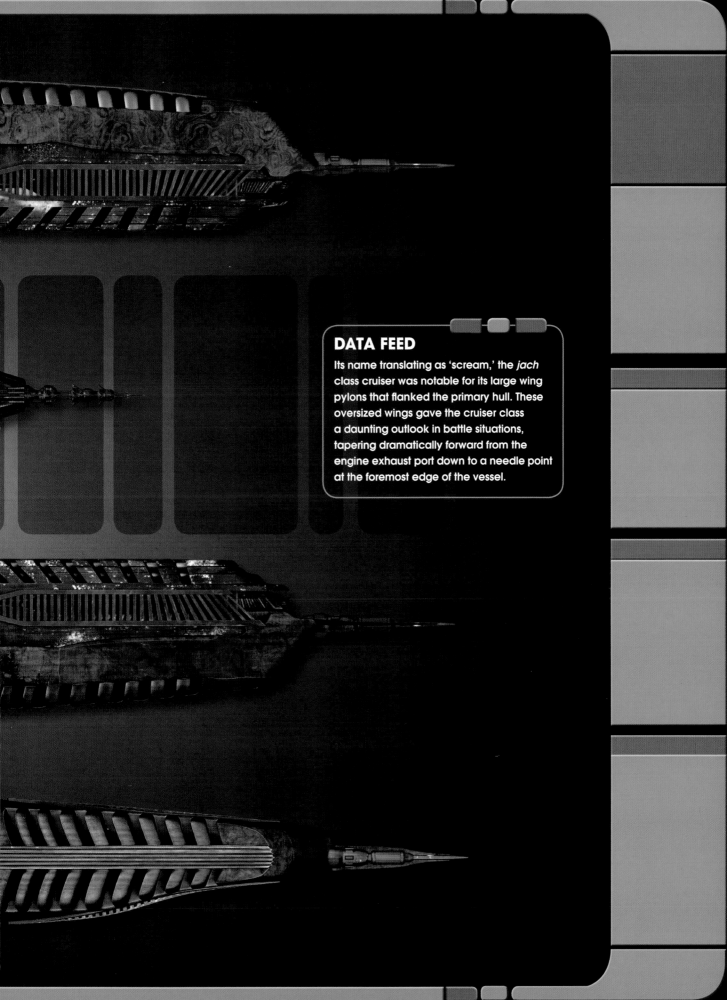

DATA FEED

Its name translating as 'scream,' the *jach* class cruiser was notable for its large wing pylons that flanked the primary hull. These oversized wings gave the cruiser class a daunting outlook in battle situations, tapering dramatically forward from the engine exhaust port down to a needle point at the foremost edge of the vessel.

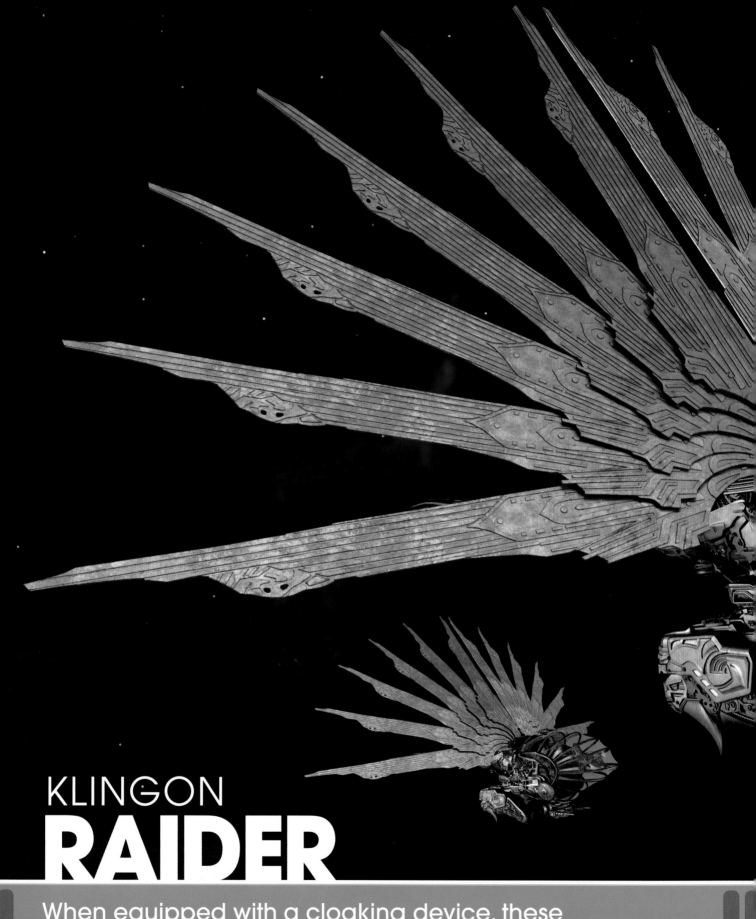

KLINGON
RAIDER

When equipped with a cloaking device, these small ships should not be underestimated.

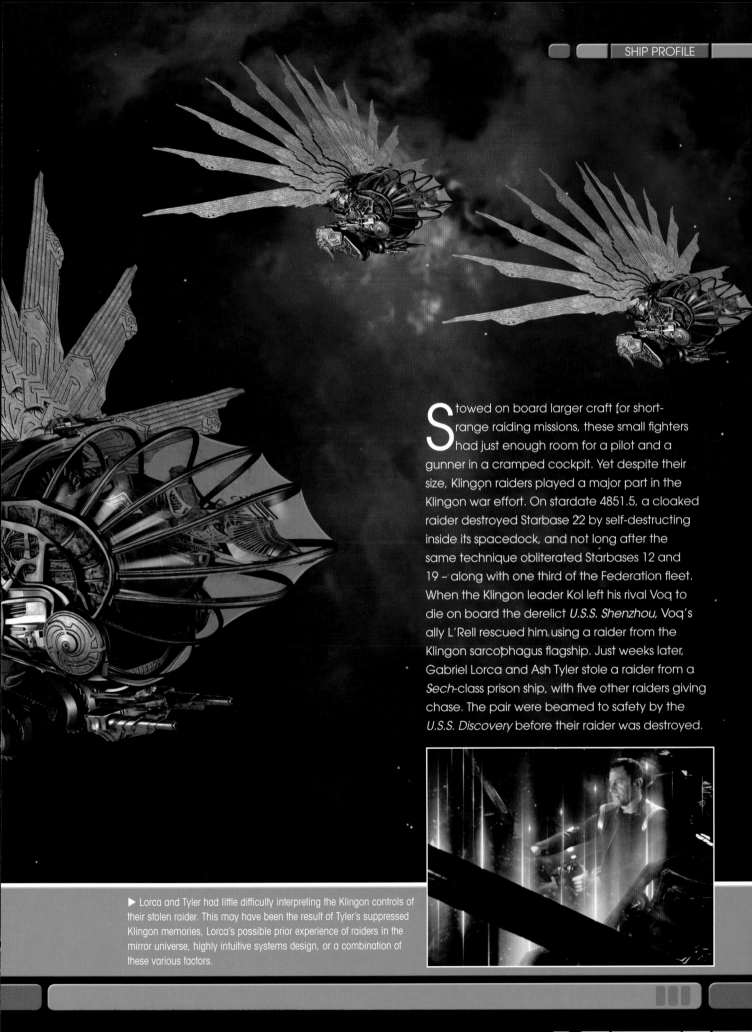

Stowed on board larger craft for short-range raiding missions, these small fighters had just enough room for a pilot and a gunner in a cramped cockpit. Yet despite their size, Klingon raiders played a major part in the Klingon war effort. On stardate 4851.5, a cloaked raider destroyed Starbase 22 by self-destructing inside its spacedock, and not long after the same technique obliterated Starbases 12 and 19 – along with one third of the Federation fleet. When the Klingon leader Kol left his rival Voq to die on board the derelict *U.S.S. Shenzhou*, Voq's ally L'Rell rescued him using a raider from the Klingon sarcophagus flagship. Just weeks later, Gabriel Lorca and Ash Tyler stole a raider from a *Sech*-class prison ship, with five other raiders giving chase. The pair were beamed to safety by the *U.S.S. Discovery* before their raider was destroyed.

▶ Lorca and Tyler had little difficulty interpreting the Klingon controls of their stolen raider. This may have been the result of Tyler's suppressed Klingon memories, Lorca's possible prior experience of raiders in the mirror universe, highly intuitive systems design, or a combination of these various factors.

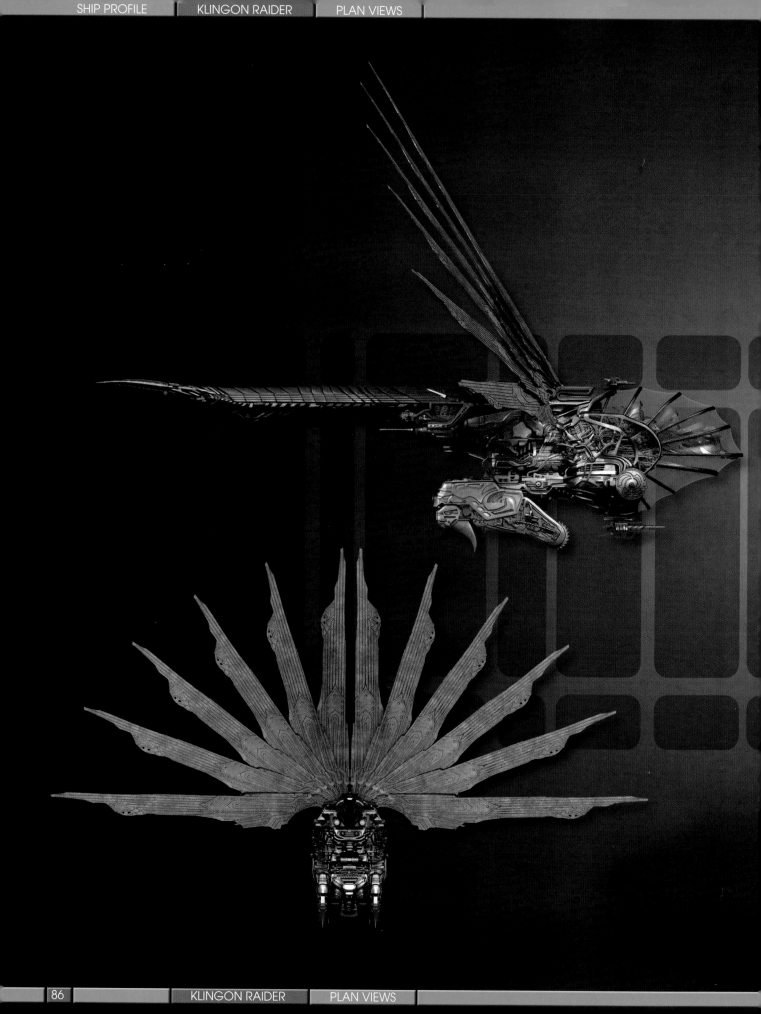

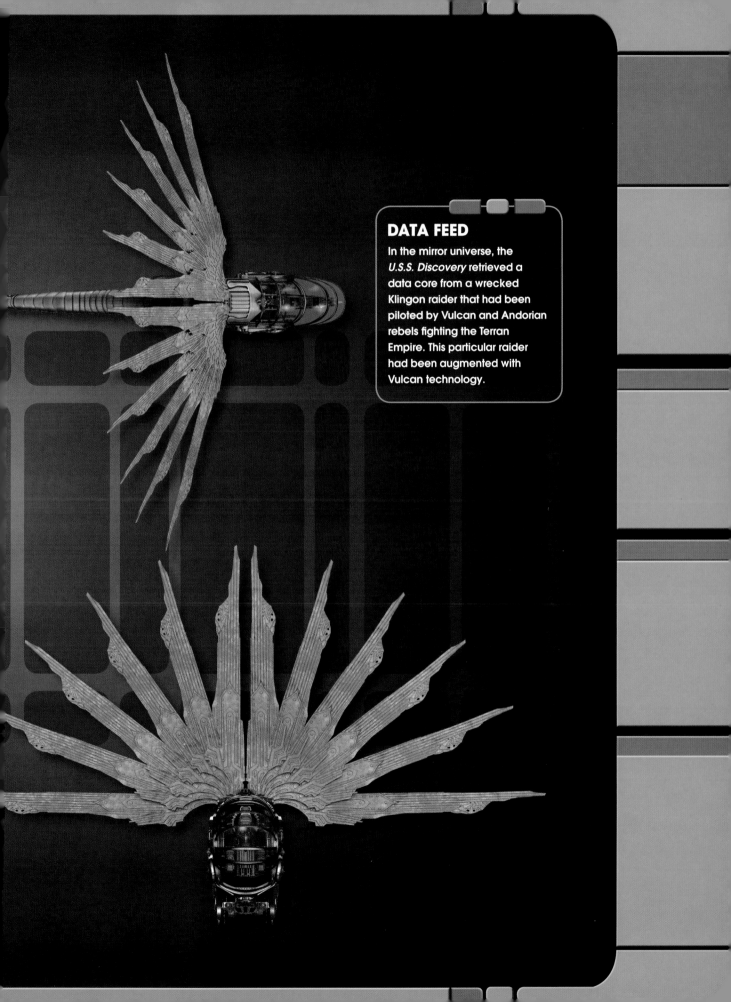

DATA FEED

In the mirror universe, the *U.S.S. Discovery* retrieved a data core from a wrecked Klingon raider that had been piloted by Vulcan and Andorian rebels fighting the Terran Empire. This particular raider had been augmented with Vulcan technology.

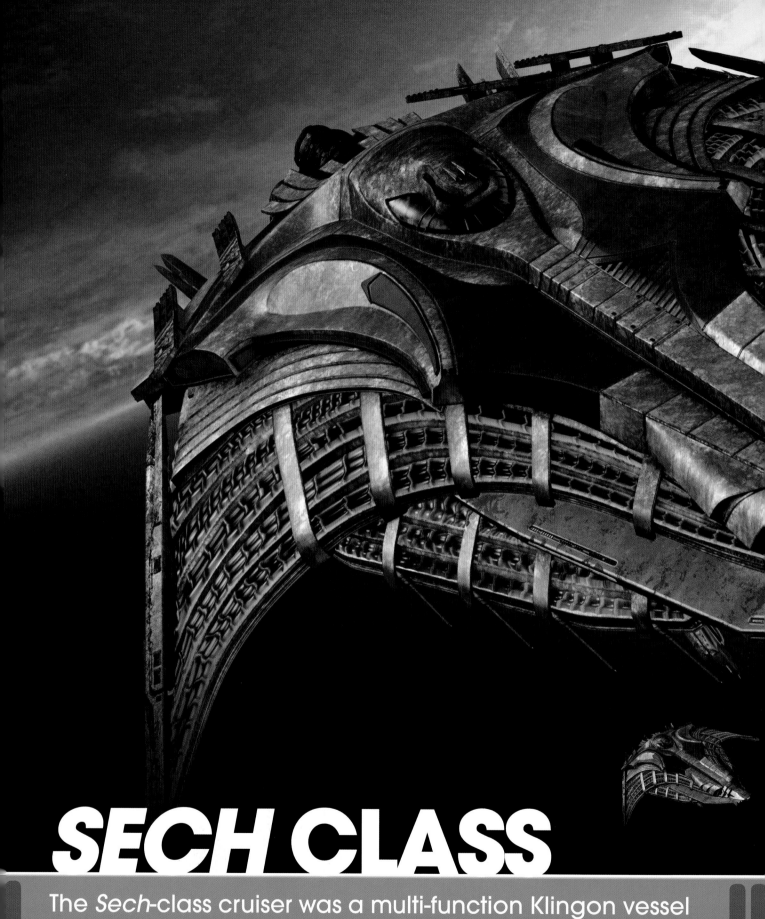

SECH CLASS

The *Sech*-class cruiser was a multi-function Klingon vessel serving as both battle cruiser and prisoner transport.

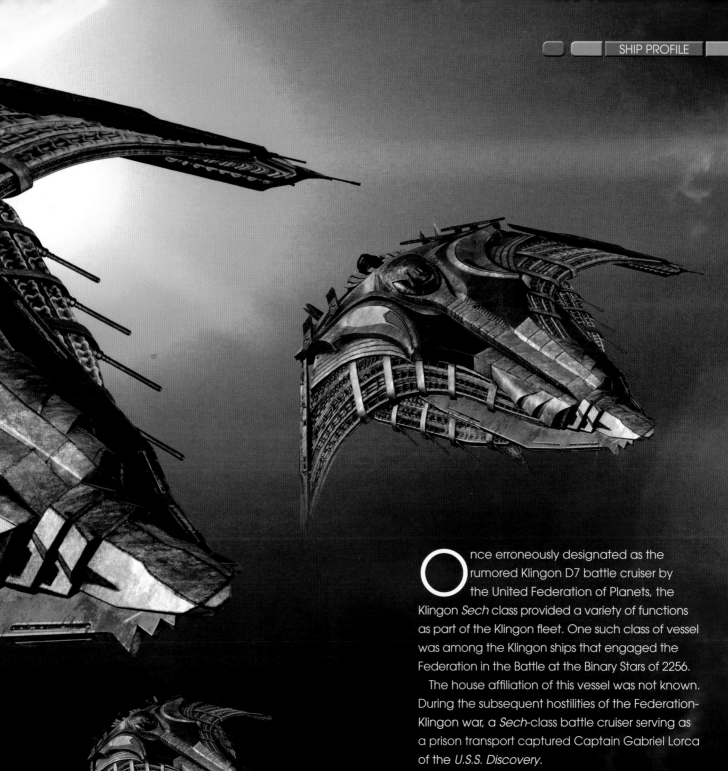

Once erroneously designated as the rumored Klingon D7 battle cruiser by the United Federation of Planets, the Klingon *Sech* class provided a variety of functions as part of the Klingon fleet. One such class of vessel was among the Klingon ships that engaged the Federation in the Battle at the Binary Stars of 2256.

The house affiliation of this vessel was not known. During the subsequent hostilities of the Federation-Klingon war, a *Sech*-class battle cruiser serving as a prison transport captured Captain Gabriel Lorca of the *U.S.S. Discovery*.

The sleek, three-point configuration of the *Sech*-class made it an effective addition to enemy engagements, while its lateral mounted tractor beam was powerful enough to capture enemy shuttlecraft.

DATA FEED

The docking bay of a *Sech*-class ship was large enough to hold several small Klingon raiders. Starfleet officers Captain Gabriel Lorca and Lieutenant Ash Tyler made their escape from a *Sech*-class prison transport aboard one such vessel, with other raiders in pursuit. They left notorious conman Harcourt Fenton Mudd behind.

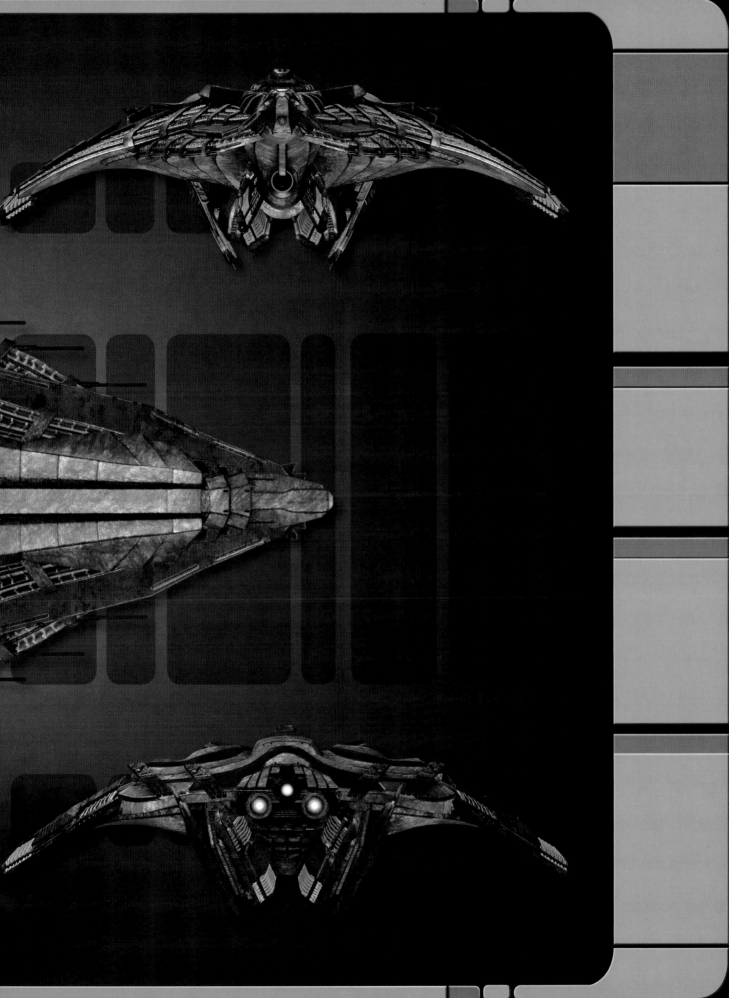

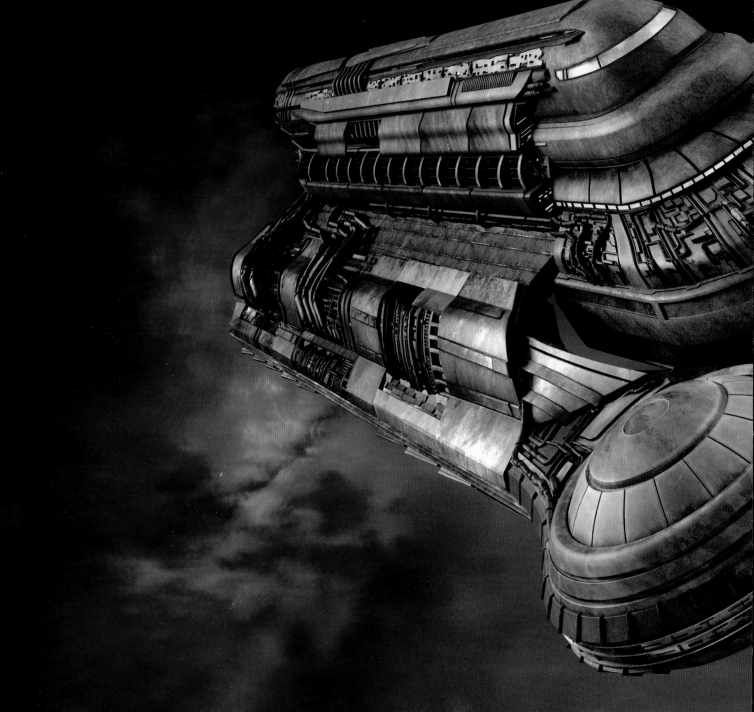

BATLH CLASS

This compact craft experiments with the
conventions of Klingon ship design.

At first, the unusual shape of the *Batlh*-class ship seems entirely separate from the lineage of most Klingon ships. However, on closer inspection, it can be seen to conform to the standard arrangement of a central hull with two powerful nacelles exceeding its length on either side. The key difference of the *Batlh* class is that it packs those features into a much tighter profile, providing a smaller target for enemy ships. At least one *Batlh*-class vessel was present at the Battle at the Binary Stars in 2256, and at the head of the fleet that was headed to Earth when the Federation-Klingon War ended in 2257.

DATA FEED

The Klingon term *batlh* encapsulates notions of honor. The *Paq'batlh* or 'Book of Honor' is a collection of ancient Klingon scrolls that details the legends of Kahless and is seen by many Klingons as a guide to living a glorious warrior's life.

▶ The *Batlh*-class ship alongside the Klingon Fleet, before the Battle at the Binary Stars.

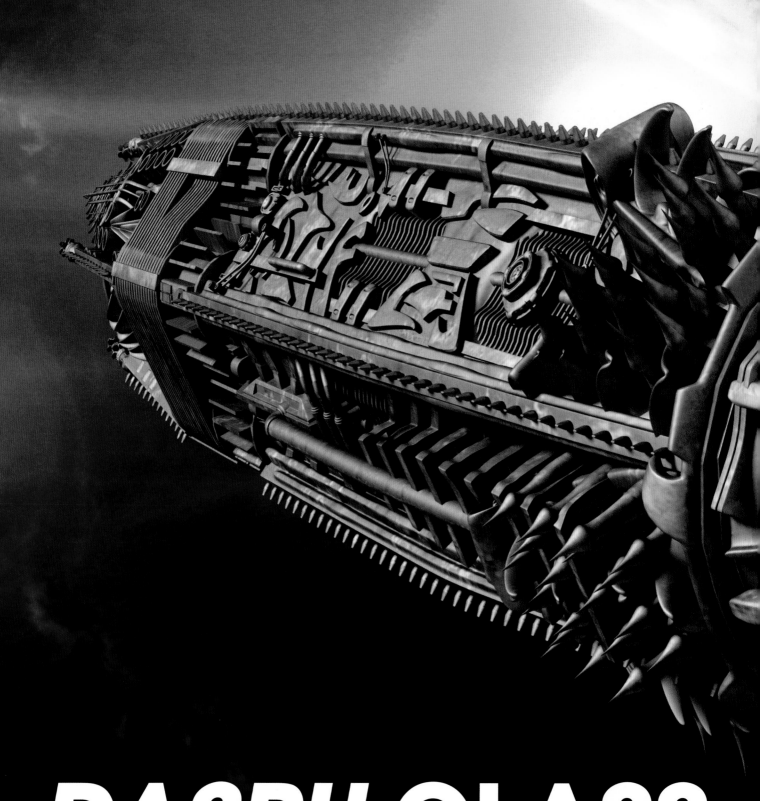

DASPU CLASS

The *DaSpu* class provided essential support to the Klingon fleet in enemy engagements.

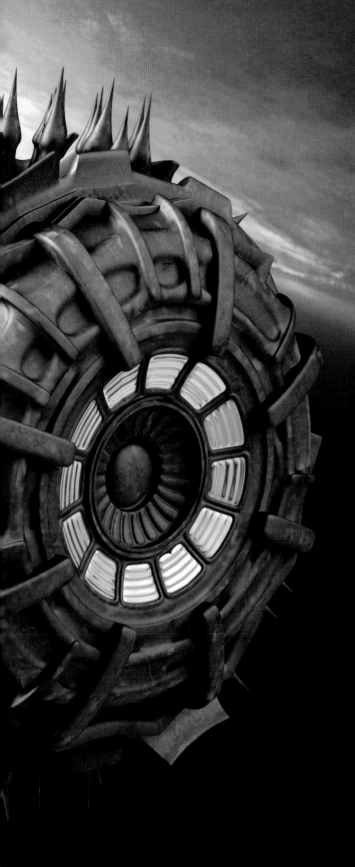

DATA FEED

The *DaSpu* class was designed in a cylindrical configuration, with a single engine located in the aft section. Its surface was encrusted with a network of spikes, while protrusions from its forward section gave the image of a dart-like weapon. The single-engine exhaust located in the aft section powered the vessel through space.

The cylindrical, single-engined *DaSpu* class may have lacked the ornate design of other ships of the Klingon fleet, but it was nevertheless an effective part of the Empire's battle supremacy. At least three *DaSpu* class ships were present in 2256 at the Battle at the Binary Stars, providing effective support and engagement against the Federation fleet that arrived in force.

▶ The *DaSpu* or 'boot spike' class with the Klingon Fleet.

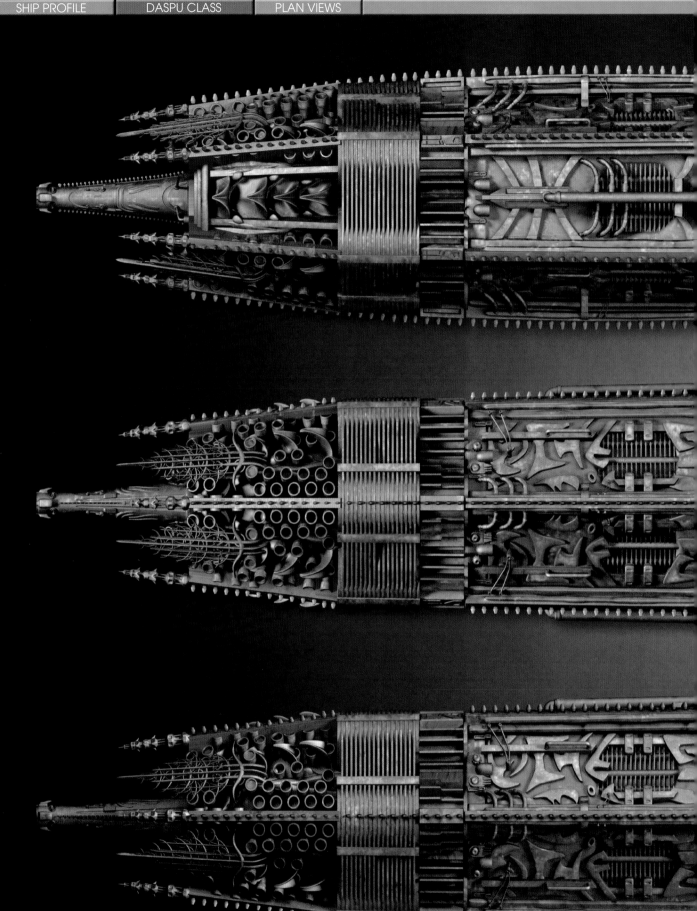

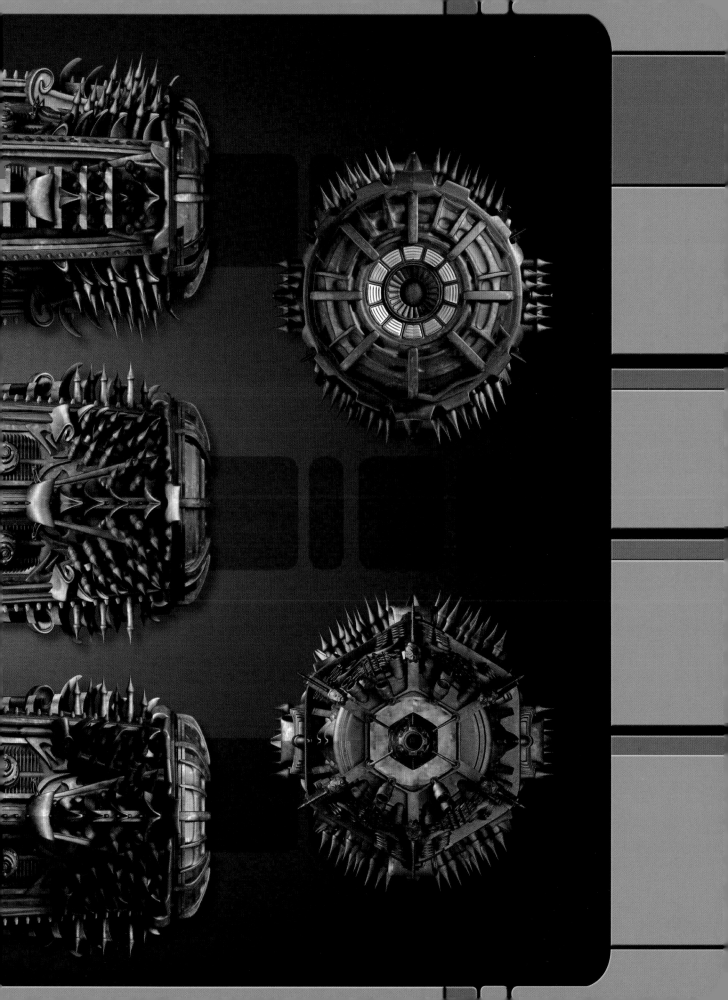

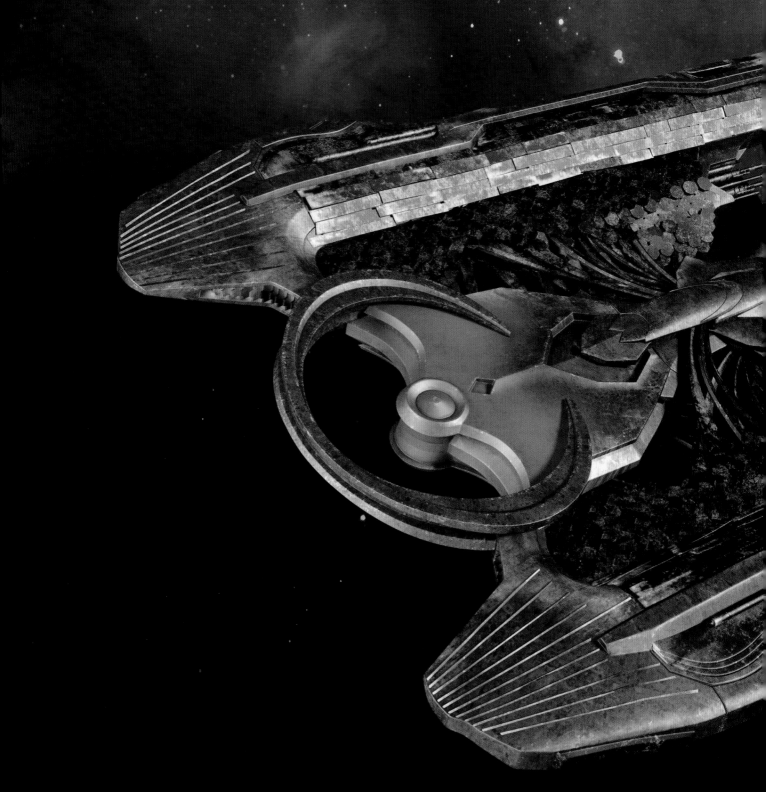

QAW' CLASS

The classic design configuration of the *Qaw'* class marked it out as a recognizable part of the Klingon fleet.

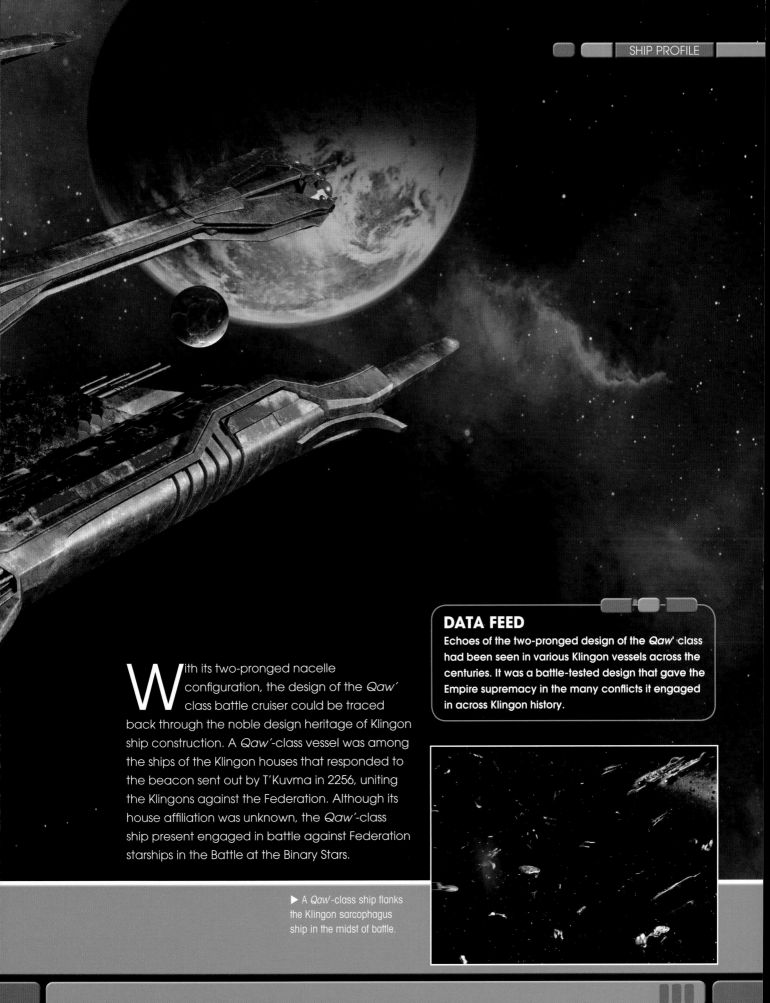

DATA FEED

Echoes of the two-pronged design of the *Qaw'* class had been seen in various Klingon vessels across the centuries. It was a battle-tested design that gave the Empire supremacy in the many conflicts it engaged in across Klingon history.

With its two-pronged nacelle configuration, the design of the *Qaw'* class battle cruiser could be traced back through the noble design heritage of Klingon ship construction. A *Qaw'*-class vessel was among the ships of the Klingon houses that responded to the beacon sent out by T'Kuvma in 2256, uniting the Klingons against the Federation. Although its house affiliation was unknown, the *Qaw'*-class ship present engaged in battle against Federation starships in the Battle at the Binary Stars.

▶ A *Qaw'*-class ship flanks the Klingon sarcophagus ship in the midst of battle.

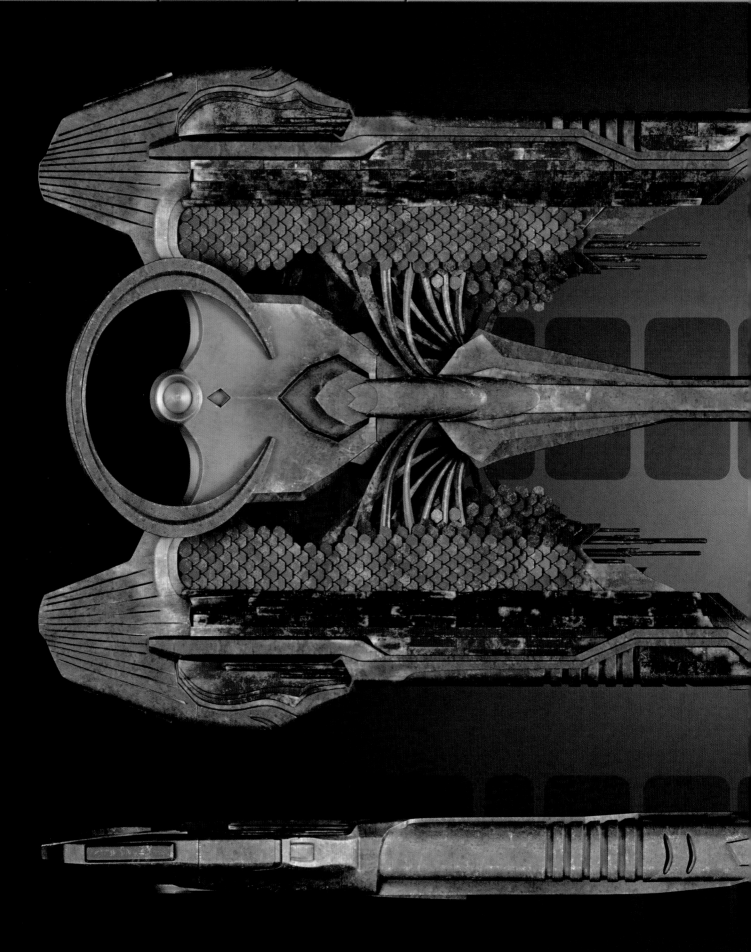

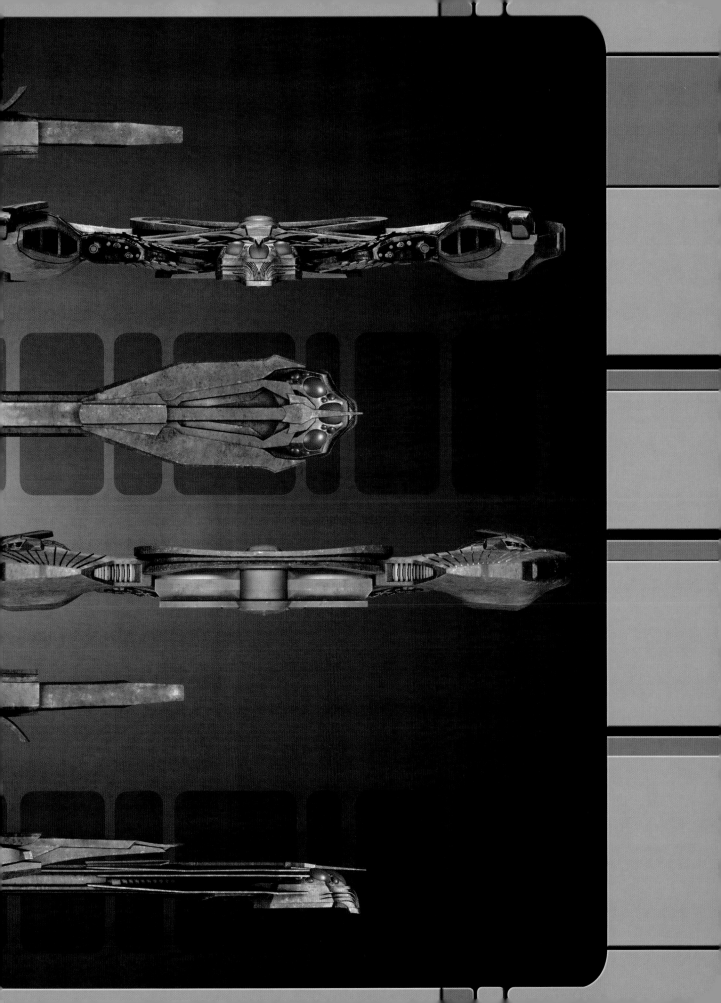

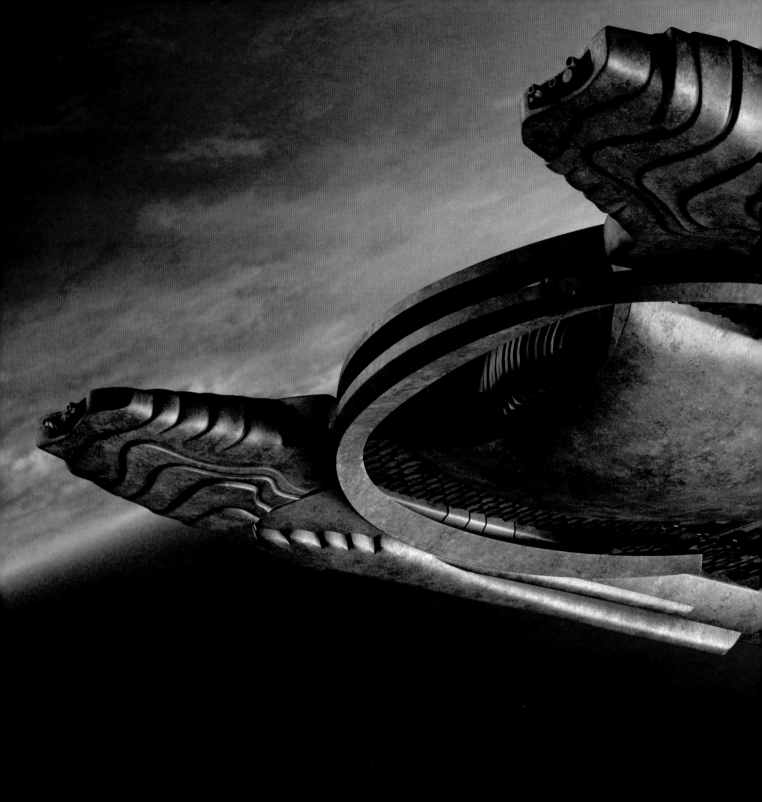

QOJ CLASS

A deceptively sleek design marked out the *Qoj* class warship from other vessels of the Klingon fleet.

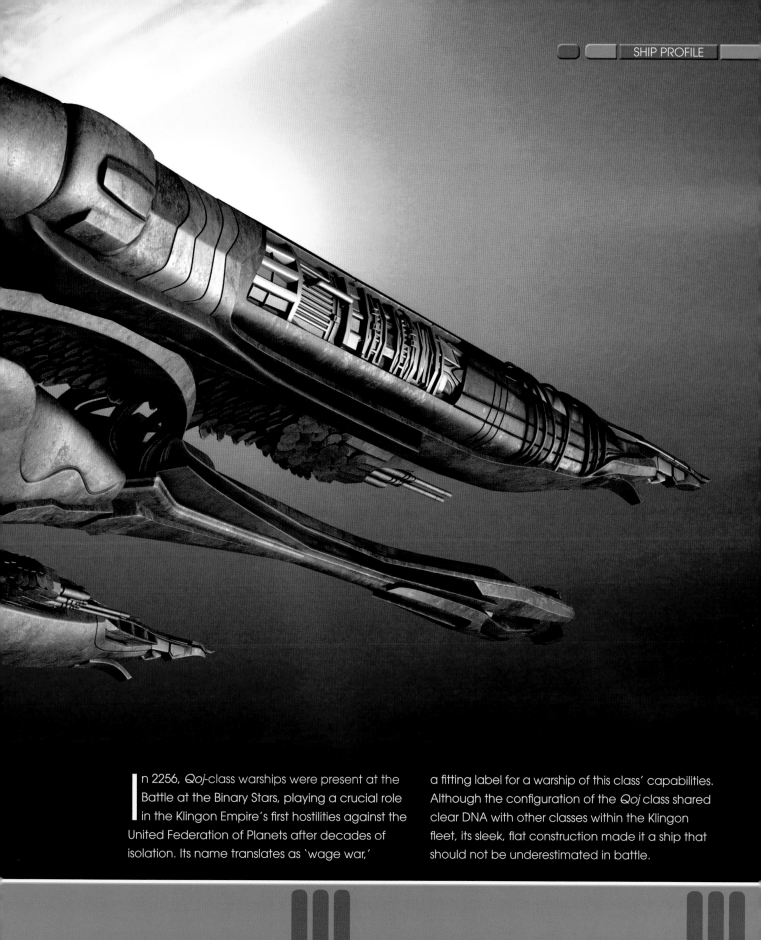

I n 2256, *Qoj*-class warships were present at the Battle at the Binary Stars, playing a crucial role in the Klingon Empire's first hostilities against the United Federation of Planets after decades of isolation. Its name translates as 'wage war,'

a fitting label for a warship of this class' capabilities. Although the configuration of the *Qoj* class shared clear DNA with other classes within the Klingon fleet, its sleek, flat construction made it a ship that should not be underestimated in battle.

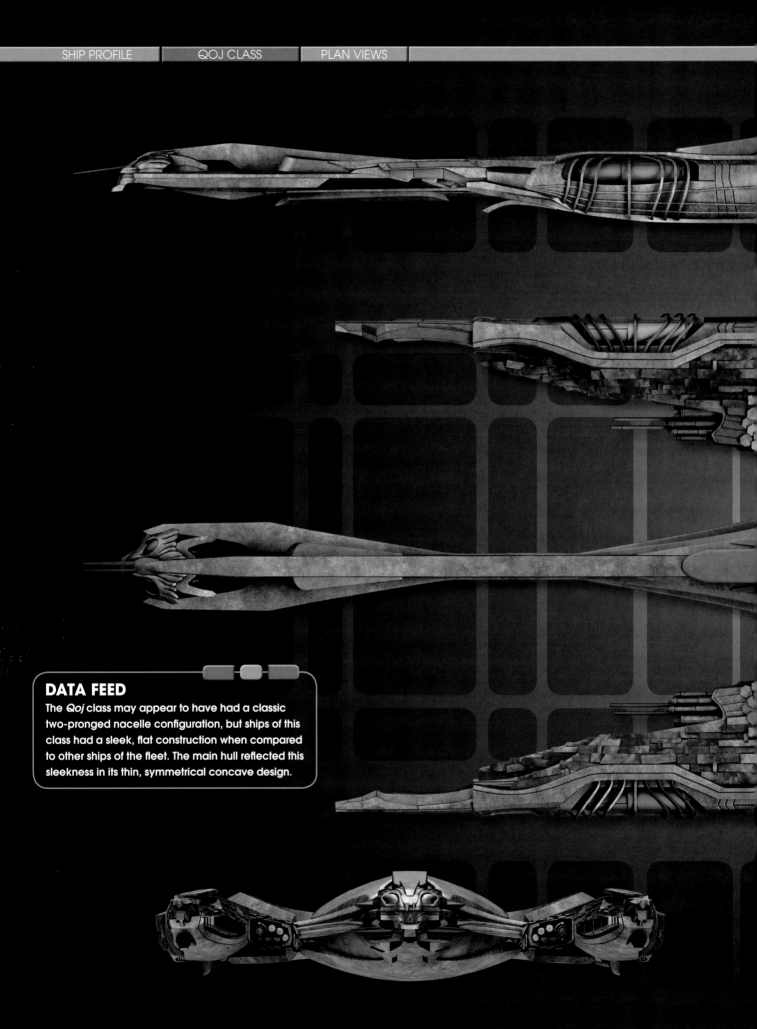

DATA FEED

The *Qoj* class may appear to have had a classic two-pronged nacelle configuration, but ships of this class had a sleek, flat construction when compared to other ships of the fleet. The main hull reflected this sleekness in its thin, symmetrical concave design.

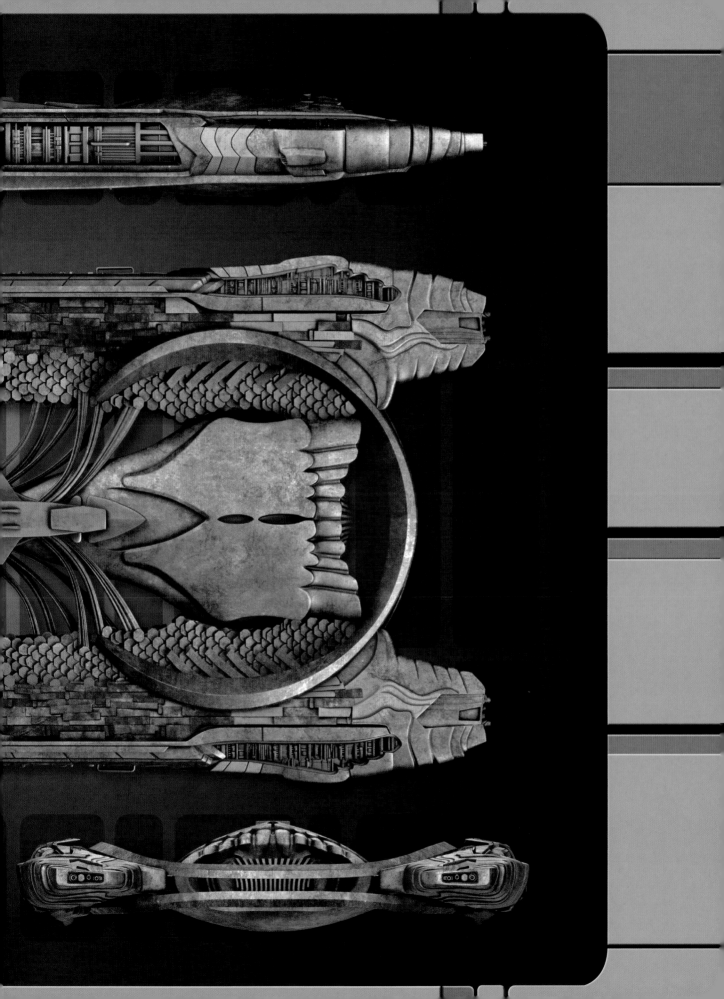

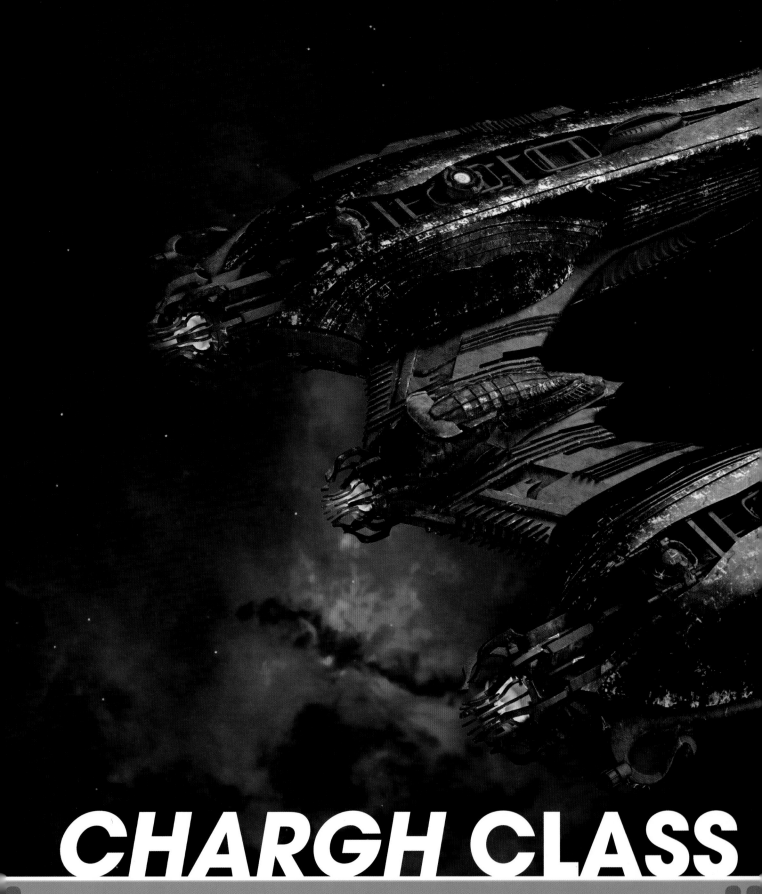

CHARGH CLASS

These fast and maneuverable battle cruisers were a mainstay of Klingon sneak attacks.

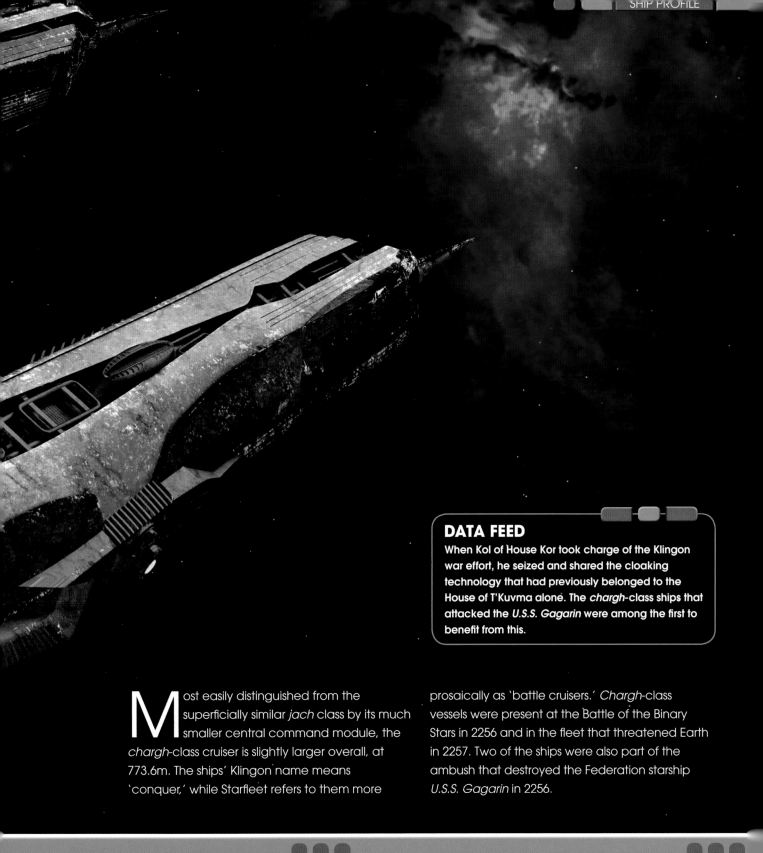

DATA FEED

When Kol of House Kor took charge of the Klingon war effort, he seized and shared the cloaking technology that had previously belonged to the House of T'Kuvma alone. The *chargh*-class ships that attacked the *U.S.S. Gagarin* were among the first to benefit from this.

Most easily distinguished from the superficially similar *jach* class by its much smaller central command module, the *chargh*-class cruiser is slightly larger overall, at 773.6m. The ships' Klingon name means 'conquer,' while Starfleet refers to them more prosaically as 'battle cruisers.' *Chargh*-class vessels were present at the Battle of the Binary Stars in 2256 and in the fleet that threatened Earth in 2257. Two of the ships were also part of the ambush that destroyed the Federation starship *U.S.S. Gagarin* in 2256.

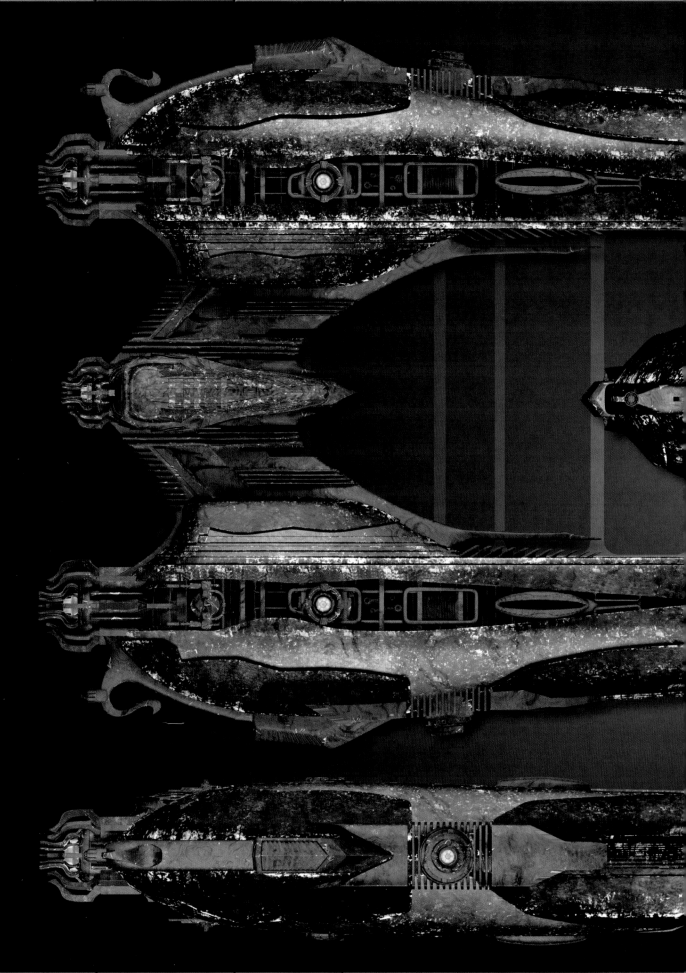

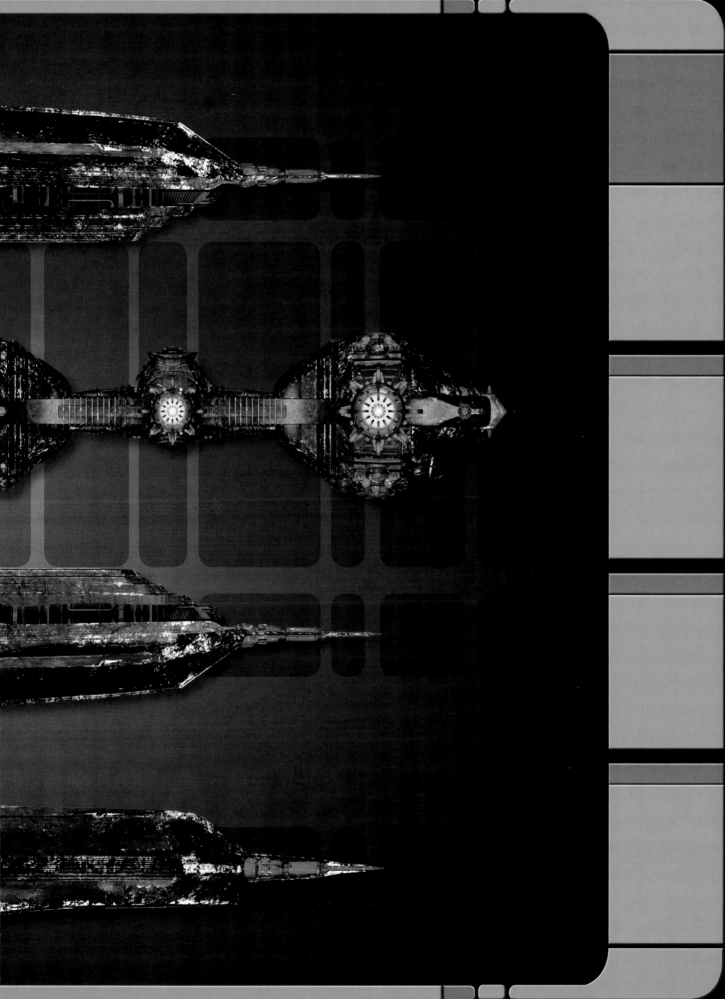

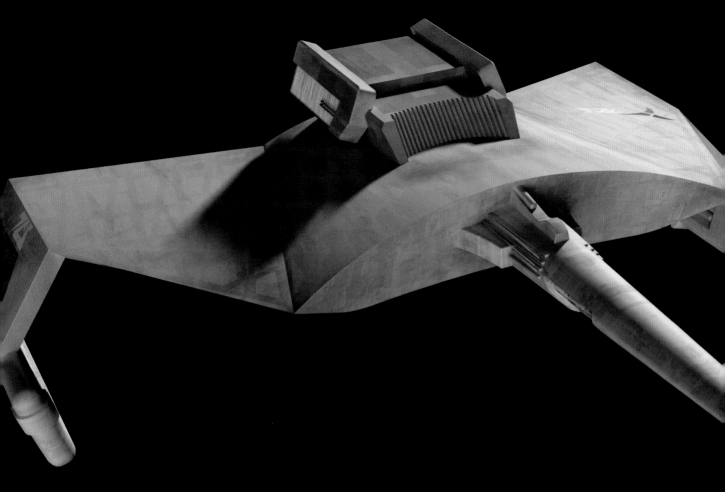

The D7-class battle cruiser appeared to be the most common type of vessel in the Klingon Imperial Fleet in the 2260s. It was 228 meters in length, had a crew complement of around 440, and like all Klingon ships was heavily armed. By 2268, these vessels also featured a cloaking device, which the Klingons acquired from the Romulans in exchange for D7 battle cruisers.

The overall layout of the D7 was a design evolution of the earlier D5-class ships, and was almost predatory in appearance. It featured a spread-wing engineering hull, below which hung two warp nacelles. These were capable of propelling the ship to speeds of at least warp 7. An extended neck section connected the secondary hull of the ship to the bulbous command module, on top of which was the bridge, or command center.

Unlike the later *K't'inga*-class vessels, which came into service around 2271, the D7 had

KLINGON
D7-CLASS BATTLE

The D7 class was a type of Klingon warship that posed a serious threat to Federation security in the 2270s.

DATA FEED
Klingon D7-class vessels had a fearsome reputation during the cold war with the Federation. Despite numerous skirmishes between Klingon and Federation forces, relatively few shots were fired, and nearly all the recorded engagements between their fleets were abortive or inconclusive.

smooth outer panels. There was very little surface detail, such as the radiator baffles and cabling that characterized later Klingon ships.

D7-class vessels possessed defensive shields, but it was their offensive power that made them so dangerous. They had considerable firepower at their disposal, including forward-mounted phasers, a photon-torpedo launcher in the lower half of the nose of the ship and two nacelle-mounted disruptor cannons. In addition, they were also capable of firing a magnetic pulse, which took the form of a glowing ball of light and was capable of inflicting extensive damage to a ship, even if that ship had already raised its shields.

SECURITY THREAT
The D7 class posed serious problems to the security of the Federation throughout the 2270s. This was at a time when there was a 'cold war' between the two powers, which had been going on since 2257. In 2267, the build-up of tensions led to a brief all-out war over Organia, a key strategic planet between Federation and Klingon space.

The *U.S.S. Enterprise* NCC-1701 was dispatched to Organia to prevent the Klingons from using it as a base of operations. On the way there, it was attacked with magnetic pulses from a D7-class vessel. It caused damage to decks 10 and 11 of the *Enterprise*, and minor buckling of the antimatter pods. The *Enterprise* hit back with a one hundred per cent dispersal of its phaser banks, completely destroying the Klingon vessel. The *Enterprise* continued on to Organia, where Captain Kirk and Commander Spock beamed down to the planet, but while they were there a fleet of at least seven D7-class battle cruisers

CRUISER

▲ The D7-class battle cruiser was the most powerful and rugged warship in the Klingon Imperial Fleet for much of the 23rd century. Vessels of this type were involved in numerous altercations with Starfleet along the borders of the Neutral Zone between the Federation and the Klingon Empire.

◀ The glowing blue sections on the rear of D7 ships indicated the location of the impulse engines. The four engines gave the vessel excellent maneuverability at sublight speeds, which helped during tactical engagements. The raised section above the middle two impulse engines housed the hanger bay and shuttlebay.

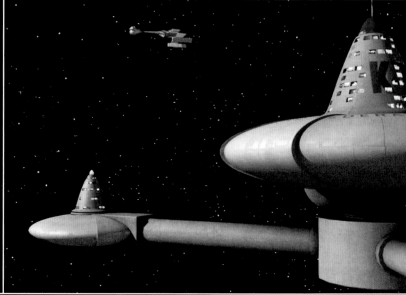

▲ Commander Kang's D7-class vessel was severely damaged while in orbit of Beta XII-A. The ship was leaking dangerous radiation, and the *Enterprise* was forced to destroy it after beaming the surviving crew to safety.

arrived. The *Enterprise* was forced to retreat, with orders to contact Starfleet Command. Fortunately, hostilities were brought to a swift end by the Organians, who despite their pre-industrial humanoid appearance, were in fact a highly advanced race of non-corporeal beings. They imposed the Treaty of Organia, which established that the Federation and Klingons could lay claim to disputed planets, but each world would be awarded to the side that could demonstrate its ability to develop it the most efficiently.

While this treaty put an end to all-out war, there were several more skirmishes involving D7-class vessels near disputed planets over the next few years. Key disputed regions included Donatu V, the Archanis sector, Capella IV and Neural. The

Klingons attempted to manipulate the inhabitants of these areas into siding with them, while D7-class vessels tried to provoke Starfleet vessels into attacking them.

TRIBBLE TROUBLE

There were several incidents involving the *Enterprise* that almost led to renewed hostilities. The first centered on a shipment of grain intended for Sherman's Planet. It was being stored on Deep Space Station K-7, but while there it was poisoned by undercover Klingon spy Arne Darvin, in collusion with Captain Koloth and his visiting crew of the D7-class *I.K.S. Gr'oth*. The crews of the *Gr'oth* and the *Enterprise* came to blows while taking shore leave on K-7, but the situation was defused when

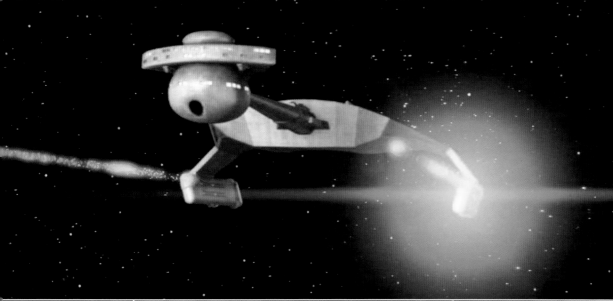

◄ A Klingon D7- ship fired its disr at the *Enterprise* to prevent Elaan reaching Troyius marrying its lead wedding was des to create an allia between the two something the Kl did not want.

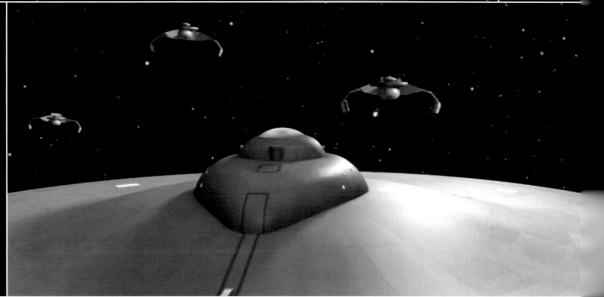

◄ The *Gr'oth* stopped at Deep Space Station K-7 in 2268. It was supposedly there so its crew could take shore leave, but they helped Arne Darvin to poison a shipment of grain.

► The *Enterprise* was normally a match for one D7-class vessel, but when it was faced with several of these ships in orbit of Organia, it was forced to retreat.

creatures known as tribbles ate the grain and died, revealing that it had been poisoned.

In 2268, a D7-class vessel attacked the *Enterprise* while it was transporting Elaan to Troyius for her wedding. Later the same year, Commander Kang's D7-class vessel was fired upon while in orbit of Beta XII-A. He believed that the *Enterprise* was responsible, but it turned out to be an entity of pure energy that fed off negative emotions. Fortunately, this was deduced before it was too late, and war was once again avoided.

The D7-class battle cruiser continued to be in service for some time, but it started to be replaced in 2371 by the *K't'inga*-class, which was very similar in appearance, but much larger at nearly 350 meters in length.

DATA FEED

Kor was the commander of a Klingon warship when he led an invasion force of 500 Klingons in the occupation of Organia. He was determined to defeat the Federation in battle, until the Organians revealed themselves to be a highly-evolved species and brought hostilities to an end. Over 20 year later, Kor became a close friend to Curzon Dax, the Federation ambassador to Qo'noS. He also became friends with Dax's subsequent host Jadzia in the 2370s.

KLINGON SABOTAGE

In 2268, the Klingons tried to sabotage a proposed alliance between the previously warring worlds of Elas and Troyius in the disputed border area of the Tellun system. The Klingons knew that Elas contained a large amount of dilithium ore, which they needed for their vessels. The alliance, which would have been cemented by the marriage of Elaan, the Dohlman of Elas, to the ruler of Troyius, would have put an end to the Klingons' claims over the area. They therefore worked in league with Kryton, an Elasian noble who was in love with Elaan and wanted to prevent the marriage.

When the *U.S.S. Enterprise* was called upon to transport Elaan to Troyius for the wedding, Kryton tried to booby trap the *Enterprise*'s engines, which would have caused an explosion if it went to warp. As the *Enterprise* made its way to Troyius, a D7-class vessel appeared, hoping to taunt the Starfleet ship into jumping to warp. Fortunately, Kryton was caught in the act, and the *Enterprise* did not take the bait. Unable to provoke the *Enterprise*, the Klingon ship resorted to an all-out attack. Fortunately, the *Enterprise* crew discovered dilithium crystals in Elaan's radan necklace. This allowed them to restore some warp power, which gave the *Enterprise* a chance to jump to warp, pivot and unleash a full spread of photon torpedoes. This forced the D7 battle cruiser to retreat, and Elaan was delivered to her wedding on Troyius, cementing the alliance between their worlds.

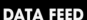

DATA FEED

Mara was the Klingon wife of Commander Kang and the science officer aboard his D7 battle cruiser.

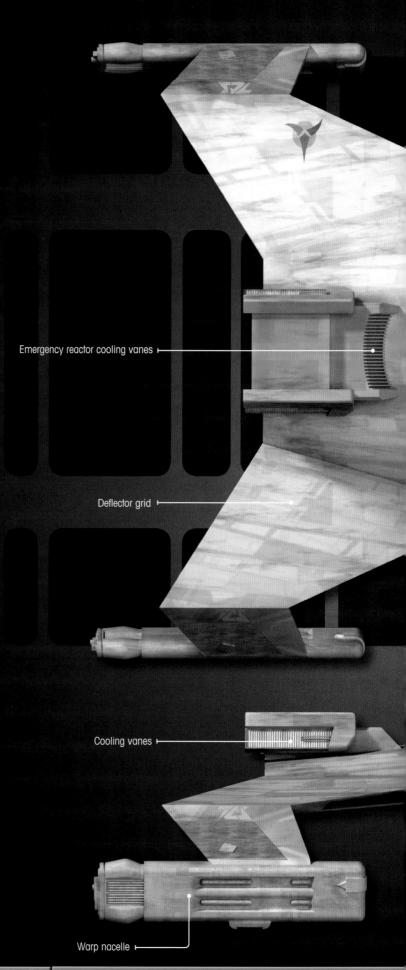

Emergency reactor cooling vanes

Deflector grid

Cooling vanes

Warp nacelle

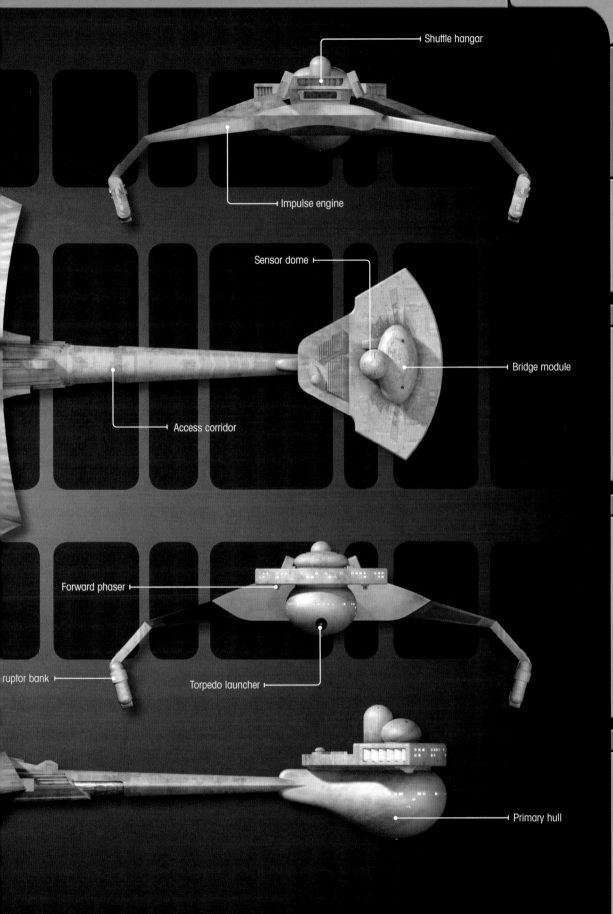

Shuttle hangar

Impulse engine

Sensor dome

Bridge module

Access corridor

Forward phaser

ruptor bank

Torpedo launcher

Primary hull

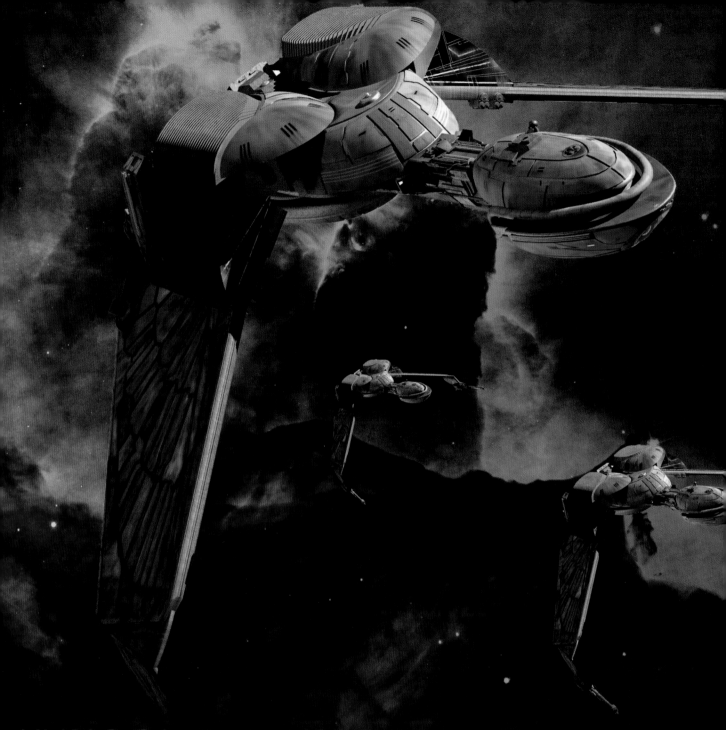

KLINGON DEFENSE FORCE
BIRD-OF-PREY

Over the years, the bird-of-prey was constantly updated and built in a number of different sizes.

◄ The exterior of the bird-of-prey hardly seemed to change in all the years it was in service. This hid the fact that internally no two birds-of-prey were the same. They were suited to different roles from scouting duties to warships, depending on how they were outfitted.

There was no such thing as a standard Klingon bird-of-prey. They were in operation from at least as early as 2285 and were still being used nearly a century later. In that time, there were several variants of the bird-of-prey, while their technology was constantly being improved.

All birds-of-prey were serpentine green in color, and were protected by armor plating. They were also all fitted with a cloaking device, but beyond this there were significant differences between each ship.

From the outside, the bird-of-prey did not appear to change at all, but there were several sizes of this class of vessel, and the most obvious differences were found in their internal layouts.

Commanders could choose how the interior of their bird-of-prey was divided, and the bulkheads were designed to be easily repositioned. Many crews were forced to share cramped quarters so that a disproportionately large area could be used for cargo. The bridges were the area that varied the most, and they could be as different as the men who commanded them. Most notably, some birds-of-prey that were in use in the 2280s featured a periscope-like device on the bridge. This could be used by the commanding officer to target the weapons system himself.

23RD-CENTURY VESSELS

In the 23rd century, all birds-of-prey encountered by Starfleet were approximately 140 meters in length, and operated with a crew of no more than 36. They were also able to move their wings into different positions. In normal flight mode, the ship operated with the wings parallel to the body, but when it was preparing to fight, the wings dropped into an 'attack' position below the main body. The wings were also capable of being raised above the central section, but this was only used when the ship landed on the surface of a planet.

By the 2360s, similar sized birds-of-prey appeared to be called B'rel-type scout vessels. By this point, they had been joined by much larger birds-of-prey that ran anywhere between 230 meters to 680 meters in length. These ships were referred to as K'vort-type cruisers. They had the same basic appearance as the smaller craft, but the spaceframe was scaled up proportionally.

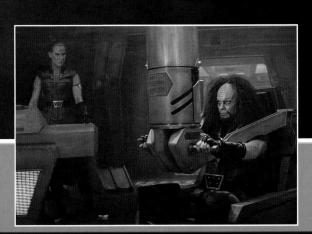

DATA FEED

In 2293, General Chang operated a prototype bird-of-prey, which unlike any other bird-of-prey before or since, could fire photon torpedoes while still cloaked.

◄ The main bridge was the one area where birds-of-prey appeared to differ the most. In the 23rd century, a periscope-like device was seen on some ships, which enabled the commanding officer to take direct control of the targeting of the weapons. No birds-of-prey seen in the 24th century had this design feature.

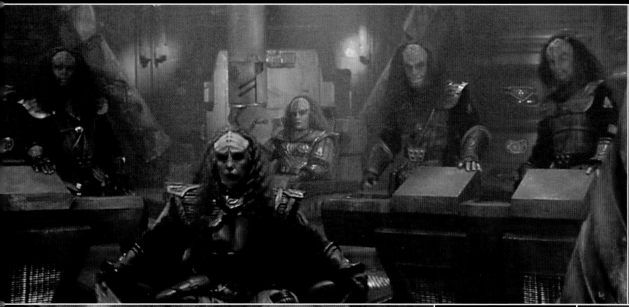

◀ The infamous Duras sisters operated a D12 bird-of-prey from at least 2369 to 2371. By this point, this type of bird-of-prey was considered obsolete because of a design flaw with its plasma coils.

▶ When the wings of a bird-of-prey were in the down position, it was a clear sign that they would attack. The photon torpedo launcher was in the nose of the ship.

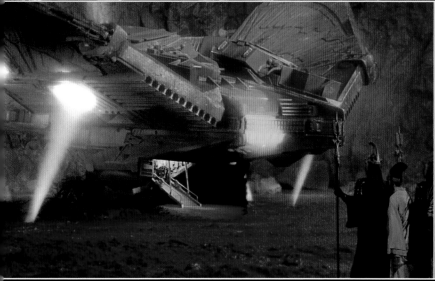

▶ Living conditions inside birds-of-prey were hardly salubrious, but this did not seem to bother the crew. The small dining area inside *B'rel*-type ships was one place where they could gather and really enjoy themselves. They would eat, drink, swap stories and even fight, but this was how they bonded.

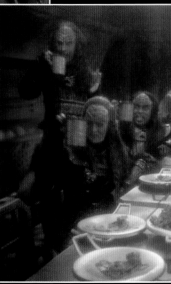

▲ One of the most distinctive features of a bird-of-prey was its ability to articulate its wings into different positions. When it landed on the surface of a planet, its wings moved into a raised position. This allowed the landing pads to extend from the underside of the ship. The crew could then disembark from a ramp that emerged from the rear of the vessel.

K'vort-type birds-of-prey were operated by much larger crews, and some of the bigger ones could accommodate more than 1,000 troops. Both the *B'rel* type and the *K'vort* type were capable of a top speed of warp 9.6, but the *K'vort* type was equipped with more weaponry.

The *B'rel* type featured two wing-mounted disruptor cannons and a torpedo launcher in the nose of the ship, much like the birds-of-prey seen in the 23rd century. Meanwhile, the larger *K'vort* type was equipped with four disruptor cannons located on the tips of the wings and two torpedo launchers.

The only larger *K'vort*-type bird-of-prey that had articulated wings was the *I.K.S. Pagh*, which Commander Riker served on in 2365 as part of an officer exchange program with the Klingons. No

other *K'vort*-type vessel was seen with movable wings, even when they attacked another ship.

Interestingly, there was another type of bird-of-prey known as the *D12*, and at least one example was still in use as late as 2371. This was operated by the Duras sisters, Lursa and B'Etor, but it was at least 20 years out-of-date by this point.

SMALLER TYPE

By the time of the events leading up to the Dominion War, and the war itself, the larger *K'vort*-type bird-of-prey no longer appeared to be in operation. All the birds-of-prey seen from around this time were the smaller *B'rel* type. The most famous of these was the *I.K.S. Rotarran*, which under the command of General Martok became one of the most famous birds-of-prey in Klingon

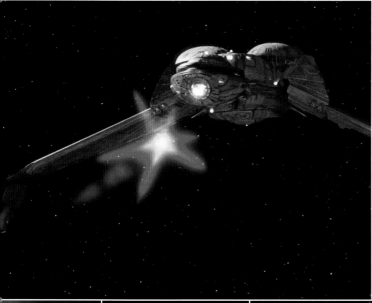

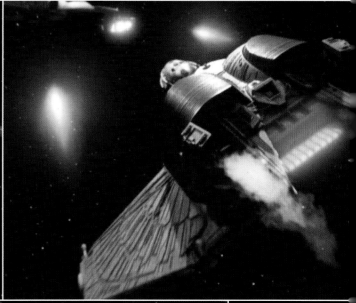

▶ Commander Riker served on a bird-of-prey named the *Pagh* in 2365. He quickly had to learn the Klingon way of doing things on board their ship. This was one of the larger *K'vort*-type vessels, and it was the only one that was seen with its wings in the down position when it was about to attack.

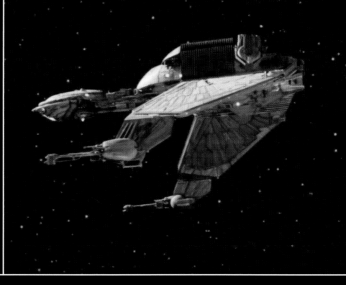

▲ The *Rotarran*, like most birds-of-prey that fought in the Dominion war, was one of the smaller *B'rel*-type ships. As was seen many times during the war, the twin primary disruptor cannons on the wings of these vessels were extremely effective against Jem'Hadar fighters, and could destroy one in as few as three shots.

history. It won many victories in the war, such as when it destroyed a Dominion shipyard at Monac IV against overwhelming odds.

The fact that all birds-of-prey were slightly different proved to be of great significance in the outcome of the Dominion War. It appeared that the Allied fleet had no answer to the energy dampening weapon that was used by the Breen after they joined forces with the Dominion.

Fortunately, one bird-of-prey named the *I.K.S. Ki'tang* proved to be immune to the devastating weapon. This was because their chief engineer had adjusted the tritium intermix to compensate for a warp core containment problem. Without this innovation, which was subsequently rolled out across the Allied fleet, the Dominion would surely have won the war.

DATA FEED

In 2373, General Martok was given his first posting since his escape from a Dominion internment camp, when he was appointed the commander of the *I.K.S. Rotarran*. Things did not go well at first, as Martok appeared to have lost his nerve after his brutal treatment in prison. It was not long though before he regained his spirit. Under his leadership, the *Rotarran* achieved near mythic status for the many battles it won in the Dominion war.

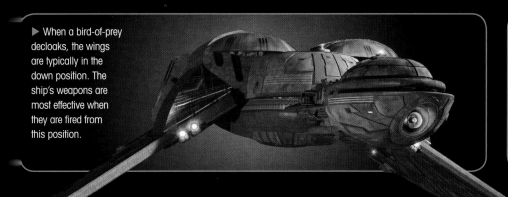

▶ When a bird-of-prey decloaks, the wings are typically in the down position. The ship's weapons are most effective when they are fired from this position.

DATA FEED

Klingon vessels seen in the 22nd century are clearly predecessors of the later bird-of-prey and have a very similar though more basic design. These earlier ships didn't feature cloaking devices, but they were armed with wingtip disruptors.

▲ In normal cruising mode, the bird-of-prey's wings are extended, creating the most efficient shape for the warp fields.

Wing positions

One of the most striking features of the bird-of-prey is its ability to move its wings into different positions each of which gives the ship a different advantage. The wing movements are achieved by using a redundant series of six electromechanical actuators, that are powered by three pairs of medium-power step-down plasma nodes. In flight mode the wings are held parallel to the body of the ship. This maximises the performance of the twin warp fields, which are generated by the superheated plasma that runs through the structure of the wings, where they energize the warp plates. In attack mode the wings are lowered to form

a triangle allowing the crew to concentrate firepower on a single target. In this position, the disruptors can draw on additional, highly-pressurised plasma, from the warp systems, and this significantly increases the destructive yield of the plasma bolts. The disruptors can, of course, still fire regardless of the position the wings are in. Unlike the larger Klingon battle cruisers, the bird-of-prey has also been designed to enter a planet's atmosphere and to set down on the surface, when it does so the crew exit from a ramp in the underside. While the ship is in the landing position the wings are raised enabling the deployment of the landing gear.

▲ A *B'rel*-class bird-of-prey drops its wings into the combat position as it faces off against the *U.S.S. Enterprise* NCC-1701 in orbit around the Genesis Planet. The conflict ended with the crews swapping places as Captain Kirk tricked the Klingons into boarding his ship before setting the *Enterprise* to self destruct. Kirk later boarded and commandeered the Klingon ship, eventually renaming it HMS *Bounty*.

▶ The wings swing up when the bird-of-prey prepares to land on the surface of a planet, allowing the landing gear to be deployed. The wings are not put in this position for any other purpose.

CLOAKING DEVICE

The cloaking device is one of the most important 'weapons' in the bird-of-prey's arsenal. It uses an instantaneous teleportation field around the ship, making it appear as if it isn't there. The technology was developed by the Romulans but was acquired by the Klingons in 2269, who have fitted it to their ships ever since. On the bird-of-prey, the emitter runs around the outside of the nose section and is capable of generating a field that covers the entire ship. The technology evolved constantly to counter improving sensor technology. For example, in the 2290s the Federation managed to detect a cloaked bird-of-prey by tracking its engine emissions.

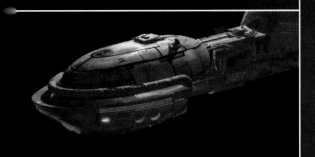

▲ The bird-of-prey's impulse engines generate a bright orange glow that can be easily seen from the back of the ship.

▲ The powerful Klingon disruptors work by firing concentrated bolts of plasma rather than a directed energy beam like a phaser.

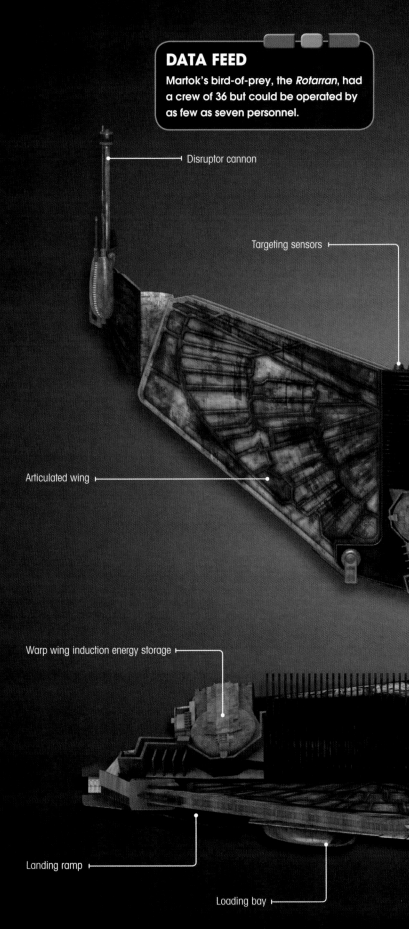

DATA FEED

Martok's bird-of-prey, the *Rotarran*, had a crew of 36 but could be operated by as few as seven personnel.

Disruptor cannon

Targeting sensors

Articulated wing

Warp wing induction energy storage

Landing ramp

Loading bay

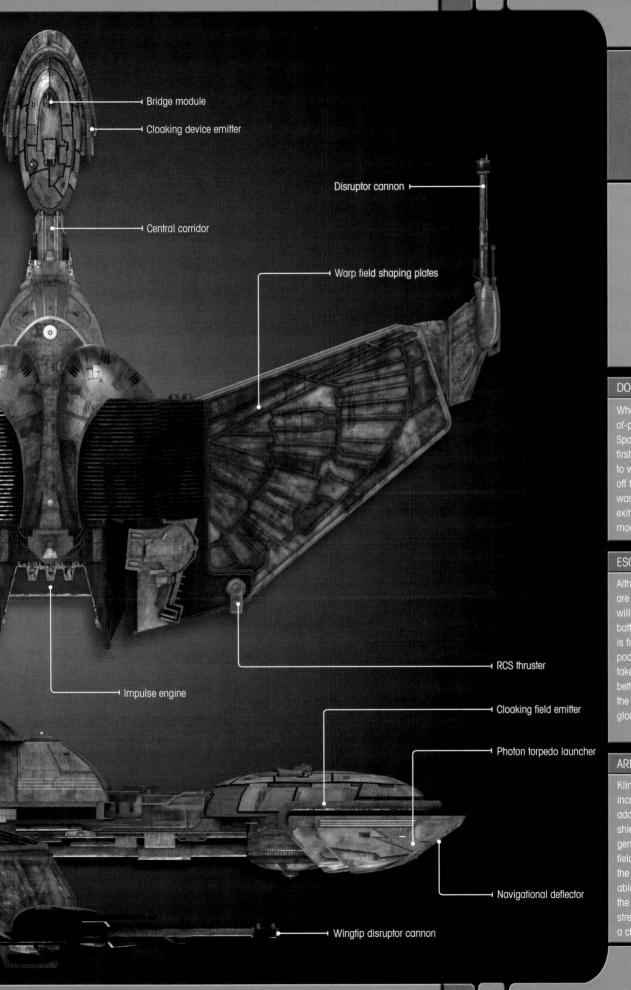

Bridge module

Cloaking device emitter

Central corridor

Disruptor cannon

Warp field shaping plates

RCS thruster

Impulse engine

Cloaking field emitter

Photon torpedo launcher

Navigational deflector

Wingtip disruptor cannon

DOCKING PORT

When a Klingon bird-of-prey docked at Deep Space 9 it did so nose first, allowing the crew to walk directly on and off the station. There was also an emergency exit hatch in the bridge module.

ESCAPE PODS

Although the Klingons are famous for their willingness to die in battle, the bird-of-prey is fitted with escape pods. The Klingons take the view that it is better to live and win the war than to die gloriously in one battle.

ARMOUR PLATING

Klingon ships are incredibly tough and, in addition to conventional shields which work by generating an energy field around the ship, the bird-of-prey had ablative armor, where the hull plating was strengthened by running a charge through it.

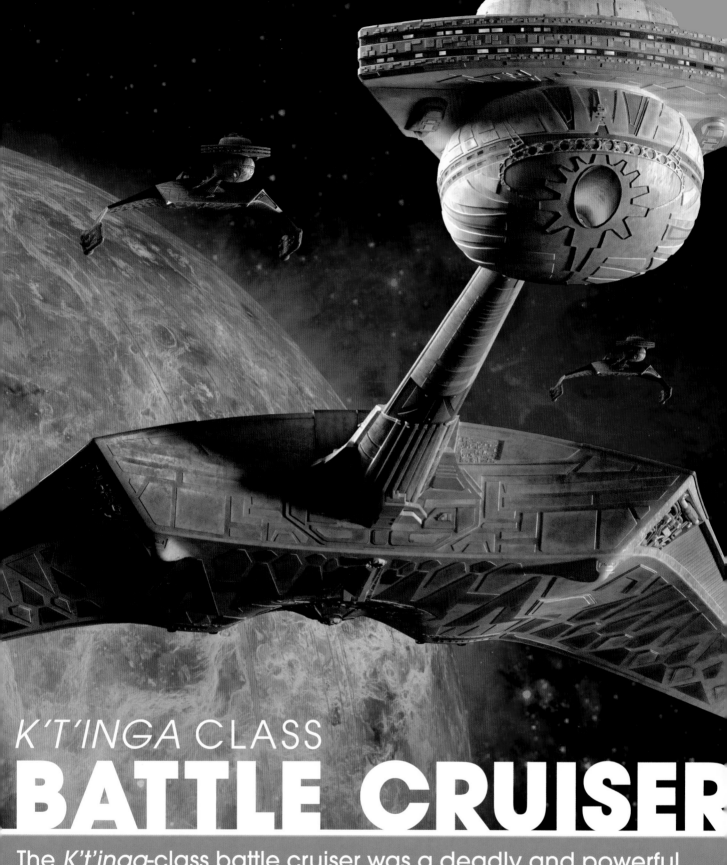

K'T'INGA CLASS
BATTLE CRUISER

The *K't'inga*-class battle cruiser was a deadly and powerful warship that served in the Klingon fleet for over a century.

K'inga-class vessels were formidable Klingon battle cruisers. They were roughly analogous to the *U.S.S. Enterprise* NCC-1701 in terms of both size and firepower when they were on the Klingon front line in the late 23rd century.

At 349.54 meters long and with a standard crew of around 800 personnel, the *K't'inga* class was much larger than the bird-of-prey, the other main class of ship that made up the majority of the Klingon Defense Force in the late 23rd century. *K't'inga*-class vessels were also more heavily armed than the bird-of-prey ships, with fore and aft photon torpedo launchers and six disruptor cannons. Some were also equipped with experimental concussion weapons.

The *K't'inga* class was one of the first types of Klingon vessel to be equipped with cloaking technology which was acquired from the Romulans. The technology meant these ships were unable to fire while still cloaked. Nevertheless, in the days before the Khitomer Accords of 2293 when the Klingons and the Federation signed a peace treaty, a *K't'inga*-class vessel decloaking and suddenly shimmering into view was one of the most feared sights in the Alpha Quadrant, as few ships could match its tactical abilities.

CONFIGURATION AND LAYOUT

K't'inga-class vessels first entered operation around 2271 and were a design evolution of the earlier D battle cruisers, which they were similar to in both size and overall shape. The engineering hull of the ship formed two wings with the warp nacelles hanging down below them on each side. The plasma in the nacelles shined with either a green or, more often, cyan light. An extended neck connected the engineering hull to the command hull and the bridge was a rounded tower mounted on top of this 'cobra' head. Unlike the D7, which was covered in smooth, protective panels, the surface of the *K't'inga* class was much more detailed with features, such as sensors, cargo hatches, and running lights clearly visible.

The interior of the *K't'inga* class was sparse, functional and lean with few concessions given to the comfort of the crew. As a militaristic race with a strict code of honor, the Klingons prided themselves in enduring harsh, almost brutal conditions as they believed it would make them better warriors. For example, the crew quarters aboard a typical Klingon vessel were dark, dingy and consisted of just a shelf recessed into a wall that acted as a bunk. It was made of metal and

DATA FEED

One of the biggest technological revolutions in Klingon ships came in 2268 when the infamous Klingon-Romulan alliance began. The Romulans gave the Klingons access to their cloaking technology and from that point on most Klingon ships have been fitted with cloaking devices, giving them a huge tactical advantage over their Federation counterparts.

◄ Unlike the earlier D7 battle cruisers that had smooth outer panels, the exterior of the *K't'inga*-class vessels had much more surface detail, such as these radiator baffles.

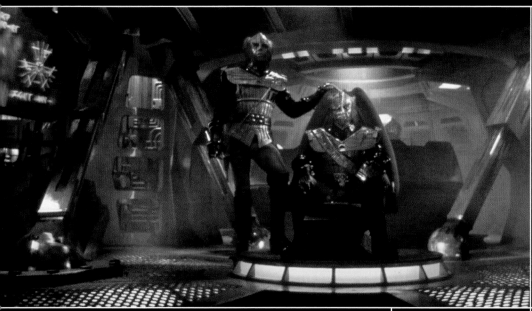

◀ The dimly-lit bridge aboard a *K't'inga*-class vessel was stripped back and lean. The captain sat at the front in isolation with the other bridge consoles located behind in an area separated by large stanchions.

▶ The bridge on *K't'inga*-class ships was located on top of the 'cobra' head at the front of the ship, directly in front of the dome-shaped sensor tower.

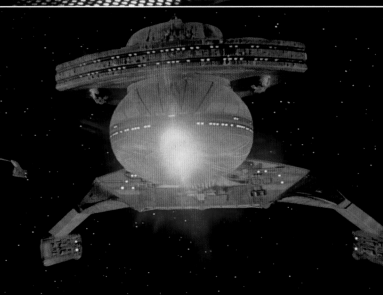

▶ Similar designs of battle cruiser had formed the backbone of the Klingon fleet since the 22nd century, and were commanded by legendary figures such as Kor and Kang. The design was so well regarded that Chancellor Gorkon made one his flagship, *Kronos One*. Most *K't'inga*-class vessels were light gray-green in color, but *Kronos One* had gold accents and maroon paneling, while the plasma in the nacelles gave off a cyan-colored glow.

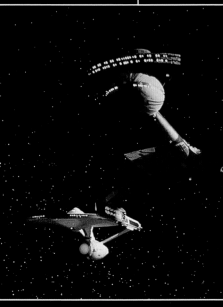

▲ The *K't'inga*-class was fitted with two torpedo launchers, one aft and one in the front section on the lower part of the 'cobra' head as seen above.

had no bedding as Klingons believed it would soften their bodies to put down a pad.

FUNCTIONAL BRIDGE

The bridge of the *K't'inga* class was similarly utilitarian and bathed in red light, which gave it a dark, moody atmosphere. On the earliest models the commanding officer sat in the forward part of the bridge, on a circular raised platform. The area directly around him was completely bare with all the screens and consoles located on the walls. The main viewer was positioned directly in front of the commanding officer's chair and there were also several more monitors surrounding the viewer on which tactical information could be displayed. Two bridge officers sat at stations directly behind the

captain in a raised area that was separated from him by a framed archway. There were two further seated consoles in this area that could rotate so the operators could continue to work and see the various wall-mounted consoles without having to leave their seats.

The *K't'inga* class was the most advanced ship in the Klingon fleet in the late 23rd century as evidenced by the fact that one such ship, named *Kronos One*, served as Chancellor Gorkon's flagship. Other *K't'inga*-class vessels, such as the *I.K.S. T'Ong* were equipped to act as sleeper ships for deep-space exploration missions. The entire crew could be placed in cryogenic suspension, and the automatic systems were programmed to contact the Empire when they awoke.

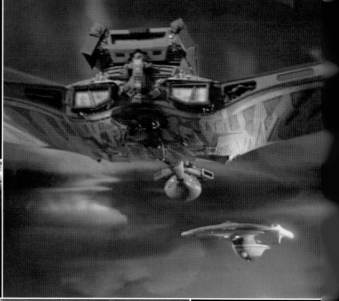

▲ A *K't'inga*-class vessel was easily a match for all Starfleet ships in the late 23rd century in terms of firepower. In fact, their ability to cloak gave them a significant tactical advantage.

◀ Chancellor Gorkon was assassinated in the large stateroom on board *Kronos One* after the ship's artificial gravity had been disabled.

the 2360s the *K't'inga* class had been
[super]seded by the larger and more powerful
[Vor']*cha* class. However, the high attrition rates of
[Fede]ration and Klingon ships during the Dominion
[War] of the 2370s meant that *K't'inga*-class vessels
[had] their operational lifespans extended.
[Ma]ny *K't'inga*-class battle cruisers were retrofitted
[with] advanced technology, including a disruptor
[mount]ed near the forward torpedo launcher. The
[cloa]king device was also upgraded as the old
[cloa]king technology had trouble masking the ship's
[plas]ma ray output. These improvements allowed
[the K]*'t'inga* class to be pressed back into front-line
[servi]ce and play an important part in the Klingon
[Defe]nse Force, one hundred years after they
[were] first introduced.

DATA FEED

The *K't'inga* designation for these ships has never been used in dialogue on screen. The original screenplay on which the script for *STAR TREK: THE MOTION PICTURE* was based referred to these ships as *Koro* class. This was changed to *K't'inga* class in Gene Roddenberry's novelisation of the film. The name was referenced in the *STAR TREK Encyclopedia* as a 'conjectural designation' and has been used ever since for this class of Klingon vessel. *K't'inga* literally translated from Klingon is supposed to mean 'bringer of destruction.'

▲ Areas of the ship, such as the bridge, could be enlarged on the master systems display to give more detailed information.

▲ The display would immediately alert the crew if there was a malfunction to any of the hundreds of systems on board.

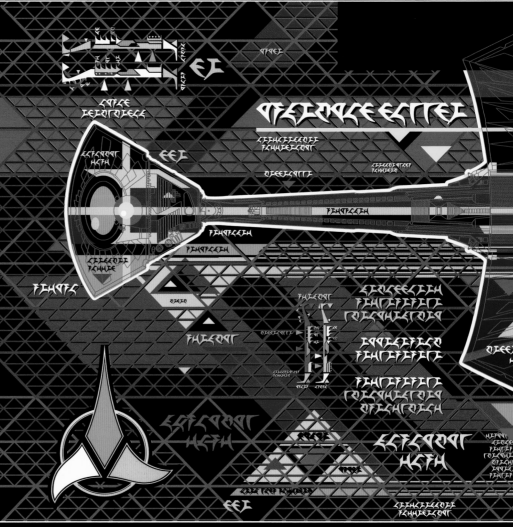

Master systems

J ust as on Starfleet ships, *K't'inga*-class vessels were equipped with a master systems display. This was a large computer console screen, usually mounted on a wall on the bridge or in the engineering section, which featured a large cutaway illustration of the vessel's systems.

The master systems display allowed crew members to monitor the functioning and 'health' of all the ship's major functions, from weapons to life support to the warp engines. The crew could see at a glance the status of the ship's systems and if there were any problems and where they were occurring.

The console also allowed the user to highlight a particular area of the ship and enlarge it. If a problem with one part of the ship was detected by the master fault display, it could be used to repair the system, or, if it was more serious, it could be used to shut the system down while repair teams were sent directly to the site of the malfunction.

Changes and recalibrations of the ship's systems could also be carried out from here depending on the ships's mission. For example, it could be used to reroute more power to the ship's weapons or shields, depending on the position it found itself in.

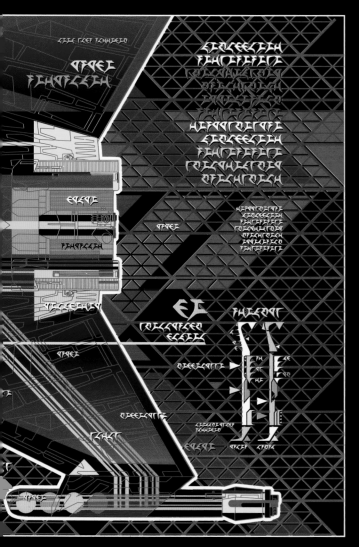

DATA FEED

Klingon consoles were designed for *STAR TREK: THE MOTION PICTURE*. Lee Cole, a production designer, used angular, primitive shapes for the alphabet that he thought embodied the Klingon's militaristic focus. The language's basic sound, along with a few words was devised by actor James Doohan, who played Scotty, especially for *STAR TREK: THE MOTION PICTURE*. The Klingon language was developed further by linguist Mark Okrand for *STAR TREK III: THE SEARCH FOR SPOCK*.

▼ On a Klingon ship the master systems display was normally displayed on the engineering station and provided information about all the ship's systems.

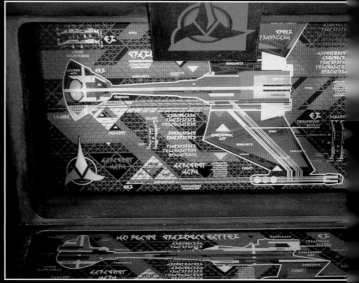

splay

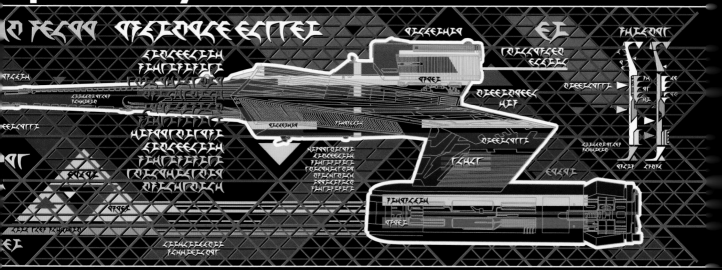

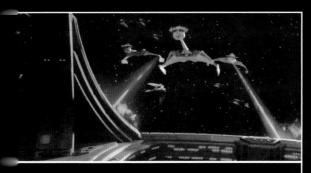

DISRUPTOR CANNONS

K't'inga-class vessels were designed for combat. Unlike Federation starships that were constructed primarily for research and exploration, Klingon vessels were optimised to seek out and destroy enemies of the Empire. In addition to the photon torpedo launchers, *K't'inga* -class vessels were equipped with six disruptor cannons. These directed energy weapons could fire in either a pulse or a continuous beam. A single blast from a disruptor was normally powerful enough to destroy an unprotected ship.

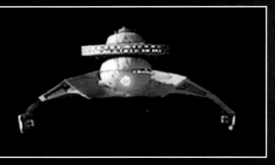

▲ In addition to the disruptor cannons, *K't'inga*-class vessels were equipped with even more destructive photon torpedoes.

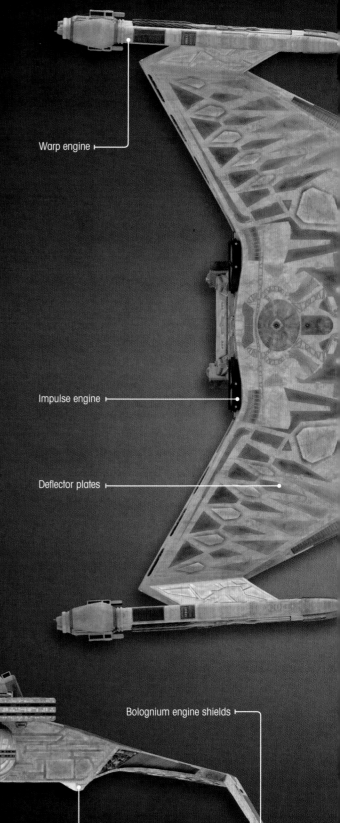

Warp engine ⊢

Impulse engine ⊢

Deflector plates ⊢

Sensor dome ⊢

Bridge ⊢

Bolognium engine shields ⊢

Disruptor weapons ⊢

⊢ Hydrogen ram intake

⊢ Photon torpedo tube

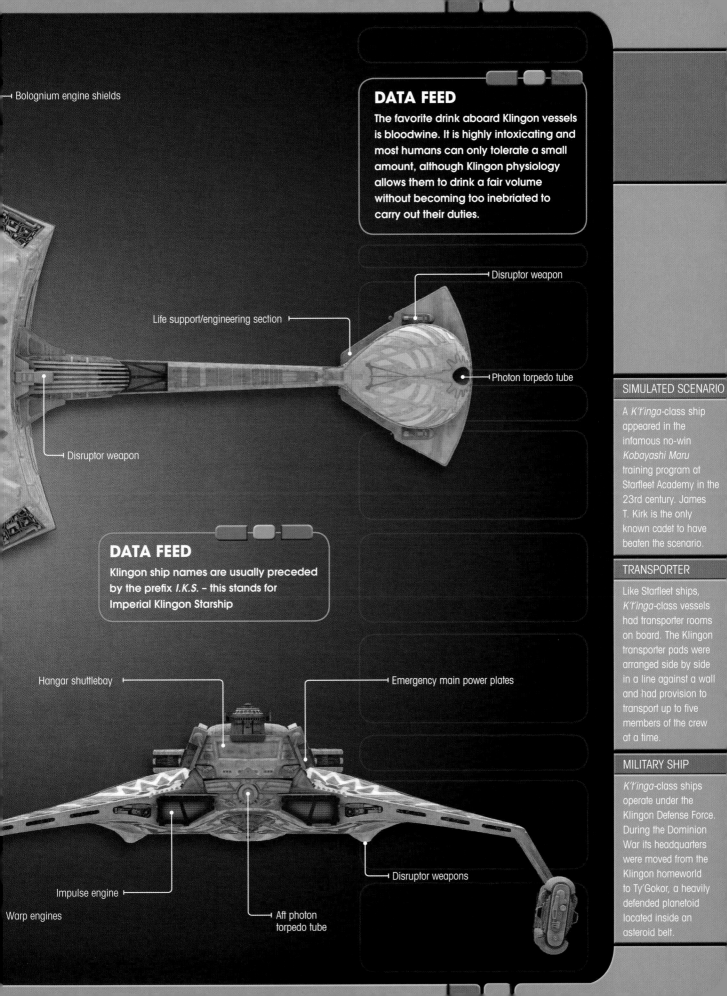

Bolognium engine shields

Disruptor weapon

Life support/engineering section

Photon torpedo tube

Disruptor weapon

Hangar shuttlebay

Emergency main power plates

Impulse engine

Warp engines

Aff photon torpedo tube

Disruptor weapons

SIMULATED SCENARIO

A *K't'inga*-class ship appeared in the infamous no-win *Kobayashi Maru* training program at Starfleet Academy in the 23rd century. James T. Kirk is the only known cadet to have beaten the scenario.

TRANSPORTER

Like Starfleet ships, *K't'inga*-class vessels had transporter rooms on board. The Klingon transporter pads were arranged side by side in a line against a wall and had provision to transport up to five members of the crew at a time.

MILITARY SHIP

K't'inga-class ships operate under the Klingon Defense Force. During the Dominion War its headquarters were moved from the Klingon homeworld to Ty'Gokor, a heavily defended planetoid located inside an asteroid belt.

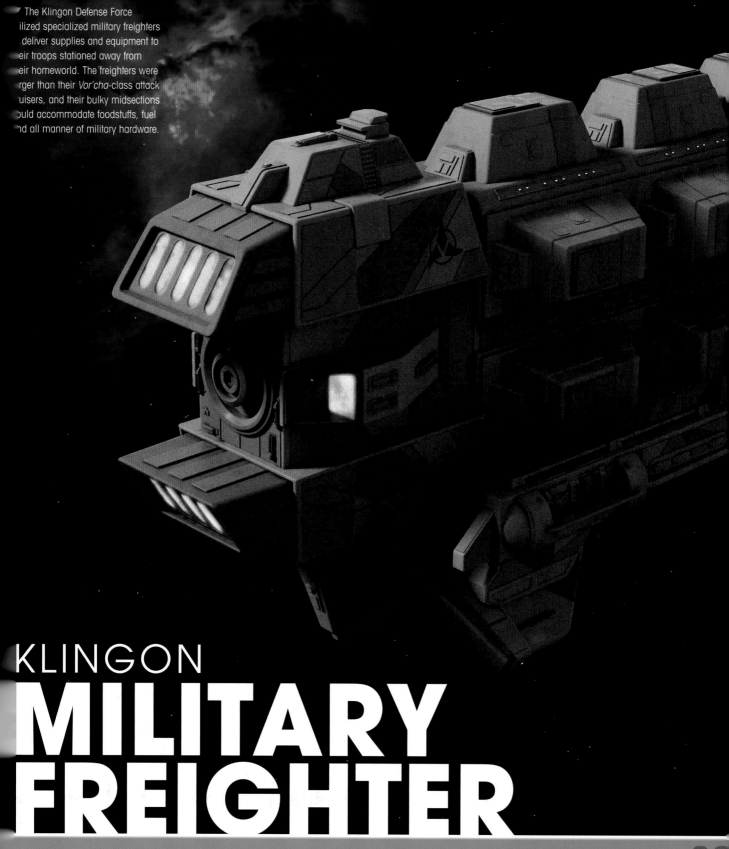

The Klingon Defense Force utilized specialized military freighters to deliver supplies and equipment to their troops stationed away from their homeworld. The freighters were larger than their *Vor'cha*-class attack cruisers, and their bulky midsections could accommodate foodstuffs, fuel and all manner of military hardware.

KLINGON
MILITARY
FREIGHTER

The Klingon military freighter was a large vessel used in the 24th century to transport cargo to fighting forces.

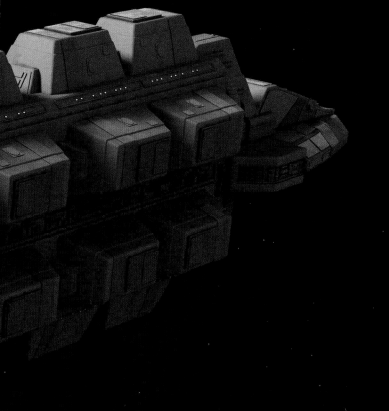

were larger scale versions of personnel transporters, and optimized for inanimate objects, meaning they could transfer a large load of material in one transporter operation.

POWERFUL ENGINES
The freighter utilized two tube-shaped warp nacelles on either side of the rear section, which were short in comparison with the rest of the vessel. Together with the warp engine, they were able to power the freighter to a maximum speed of warp 9 for short periods, but its cruising speed was nearer to warp 6. While its top speed was impressive, the freighter was big and bulky and not very maneuverable. This was not a problem unless it came under attack from starships trying to steal its cargo or stop Klingon troops being resupplied.

If a freighter was attacked, it was equipped to defend itself with several disruptor emitters, but these weapons were not as powerful as those found on dedicated warships like the Vor'cha class and the bird-of-prey. Similarly, the freighter was equipped with deflector shields, but again these were not as robust as those found on front-line Klingon fighting ships.

Freighters were normally used to transport goods and resources between Klingon outposts, but in times of war they became vitally important in keeping supply lines open. During the Dominion

A Klingon military freighter was a type of warp-powered cargo vessel used by the Klingon Empire during the 2370s. It was approximately 500 meters in length, and was mainly used to transport material goods rather than troops or people.

In appearance, it featured a sloping-nose cockpit area at the front, a large cargo area in the middle made up of five identically shaped blocks, and an engineering section at the back. Unlike other Klingon vessels, it did not resemble a predatory bird and was not aggressively styled. It was very much designed from a practical point of view, and its overall shape was boxy to maximize its load-bearing capacity.

Despite its large size, a Klingon freighter was normally operated with only about a dozen crew. There was relatively little for them to do during freight runs, except monitor the ship's navigation, systems and ensure the cargo was safe and secure. Most of the goods were transferred on and off the ship by its cargo transporters. These

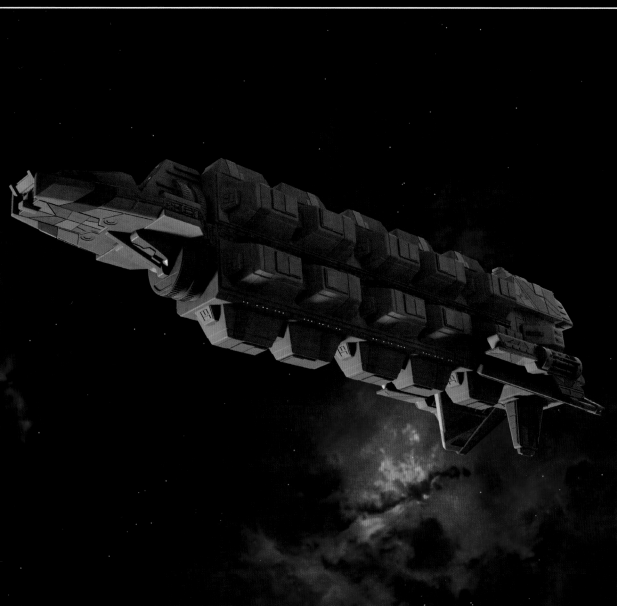

▶ General Martok's bird-of-prey continually swept by the three military freighters as they made their way to Donatu V. Martok wanted to reassure the freighter captain that his ship was on full alert for any signs of a Jem'Hadar attack.

▲ Like the rest of the Klingon fleet, the hulls on their military freighters were colored green. Other than that, the design was somewhat generic and it was not immediately obvious that they belonged to the Klingons. As a freighter, its appearance did not have to strike fear into the hearts of their enemies, but it did need to be fit for purpose.

War, these cargo vessels were essential in transferring much-needed weapons, materials and necessities to fleets and strategic positions to keep their forces fighting.

As the freighters were not fitted with cloaking devices, they were vulnerable to attack by the Jem'Hadar. Often the freighters were raided or destroyed before they could reach their destination, and it became common for them to be accompanied by warships to keep them safe.

In 2374, the *I.K.S. Rotarran*, General Martok's bird-of-prey, was ordered to escort three Klingon freighters to Donatu V. The Jem'Hadar had already destroyed three convoys of Klingon cargo vessels on the way to this planet, and it became vital that the next shipment reached its destination.

Normally, the convoy would have been protected by more than one warship, but the war was stretching Allied resources thin and the *Rotarran* was all the Klingon High Council could spare. Martok described the task as "a vital mission, impossible odds and a ruthless enemy," but he was excited by the challenge.

UNDER ATTACK

Several days into the journey, just as they expected, the convoy was attacked by Jem'Hadar fighters. While in pursuit of one fighter, the *Rotarran* took several hits from another, which caused the Klingon ship to vent plasma from the primary impulse injector. Thanks to Martok's tactical skill and despite the damage, he managed to

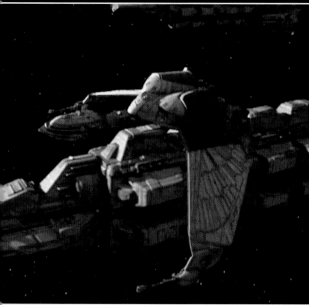

▶ Worf acted as General Martok's first officer when they served on the *I.K.S. Rotarran* together. They needed all their experience to keep the freighters safe, as the Jem'Hadar had destroyed the three previous convoys.

▼ The *Rotarran* fired its disruptor weapons on the starboard nacelle of one of Jem'Hadar fighters. As the enemy ship flew towards the convoy, it exploded in a huge ball of flame.

◀ Two Jem'Hadar fighters launched an attack on the three military freighters. Fortunately, the shields of the cargo ships held firm and the supplies that were being transported remained undamaged. The *Rotarran* was quick to defend the convoy and soon had one the fighters in its sights.

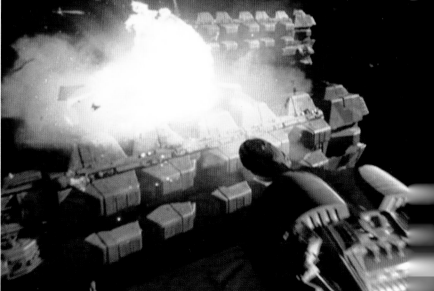

position the *Rotarran* off to the starboard side of one of the Jem'Hadar's fighters and blast its nacelle, which caused it to explode.

Alexander Rozhenko, Worf's son, was sent to repair the plasma leak before the injector exploded. Meanwhile, Martok gave the order to rapidly decelerate, which caught the pursing Jem'Hadar ship unawares and it flew past, giving the *Rotarran* the chance to fire its disruptors at it from point-blank-range. The Jem'Hadar fighter erupted into a ball of flames, and Alexander managed to seal the impulse injector.

The convoy was then able to continue on its way, and the *Rotarran*, although battered from the dogfight, successfully safeguarded all three freighters to Donatu V without further incident.

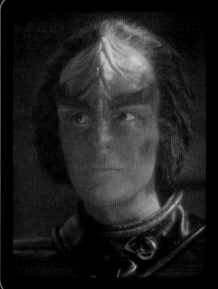

DATA FEED

Alexander Rozhenko was one of several young recruits who were assigned to the *I.K.S. Rotarran* just prior to its mission of protecting the Klingon freighters. Alexander was Worf's son and he had spent much of his youth living with Worf's adoptive human parents. As a result, his combat skills were sorely lacking and the Klingons on the *Rotarran* considered him soft and weak. His crew eventually accepted him, however, while Worf resolved to make him a better warrrior.

PROTECTION DETAIL

Keeping supply lines open was vitally important in the Dominion War. In the early months of the conflict, Allied forces suffered catastrophic losses at the hands of the Jem'Hadar. Fighting was relentless, and Allied troops and ships constantly needed resupplying. Without weapons, replacement starship parts and basic food necessities that were brought to strategic positions by military freighters, the Allies would have quickly lost the war.

One of the crucial Klingon outposts in keeping the Dominion from advancing was Donatu V. Three separate convoys of Klingon freighters carrying essential supplies there had been destroyed by the Jem'Hadar. This caused the outpost to be dangerously low on all sorts of equipment and provisions, meaning it would soon be overrun by the Dominion.

Fortunately, due to the heroic efforts of the crew of the *Rotarran*, who saw off an attack by Jem'Hadar fighters, the next convoy of freighters made it to Donatu V. The outpost was thus resupplied and the forces based there were able to continue the fight.

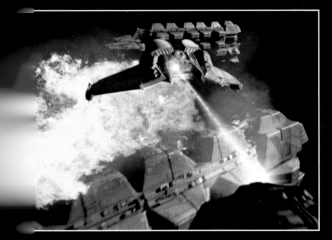

▲ Life for the crews of Klingon freighters was incredibly dangerous during the Dominion War as their ships were often attacked by the Jem'Hadar, but the *Rotarran* saved one convoy on its way to Donatu V.

DATA FEED

The Klingons also operated civilian transport ships in the 24th century. As their name implied, they were used to transfer people, rather than cargo, and could accommodate at least 440 individuals.

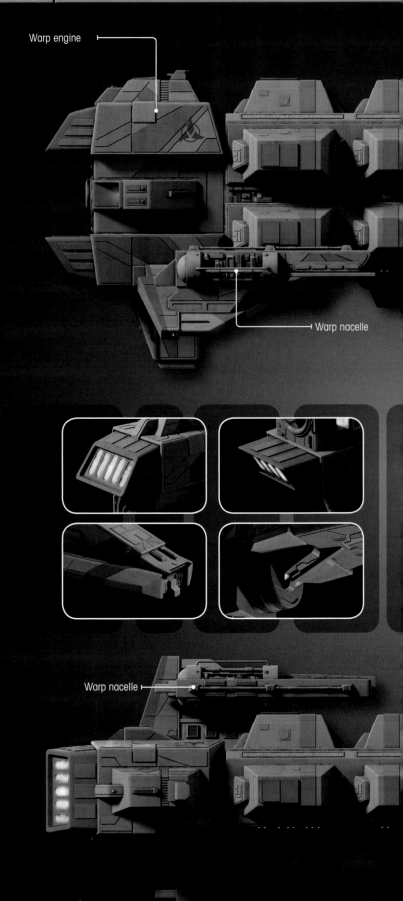

Warp engine

Warp nacelle

Warp nacelle

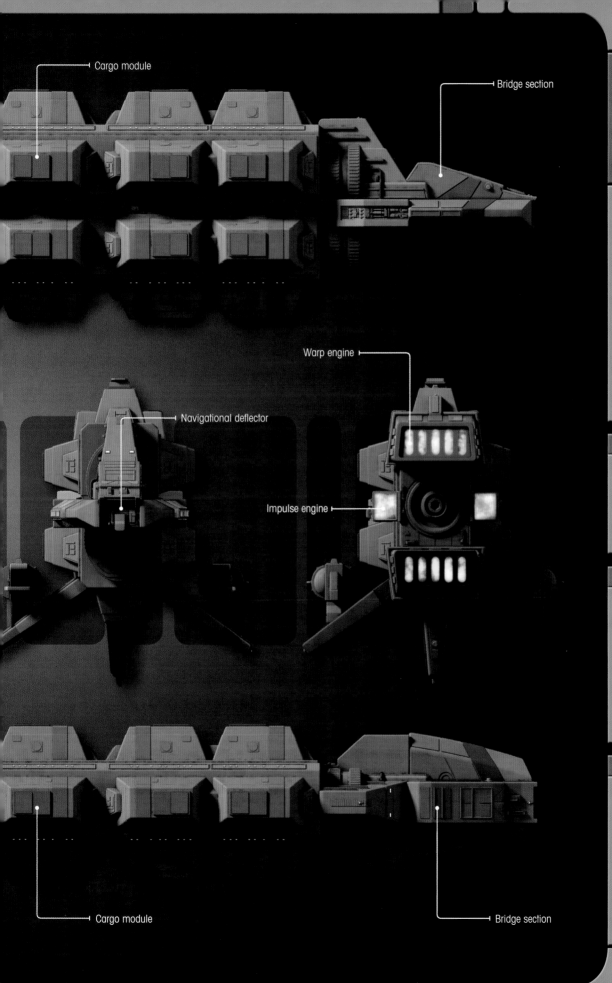

Cargo module

Bridge section

Warp engine

Navigational deflector

Impulse engine

Cargo module

Bridge section

FREIGHTER NAME

One of the three Klingon
military freighters that
was successfully
escorted to Donatu V by
the *Rotarran* was named
the *I.K.S. Par'tok*.

PLANETARY DISPUTE

Donatu V was located
not far from Deep Space
Station K-7, where
there was trouble with
tribbles, and Sherman's
Planet. Ownership of
this planet was disputed
between the Federation
and the Klingon Empire
during the 23rd century.

KLINGON SPIES

Three Klingon
intelligence operatives
named Bo'rak, Atul and
Morka arrived at Deep
Space 9 on a Klingon
freighter in 2371. They
claimed their ship had
developed a computer
error, but they had really
be sent to spy on a
Romulan delegation.

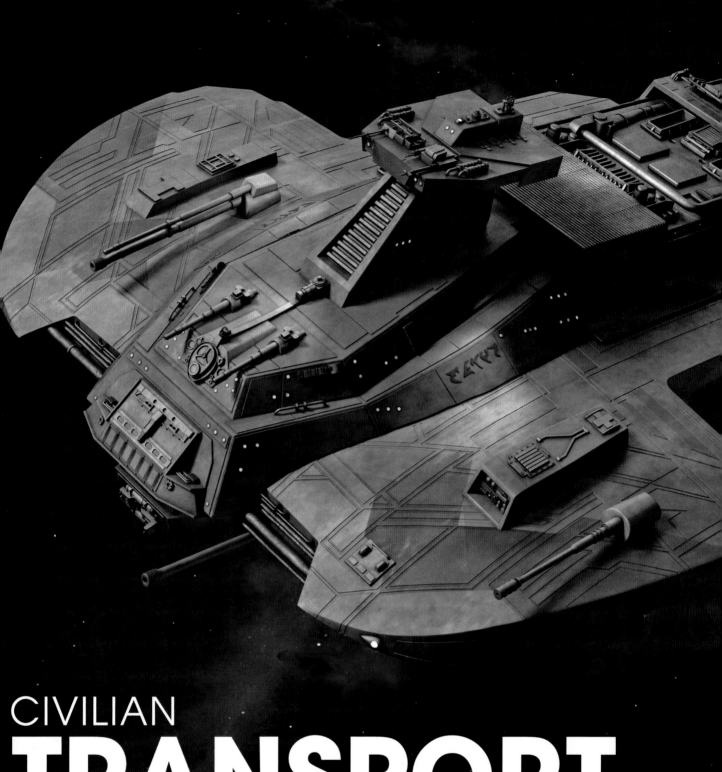

CIVILIAN
TRANSPORT

A Klingon civilian transport ship was at the heart of a conspirac[y]
to discredit a Federation officer during a period of hostilities.

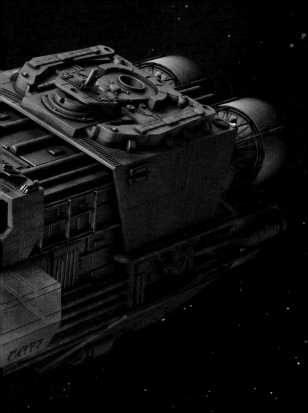

Military ships of the Klingon fleet were among the most feared and recognizable vessels in the Galaxy. Klingon civilian vessels, however, were less distinctive, providing a more functional, serviceable design for the transport of non-military citizens of the Empire.

Klingon civilian transports were often mistaken for other, similar transport ships outside the Empire, a marker of their design for function rather than combat efficiency. They were of a long, slender configuration with a pronounced forward section. The bridge was seemingly located in a tower ranged above a primary hull, marked out by the swept-up wings adding to the bulbous appearance of the ship's forward section.

Although unremarkable of design, in 2372, a civilian transport became involved in a battle with the U.S.S. Defiant, which was engaged in skirmish with a Klingon bird-of-prey and a K't'inga class cruiser during a convoy mission. The civilian transport decloaked directly in front of the Defiant as its commander, Lieutenant Commander Worf, ordered a barrage of quantum torpedoes. The transport was destroyed, apparently killing all 441 civilians on board. It was declared a massacre by the Empire.

The incident was the catalyst for an extradition hearing against the Federation's Klingon officer; however, the work of Captain Benjamin Sisko and his security chief uncovered a conspiracy to dishonor Worf. The civilian transport ship was empty; the passenger manifest of those who were killed, provided as evidence to the hearing, was identical to that of the passengers who perished when another transport crashed on Galorda Prime three months previously. Had the ploy succeeded, it would have seen Worf's extradition to Qo'Nos and provided opportunity for the Klingon Empire to annex more sectors of Cardassian territory during the Klingon-Caradassian War.

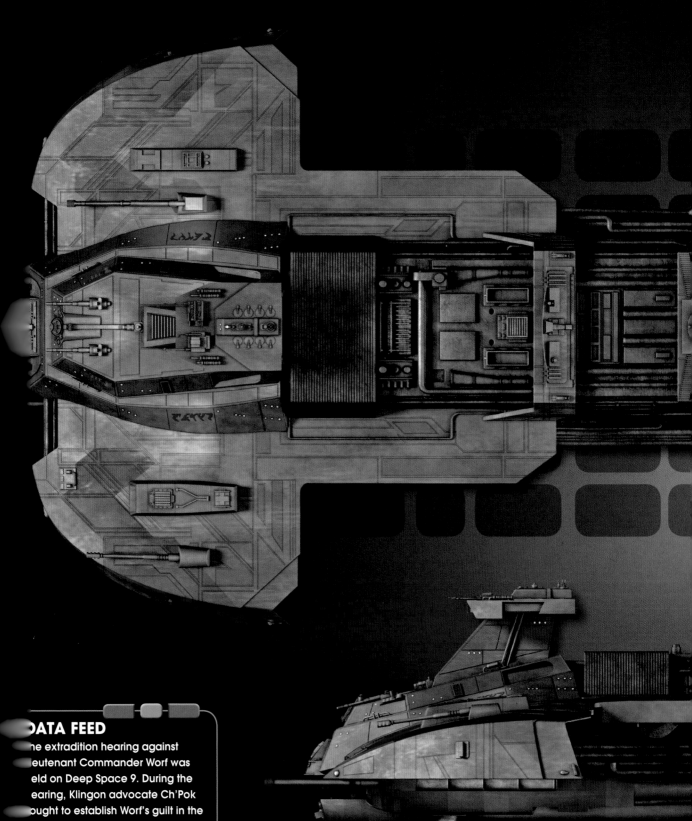

DATA FEED

The extradition hearing against Lieutenant Commander Worf was held on Deep Space 9. During the hearing, Klingon advocate Ch'Pok sought to establish Worf's guilt in the massacre of the civilians aboard the transport ship.

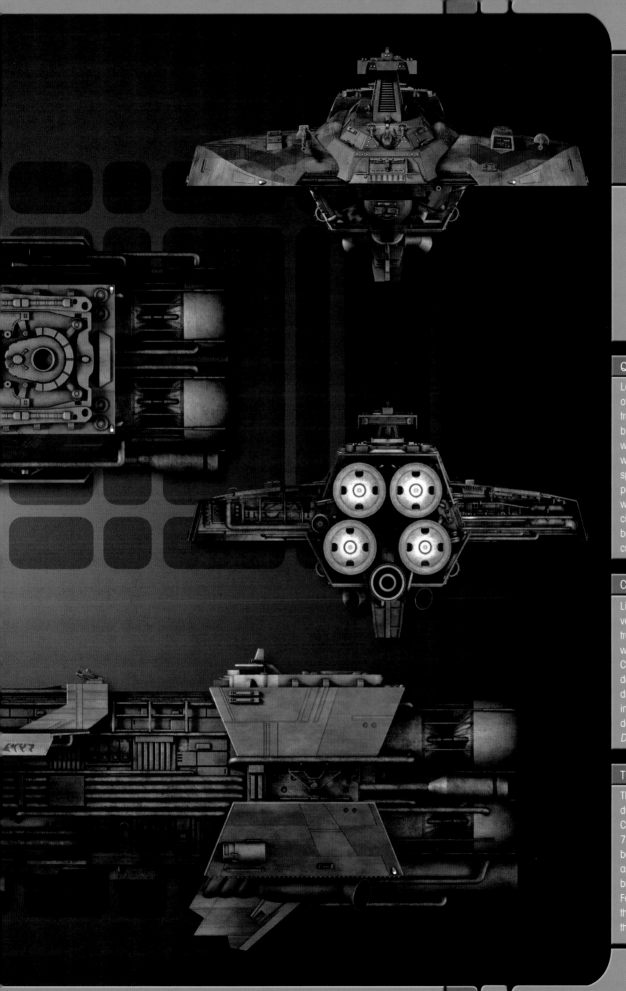

QUAD ENGINES

Located at the aft section of the ship, the civilian transport was powered by quad engines and was capable of both warp and sub-light speeds. Its total passenger capacity was unknown but 441 civilian Klingons were on board during the original crash on Galorda.

CLOAKING DEVICE

Like most Klingon vessels, the civilian transport was equipped with a cloaking device. Chief Miles O'Brien detected a tachyon surge during the battle that indicated a ship was decloaking ahead of the *Defiant*.

TIME OF WAR

The incident took place during the Klingon-Cardassian War of 2372-73 in which the alliance between the Federation and Klingon Empire broke down due to the Federation's support of the Cardassians during this period.

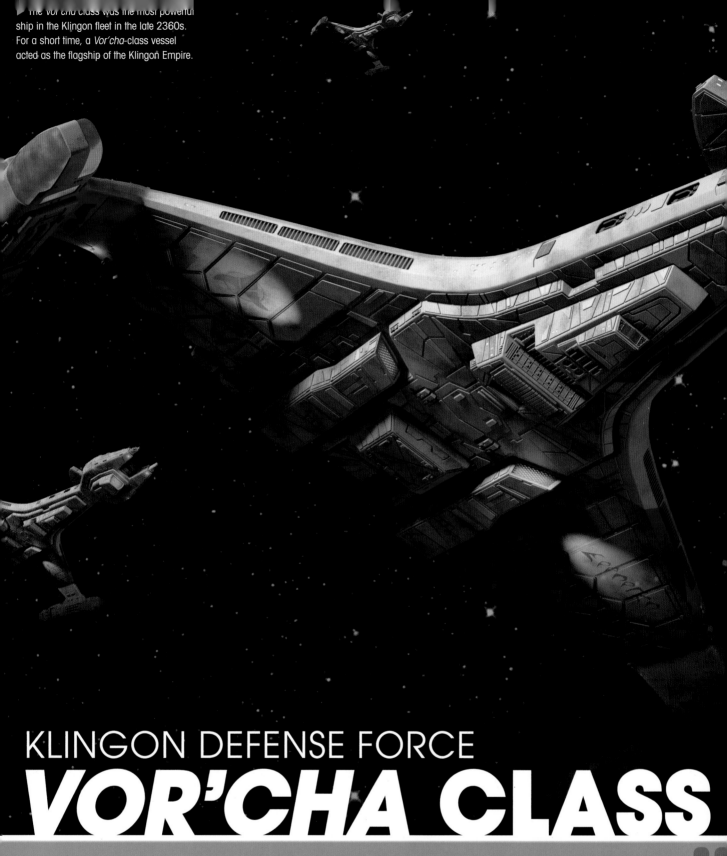

The *Vor'cha* class was the most powerful ship in the Klingon fleet in the late 2360s. For a short time, a *Vor'cha*-class vessel acted as the flagship of the Klingon Empire.

KLINGON DEFENSE FORCE

VOR'CHA CLASS

The *Vor'cha* class was a Klingon attack cruiser that saw action in several conflicts in the 24th century.

Although the *Vor'cha* class was of unmistakably Klingon design, it differed from their earlier classes of ship in several ways. The most obvious difference was a much flatter front head section. This contained a forked nose featuring the ship's primary disruptor cannon: an enormously powerful weapon that was capable of firing solid or intermittent disruptor beams. Other differences included a much thicker connecting neck between the front bridge module and main body, while there was also much more surface detail all over the hull, with heavy armor plate panels and slotted radiator blocks clearly visible.

The Klingon Defense Force added the powerful *Vor'cha*-class attack cruiser to their fleet in the latter half of the 24th century. This new, more advanced class of starship was designed to replace the aging *K't'inga*-class battle cruiser that entered service nearly one hundred years earlier in the 2270s. At 481.32 meters in length, the *Vor'cha* class was more than 130 meters longer than its predecessor and could accommodate a crew numbering as many as 1,900 personnel.

The overall design of the *Vor'cha* class was very recognizable as it incorporated the same basic shape as earlier Klingon ships, such as the D7 and *K't'inga*-class battle cruisers. Like them, the bridge module at the front was separated from the main body by a long neck that flared out into wings, which contained the warp nacelles.

SHARED TECHNOLOGY

A lasting period of peace between the Federation and the Klingon Empire following the Khitomer Accords of 2293 saw a sharing of technologies. This ultimately led to some aspects of Starfleet ship design translating into the hardware used in the construction of the *Vor'cha* class. This was most notable in the look and shape of the canted warp nacelles that featured Bussard collectors on the front of them.

The hull of the *Vor'cha* class was, at first, colored a much lighter green than the gritty, dark green of the *B'rel*-class bird-of-prey that was in service at the same time. This changed in the mid 2370s as more *Vor'cha*-class ships entered active duty and their color reverted to the darker green seen on other classes of Klingon ships.

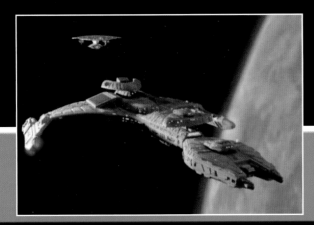

DATA FEED
Vor'cha-class ships made up part of the Ninth Fleet during the Dominion War. This was a combined force of Alpha Quadrant ships led by General Martok.

◄ An exchange of technology between the Federation and the Klingons resulted in a new warp nacelle design on the *Vor'cha* class. Earlier Klingon ships featured rectangular nacelles that emitted a green or cyan color, but they were now more rounded and featured red Bussard collectors on the ends.

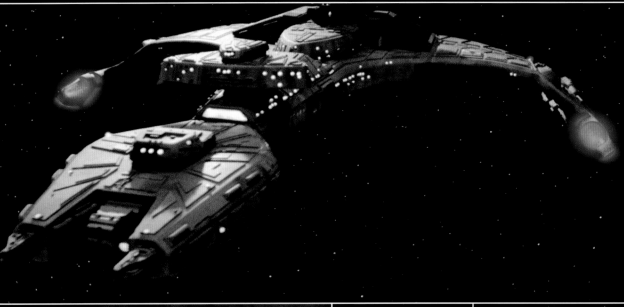

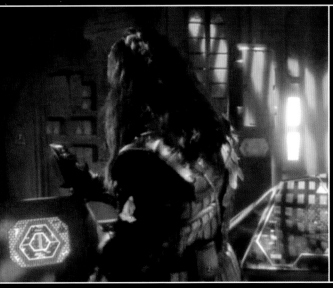

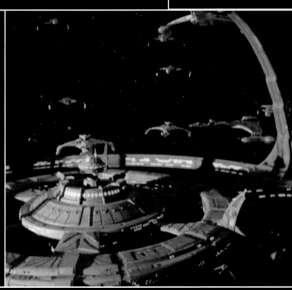

▲ The overall aggressive look of the Vor'cha class was matched by its fearsome firepower. The outer hull was also clad in heavy armor plating. By the time of the Dominion War many Vor'cha-class ships had feathers painted on their hulls.

▶ Several Vor'cha-class ships were part of a fleet that launched an attack on Deep Space 9 in 2372, bringing an end to the Khitomer Accords.

▲ Many of the ship's functions could be accessed from an unmanned computer control room that was filled with consoles. The Klingon defense system database could also be accessed from here.

As with earlier Klingon vessels, Vor'cha-class ships were equipped with cloaking devices that rendered them invisible to the naked eye and sensors, although they still could not fire when cloaked.

The interior of the Vor'cha class was much more spacious than other Klingon ships and featured at least 26 decks, although furnishings and decor were spartan as befitted the Klingon belief that harsh living conditions made them better warriors.

An armory was located in the upper half of the ship, and main engineering, which contained the reactor core, was on deck 26. Vor'cha-class ships also featured a computer control room that was normally unmanned. Given its importance, entry to the room was only possible through a DNA-based hand print verification lock. The computer consoles inside could be used to access the navigational

control systems and the Klingon defense system database. These records also contained false files and databases of disinformation in the event that they were accessed by enemy spies.

VOR'CHA IN ACTION
Starfleet's earliest recorded encounter with a Vor'cha-class ship occurred in 2367 when one was serving as Chancellor K'mpec's flagship. It surprised the crew of the U.S.S. Enterprise NCC-1701-D by decloaking next to it while both ships were in the Gamma Arigulon system. The reason for the clandestine approach soon became apparent when K'mpec revealed that he was slowly being poisoned and wanted Captain Picard to act as the Arbiter of Succession when the Klingon High Council met to decide their next leader.

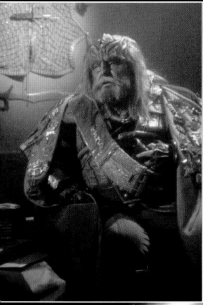

◄ When Chancellor K'mpec realised that he was dying he held talks with Captain Picard about his concerns for the future of the Klingon Empire aboard his flagship Vor'cha-class vessel.

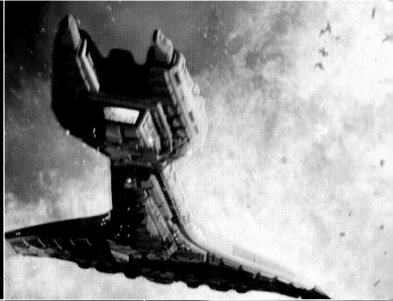

▶ Vor'cha-class ships were often in the thick of the action during the battles that raged in the late 24th century. They proved vital in protecting their Empire.

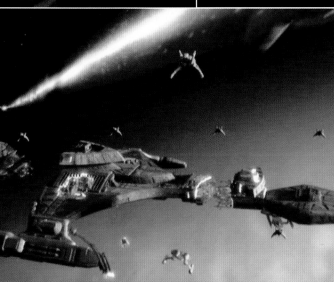

◄ Several Vor'cha-class ships were destroyed in suicide runs by Jem'Hadar ships in the First Battle of Chin'toka, but their sacrifice was not in vain. By this point they made up a significant part of the Klingon fleet.

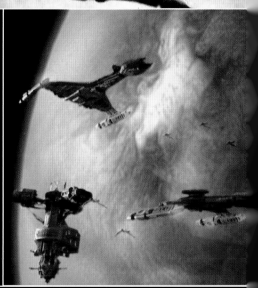

▶ In 2373, the Klingon military headquarters was moved to Ty'Gokor, a heavily fortified planetoid protected by dozens of warships.

In 2367, the Vor'cha-class I.K.S. Bortas served as Gowron's flagship during the Klingon Civil War. By 2371, the Klingons had introduced another new class of ship, the Negh'Var warship. This was similar to the Vor'cha class in appearance, but was even larger and more powerful, and as such, it took over as the flagship class of the Klingon Imperial Fleet.

Despite the introduction of the Negh'Var class, the production of Vor'cha-class ships was stepped up and they became a strong presence during the Klingon-Cardassian War of 2372-2373 and the subsequent attack on Deep Space 9 that precipitated a brief Federation-Klingon War.

The Vor'cha class also played a vital part in the Dominion War, seeing action in most of the major battles of the conflict, including the final victorious showdown during the Battle of Cardassia.

DATA FEED

Gowron, who became Chancellor of the Klingon High Council, used the Vor'cha-class I.K.S. Bortas as his flagship during the Klingon Civil War of 2367-2368. Worf briefly served as weapons officer aboard the Bortas during the early part of that conflict. The Bortas came under surprise attack from ships loyal to the House of Duras, but it survived thanks to the assistance of the I.K.S. Hegh'ta commanded by Worf's brother Kurn.

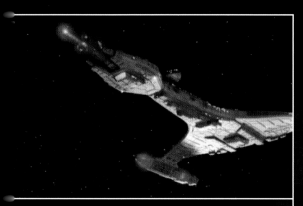

SHIP OF WAR

The *Vor'cha*-class attack cruiser was the most advanced type of ship in the Klingon fleet during the 2360s. As befitting its status, it was often used to transport Klingon dignitaries, but it was principally designed for combat. It was highly maneuverable for a large ship and equipped with a vast array of weaponry, including torpedo launchers and disruptor cannons. Its main weapon was a disruptor cannon in the 'nose' of the ship that was powerful enough to destroy a heavily fortified subterranean base. *Vor'cha*-class ships were involved in numerous conflicts in the latter half of the 24th century, most notably helping the Federation Alliance that defeated the Dominion.

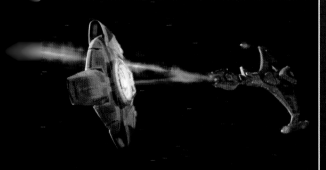

DATA FEED

The *Vor'cha* class's secondary hull was composed of duranium alloy. This extremely strong metallic substance was used in the hull construction of starships from numerous races, including humans, Cardassians, Ferengi and Andorians.

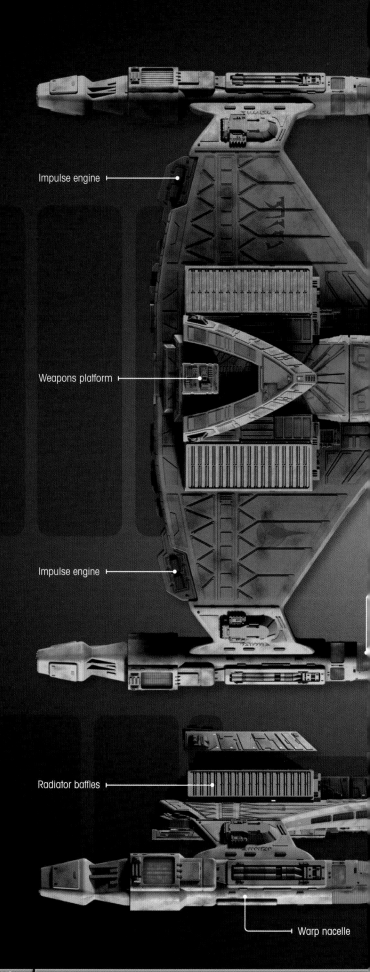

Impulse engine

Weapons platform

Impulse engine

Radiator baffles

Warp nacelle

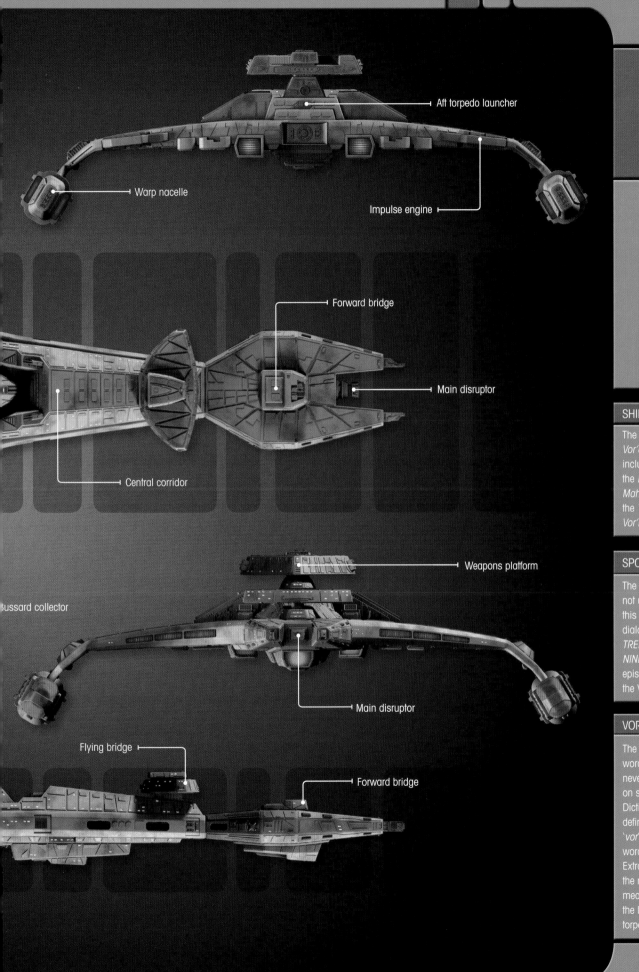

Aft torpedo launcher

Warp nacelle

Impulse engine

Forward bridge

Main disruptor

Central corridor

Weapons platform

Bussard collector

Main disruptor

Flying bridge

Forward bridge

SHIP NAMES

The names of some *Vor'cha*-class ships include the *Bortas,* the *Drovana,* the *Maht-H'a,* the Qu'Vat, the *Toh'Kaht* and the *Vor'nak.*

SPOKEN WORD

The name *Vor'cha* was not used to describe this class of ship in dialogue until the *STAR TREK: DEEP SPACE NINE* fourth season episode 'The Way of the Warrior.'

VOR'CHA MEANING

The meaning of the word *Vor'cha* was never explicitly stated on screen. The Klingon Dictionary gives the definition of the word 'vor' as 'cure' and the word 'cha' as 'torpedoes.' Extrapolating from this, the name *Vor'cha* could mean something along the lines of 'to cure with torpedoes.'

▶ Noggra's Klingon shuttlecraft docked at the Federation space station Deep Space 9 sometime around stardate 49556.2.

KLINGON
TRANSPORT 2372

The Klingon Noggra traveled on a mercy mission to Deep Space 9 in his shuttle craft to honor an old friend.

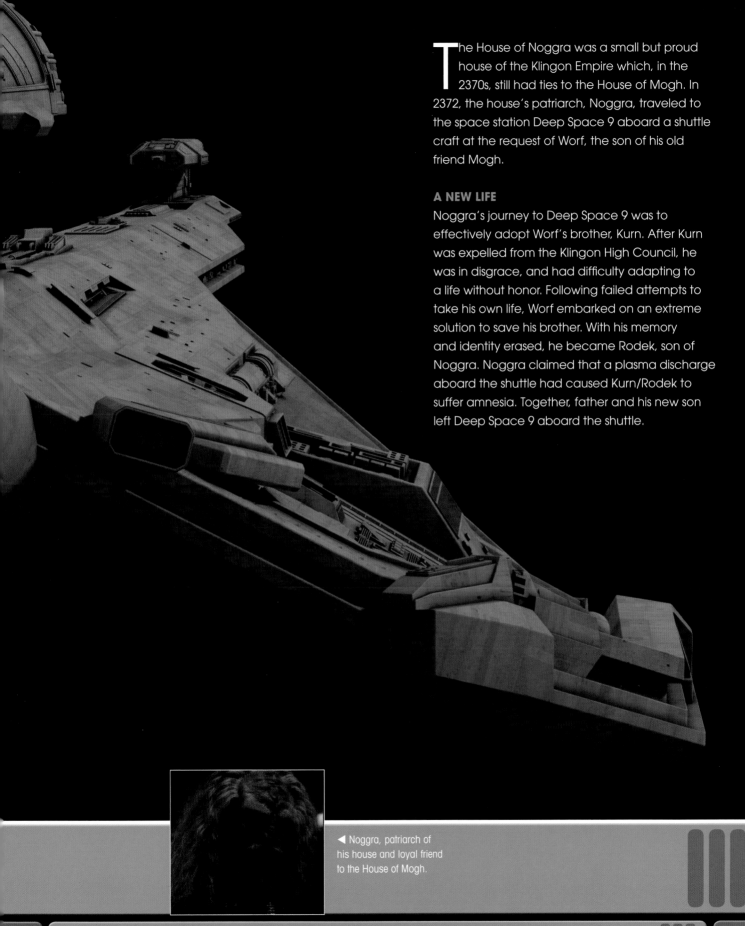

The House of Noggra was a small but proud house of the Klingon Empire which, in the 2370s, still had ties to the House of Mogh. In 2372, the house's patriarch, Noggra, traveled to the space station Deep Space 9 aboard a shuttle craft at the request of Worf, the son of his old friend Mogh.

A NEW LIFE

Noggra's journey to Deep Space 9 was to effectively adopt Worf's brother, Kurn. After Kurn was expelled from the Klingon High Council, he was in disgrace, and had difficulty adapting to a life without honor. Following failed attempts to take his own life, Worf embarked on an extreme solution to save his brother. With his memory and identity erased, he became Rodek, son of Noggra. Noggra claimed that a plasma discharge aboard the shuttle had caused Kurn/Rodek to suffer amnesia. Together, father and his new son left Deep Space 9 aboard the shuttle.

◀ Noggra, patriarch of his house and loyal friend to the House of Mogh.

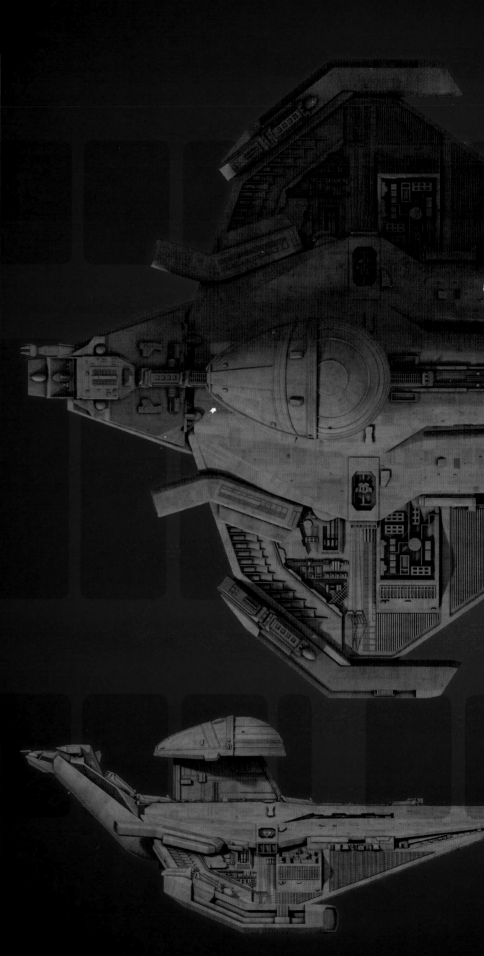

HONORABLE SOLUTION

After Kurn's dishonour and the enforced dissolution of the House Mogh, Worf realised the only solution for his younger brother was a complete change of identity. Renamed Rodek, his face, as well as his mind, was altered and he began a new life, no longer knowing his origins or his family.

DATA FEED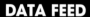

The shuttle used by Noggra – which docked at one of Deep Space 9's upper pylons – was of a standard configuration that had clear lineage to classic Klingon ship design. This was evident in the green hue of the hull plating and the long neck section tapering forward in a strut to the forward nose section.

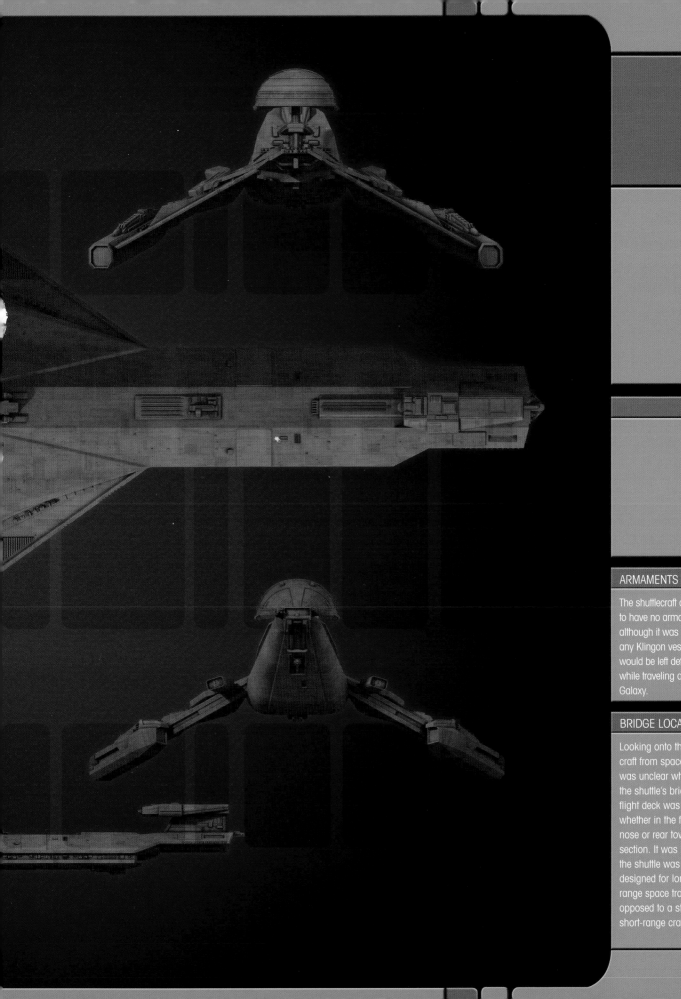

ARMAMENTS

The shuttlecraft appeared to have no armaments, although it was unlikely any Klingon vessel would be left defenseless while traveling across the Galaxy.

BRIDGE LOCATION

Looking onto the shuttle craft from space, it was unclear where the shuttle's bridge or flight deck was located, whether in the forward nose or rear tower section. It was likely the shuttle was designed for longer-range space travel as opposed to a standard short-range craft.

▲ Similarly styled to the smaller *Vor'cha*-class attack cruisers, the *I.K.S. Negh'Var* was more of a warship. What it lacked in maneuverability, it more than made up for in firepower, and there were few ships that could outgun it. The *I.K.S. Negh'Var* was the first ship of its type, but a few years after its introduction, several more *Negh'Var*-class vessels had joined the Klingon fleet.

KLINGON DEFENSE FORCE

I.K.S. NEGH'VAR

Launched in 2372, the *I.K.S. Negh'Var* was hugely powerful and the new flagship of the Klingon Empire.

The Klingons embarked on a major starship building program in the latter half of the 24th century to replace their aging fleet of *K't'inga*-class vessels. First, they introduced the 481 meter long *Vor'cha*-class attack cruiser in around 2367, and then the even larger 686 meter long *I.K.S. Negh'Var* warship was added to their fleet in 2372. This prodigious vessel served as the flagship of the Imperial Fleet, and appeared to be the only ship of its class for a time, although by 2375 there were multiple *Negh'Var* warships in service.

As befitting the pride of the Imperial Fleet, the *Negh'Var* was a mightily impressive and intimidating vessel. It could accommodate a crew numbering as many as 2,500 personnel, and it boasted more firepower than just about any other ship in the Alpha or Beta Quadrants. Its weaponry included 20 ship-mounted disruptor cannons, one large forward disruptor, and four torpedo launchers. Like other Klingon ships, it also featured a cloaking device that could render it invisible to both the naked eye and other ships' sensors.

FAMILIAR DESIGN

The design of the *Negh'Var* class was clearly based on the layout of the earlier *Vor'cha* class and they shared many similar features, in particular the central 'neck' section of both classes appeared to be almost identical. There were, however, several notable differences, the most obvious of which was that the *Negh'Var* class was much larger – more than 200 meters longer and roughly 128 meters wider. In addition, the bridge module on the *Negh'Var* class was located on top of a wider 'cobra' head front section. Meanwhile, the 'wings,' which contained embedded warp nacelles, swept forward, whereas on the *Vor'cha* class, the nacelles were separate elements attached to the end of the 'wings,' and swept backwards.

The *Negh'Var* also featured additional elements such as a short spike-like protuberance that jutted out from a gap in the front of the ship, and pod-like weapon structures under the wings that emitted disruptor beams. Finally, the *Negh'Var* featured a built-up triangular-shaped superstructure on top of the aft dorsal section that featured several spikes protruding from the rear of it.

The hull color of the *Negh'Var* was the same dark green as that found on the *B'rel*-class bird-of-prey of

◀ One of the most prominent features of the *I.K.S. Negh'Var* was a short spike that was situated in a gap at the front of the 'cobra' head prow of the ship. It also featured weapon pods on the ventral side, on either side of the main body, and embedded warp nacelles that glowed red towards the outside of the forward-swept 'wings.'

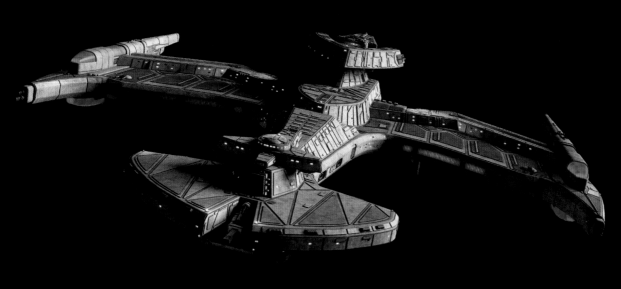

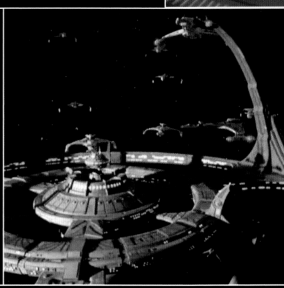

▲ Like the rest of the Klingon fleet, the *Negh'Var* was aggressively styled, and the outer hull was covered in armor plating and radiator blocks.

▶ An entire Klingon fleet led by the *Negh'Var* arrived at Deep Space 9 supposedly to protect Bajoran space from a Dominion invasion.

▲ The first time Starfleet encountered the *I.K.S. Negh'Var* was when it suddenly decloaked in close proximity to Deep Space 9. Both Sisko and Dax had heard of it before and knew it was the new Klingon flagship.

the same era, although some panels on the dorsal side were painted a rusty red. The hull also featured numerous raised heavy armor plate panels and slotted radiator blocks.

CHANGELING COMMANDER

The *I.K.S. Negh'Var* was first encountered by Starfleet in 2372 when it, and an entire Klingon fleet, suddenly decloaked in close proximity to Deep Space 9. The ship was commanded by General Martok who, unbeknownst to both the Klingons and the Federation, was in fact a Changeling. He claimed that the Klingon fleet was there to help protect Bajoran space from Dominion attack, but he was really trying to provoke a war between the major powers of the Alpha Quadrant, dividing and weakening them, before a Dominion invasion.

The Martok Changeling was almost successful too. He convinced Chancellor Gowron that a coup on Cardassia Prime had been orchestrated by Changeling infiltrators, and that it was necessary to take control of Cardassia in order to keep the Alpha Quadrant safe from the Dominion.

He then led a Klingon invasion force from the *Negh'Var* and it soon overran the Cardassian fleet. The Klingons would have almost certainly captured and killed the leaders of Cardassia, but Captain Sisko managed to coordinate a plan with Gul Dukat and rescue them using the *U.S.S. Defiant* NX-74205.

The Klingons were incensed by Captain Sisko's actions. The Martok Changeling returned to Deep Space 9 aboard the *Negh'Var*, leading a fleet that proceeded to attack the station. Fortunately, the station's weaponry had recently been upgraded

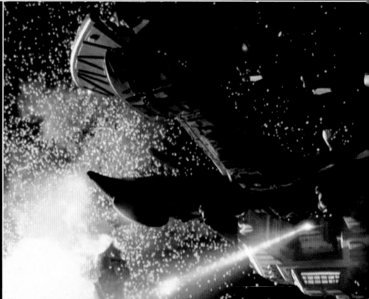

◀ The *Negh'Var* led a Klingon task force in an attack against Deep Space 9 after Captain Sisko had brought the leaders of Cardassia there to keep them safe.

▶ While several Klingon ships were destroyed while attacking Deep Space 9, the *Negh'Var* survived and disabled two of the station's shield generators.

◀ With Deep Space 9's shields temporarily offline, numerous Klingon troops from the *Negh'Var* were able to beam onto the station and continue the fight.

▶ Ultimately, the Klingon assault failed and the *Negh'Var* was forced to withdraw, but Gowron warned that he would not forget what had happened.

and they were able to hold off the onslaught long enough for reinforcements to arrive, forcing the *Negh'Var*, and the rest of the fleet, to retreat.

DRIVEN BACK

The Klingons returned to their assault on Cardassia, but when the Dominion joined forces with the Cardassians, the tide of the war began to turn. In mid-2373, the *Negh'Var*, carrying Chancellor Gowron, was forced to withdraw to Deep Space 9 along with the rest of the Klingon invasion force.

As the war with the Dominion escalated, the Klingons poured their resources into building new ships. By 2375, there were multiple *Negh'Var*-class warships engaged in the conflict, and they ultimately helped the Federation and its allies defeat the Dominion.

DATA FEED

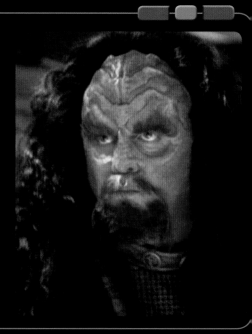

At some point during 2371, General Martok was captured by the Dominion and sent to Internment Camp 371. Meanwhile, a Changeling adopted his form and took his place as one of the most important leaders in the Klingon military. The Changeling Martok took command of the *Negh'Var* and launched an unfounded attack on Cardassia, knowing that it would provoke a conflict between the Federation and the Klingon Empire.

ALTERNATIVE VERSIONS

In addition to the *Negh'Var*-class ships operating in the regular universe, they were also found in several alternate realties where their appearance differed slightly from the layout in the prime universe. In around 2395, in an alternate future created by the omnipotent being Q, two Klingon warships almost identical to the *Negh'Var* class attacked the *U.S.S Pasteur* NCC-58925.

The *Negh'Var* was also found in the Mirror Universe. Here, it was absolutely massive at approximately 2 km long. It was commanded by Regent Worf, and in 2372, it spearheaded an Alliance fleet on a failed offensive to retake Terok Nor from the Terran Rebellion. In 2375, it was sabotaged, leaving it completely defenceless, and the Regent was forced to surrender as a prisoner of war.

In another alternative future, a Klingon scientist named Korath had several *Negh'Var*-class ships at his disposal. Korath used these ships to attack Admiral Janeway's shuttle after she stole a chrono deflector from him.

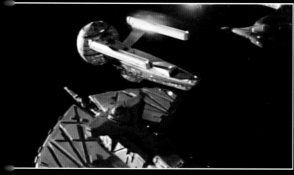

▲ The *Negh'Var*-class ships operated by Korath also featured a long spike in the nose and were equipped with nadion-based weapons.

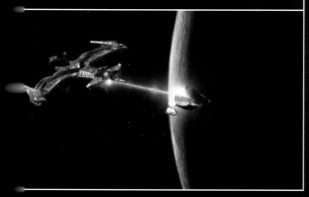

▲ The *Negh'Var*-class vessel in an alternative future created by Q featured a long spike in the front nose and a pale green colored hull.

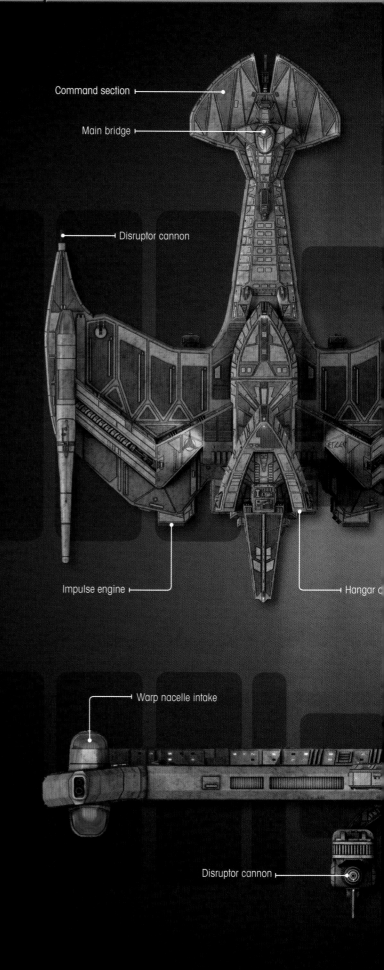

Command section
Main bridge
Disruptor cannon
Impulse engine
Hangar
Warp nacelle intake
Disruptor cannon

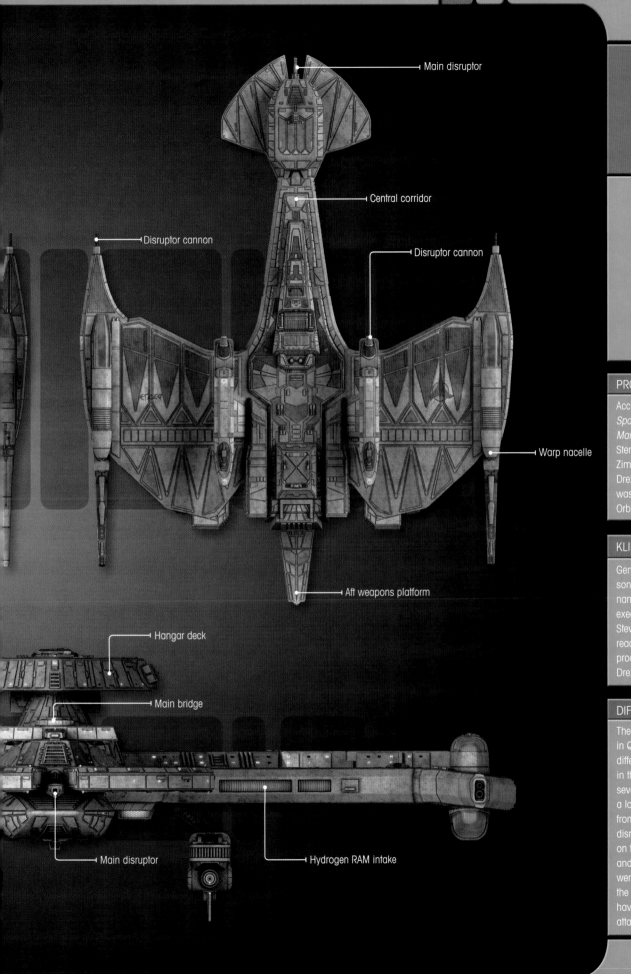

Main disruptor

Central corridor

Disruptor cannon

Disruptor cannon

Warp nacelle

Aft weapons platform

Hangar deck

Main bridge

Main disruptor

Hydrogen RAM intake

PRODUCTION BASE

According to the *Deep Space Nine Technical Manual* written by Rick Sternbach, Herman Zimmerman and Doug Drexler, the *Negh'Var* was built at the Qo'noS Orbital Factory Base.

KLINGON NAME

General Martok had a son named Drex. The name was given by executive producer Ira Steven Behr after he read the nickname on production staffer Doug Drexler's crew jacket.

DIFFERENT LAYOUT

The *Negh'Var* ship seen in Q's anti-time future differed from the version in the prime universe in several ways. It featured a longer spike protruding from the nose, there were disruptor cannons located on the tips of the 'wings,' and two 'fang'-like spikes were attached below the bow. It also did not have the weapon pods attached below the wings

SIZE CHART

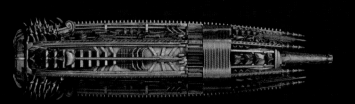

DASPU CLASS

527.30m

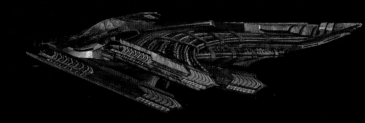

SECH CLASS

558.8m

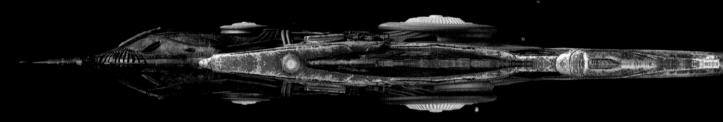

QUGH CLASS

1360.5m

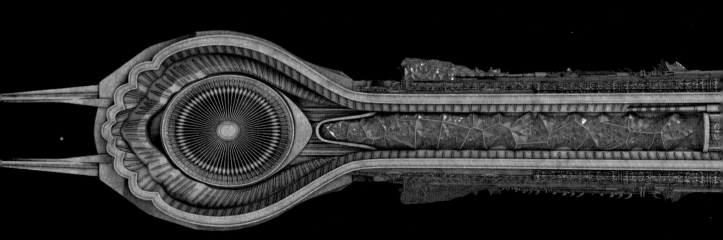

INGON SARCOPHAGUS SHIP

50m

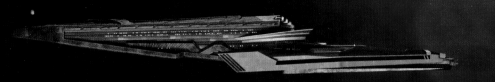

'ETLH CLASS
733.53m

KLINGON BIRD-OF-PREY
188.7m

KLINGON RAIDER
30m

**KLINGON DEFENSE FORCE
BIRD-OF-PREY**
139m

KLINGON BIRD-OF-PREY
110m

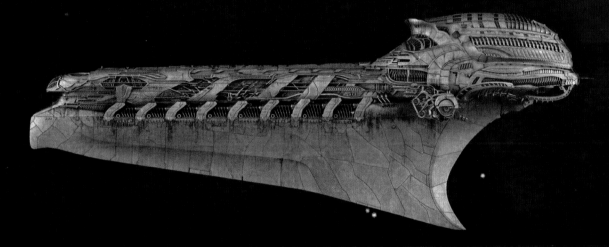

CLEAVE SHIP
934.5m

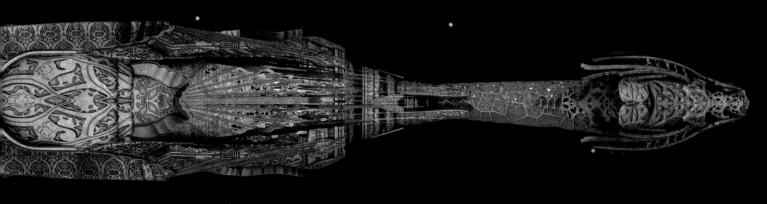

23rd & 24th CENTURY

SIZE CHART

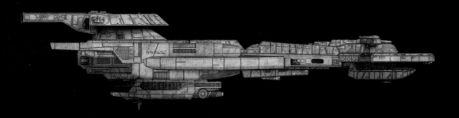

I.K.S. NEGH'VAR
682.32m

D7-CLASS BATTLE CRUISER
228m

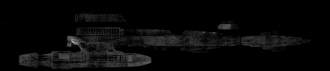

VOR'CHA CLASS
481.32m

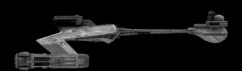

BATTLE CRUISER
349.54m

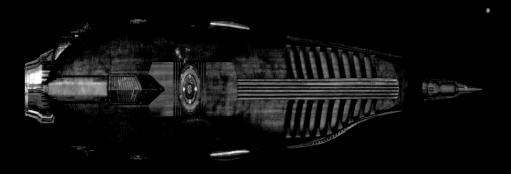

JACH CLASS
755.6m

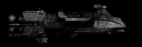

CIVILIAN TRANSPORT
200m

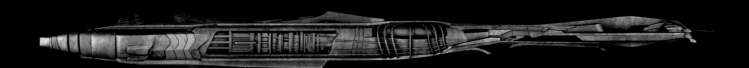

QOJ CLASS
1108.7m

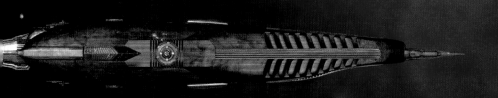

CHARGH CLASS

73.6m

MILITARY FREIGHTER

225.65m

BORTAS BIR CLASS

850.34m

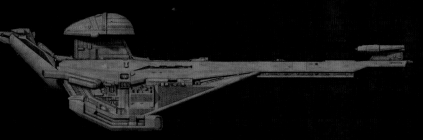

KLINGON TRANSPORT 2372

00m

BATLH CLASS

418.26m

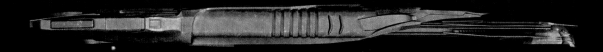

QAW CLASS

908.84m

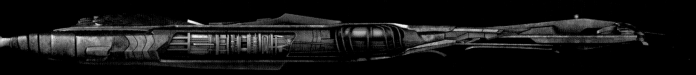

VEQLARGH CLASS

106.5m

SHIPS

CLASS OR TYPE

INDEX

www.startrek-starships.com
www.eaglemoss.com/discovery

STAR TREK SHIPYARDS:
STARFLEET SHIPS 2151–2293

This in-depth reference book, written by Ben Robinson, Marcus Riley, and Matt McAllister profiles Starfleet ships from the birth of the Federation to the launch of the *U.S.S. Enterprise* NCC-1701-B and the death of Captain Kirk. It also includes a chapter on Earth's pre-Federation vessels, including Zefram Cochrane's ship the *Phoenix*, which made mankind's first faster-than-light journey. Plus all of the Starfleet ships from the first season of *STAR TREK: DISCOVERY* and the original *STAR TREK* TV series. The book is richly illustrated with CG artwork using the original VFX models created for the *STAR TREK* TV shows and movies.

STAR TREK SHIPYARDS:
STARFLEET SHIPS 2294–THE FUTURE

This volume features small transports, fighters, multi-mission explorers and time traveling ships from the distant future. Each ship is illustrated with CG artwork, including original VFX models made for the TV show, alongside a technical overview and operational history. Chapters include size charts, showing the ships to scale. An appendix of class listings is featured at the back of the book.

ALSO AVAILABLE

STAR TREK DESIGNING STARSHIPS:
THE ENTERPRISES AND BEYOND

This book covers the genesis of more than 30 ships including seven Enterprises, and is packed with original concept art, showing fascinating directions that were explored and abandoned, and revealing the thinking behind the finished designs.

Discover the inspiration behind the designs of key ships from the first five TV series, plus the movies including *STAR TREK: THE MOTION PICTURE; STAR TREK II: THE WRATH OF KHAN; STAR TREK III: THE SEARCH FOR SPOCK* and *STAR TREK: FIRST CONTACT*.

STAR TREK DESIGNING STARSHIPS:
THE *U.S.S. VOYAGER* AND BEYOND

This book follows the journey of many of *STAR TREK*'s most famous ships, from concept sketch to screen. The designers reveal – in their own words – the often extraordinary stories behind the ships' creation. Read the story of the *U.S.S. Voyager* – a ship that drew inspiration from a killer whale; Syd Mead's fantastic living machine *V'Ger*; and the development of Doug Drexler's *Enterprise-J* – the most futuristic starship ever.

Discover the inside story on key ships from the TV series *STAR TREK, STAR TREK: THE NEXT GENERATION, DEEP SPACE NINE, VOYAGER,* and *ENTERPRISE,* and the movies *STAR TREK: THE MOTION PICTURE, STAR TREK III: THE SEARCH FOR SPOCK, STAR TREK: FIRST CONTACT, STAR TREK: INSURRECTION,* and *STAR TREK NEMESIS*.

www.startrek-starships.com

www.eaglemoss.com/discovery

CREDITS

Editor: Ben Robinson

Project Manager: Jo Bourne

Writers: Marcus Riley and Ben Robinson, with additional material by Simon Hugo and Mark Wright

Illustrators: Fabio Passaro, Ed Giddings, Adam 'Mojo' Lebowitz, and Robert Bonchune

Jacket Designer: Stephen Scanlan

Designers: Stephen Scanlan and Katy Everett

With thanks to Matt McAllister, Terry Sambridge, Colin Williams and James King

Most of the text and Illustrations originally published in *STAR TREK™ – The Official Starships Collection* and *STAR TREK™ DISCOVERY – The Official Starships Collection* by Eaglemoss Ltd. 2013-2018

Published by Hero Collector Books, a division of Eaglemoss Ltd. 2019
1st Floor, Kensington Village, Avonmore Road,
W14 8TS, London, UK.

ISBN 978-1-85875-539-7

Printed in China